Life's
too short
for bad art,
*these choices
really matter*

Brimming with creative inspiration, how-to projects, and useful information to enrich your everyday life, Quarto Knows is a favourite destination for those pursuing their interests and passions. Visit our site and dig deeper with our books into your area of interest: Quarto Creates, Quarto Cooks, Quarto Homes, Quarto Lives, Quarto Drives, Quarto Explores, Quarto Gifts, or Quarto Kids.

First published in 2021 by Ivy Press,
an imprint of The Quarto Group.
The Old Brewery, 6 Blundell Street
London, N7 9BH,
United Kingdom
T (0)20 7700 6700
www.QuartoKnows.com

A catalogue record for this book is available from the British Library.

ISBN: 978-0-7112-5606-4

10 9 8 7 6 5 4 3 2 1

Design by Eoghan O'Brien

Printed in China

Chloë Ashby

LOOK AT THIS

IF YOU LOVE

GREAT

ART

A critical curation of
100 essential artworks

IVY PRESS

CONTENTS

INTRODUCTION

I've been lucky when it comes to workplaces. More often than not, they've been a short walk away from a gallery or museum. There was one newsroom on London's Southbank, just along from Tate Modern; another in Marylebone, a close neighbour of the Wallace Collection. Come lunchtime, I'd take time out from the rattling keyboards and office chitchat to reset in front of an artwork. There was something about the pencil lines and the layers of oil paint that made me feel more present. Today, we're always in a hurry – and art is a means of slowing down and checking in with yourself.

Some of those artworks have made it into this book. When I started my selection process, a few old favourites slipped smoothly out of my head and onto the page. Take Édouard Manet's barmaid at the Folies-Bergère, whom I first met while studying art history at the Courtauld Institute of Art and who holds a special significance for the protagonist of my first novel. My dissertation was on Gustave Caillebotte's floor scrapers: there was something about the half-dressed workmen that got me (besides their gleaming bodies). Other works – such as Helene Schjerfbeck's eerily abandoned landscape and Madge Gill's feverish and frantic hallucinatory drawing – I've stumbled across at exhibitions over the years.

Once I had a working list, I began to pick it apart – because really, this book is about more than what I happen to like best. I wanted to include a mix of styles and schools, from the Renaissance to the present day, and a balance of nationalities and genders. Alongside the big names, you'll find overlooked and emerging artists. I set my sights beyond the mostly white, mostly male traditional canon. I also began to think about the themes threaded through the history of art, which became the basis for my chapters. This isn't a chronological survey – instead, it brings together works that seem worlds apart but, in fact, share certain characteristics or aims.

I'm a freelancer these days, and my workplace is my flat. At present, I'm living in Paris, and as well as the museums and galleries on offer I have a pinboard of postcards, artworks reproduced on a small scale. (Art can be consumed in more than one format.) It's worth saying that though this book contains what I consider to be 100 of the most original and inspiring artworks out there, I wouldn't necessarily want to have them all on my walls – and not just because I don't have anywhere near the space. Art can be beautiful, bewildering, brazen. It can also be hard to look at, and that's ok. There's no right or wrong way of looking at art, but it does reward those who make the effort to look twice, or more. Oh, and in the spirit of slowing down, take your time when it comes to turning these pages.

User Guide

The chapters in this book have been uniquely curated to offer an intriguing juxtaposition of works, and every entry comes packed with extra recommendations to take your appreciation to the next level. Here's a breakdown of what you can expect.

The Links

+ SEE THIS

Another great artwork by the same artist, or one that influenced or was influenced by the piece you see here.

+ VISIT THIS

Suggestions for galleries, museums or places connected to the artist or artwork.

+ READ THIS

Books with a thematic link, or biographies and articles to further your knowledge.

+ WATCH THIS

Films, documentaries, online interviews or artist talks worth investigating.

+ LISTEN TO THIS

Podcasts or pieces of music to perfectly accompany gazing upon this artwork.

+ LIKE THIS? TRY THESE

Three artists who are either from the same period or have covered similar themes in their work.

The Chapters

Oh, What a Feeling! (10–29)
The tortured artist is a familiar trope. Less so art that tortures those who look at it. Joy, pity, anxiety, fear: these are all fitting responses to the emotional rollercoasters in this chapter.

You Can Leave Your Hat On (30–49)
Nakedness in art has enchanted and enraged audiences across the ages. Here we explore myriad variations, from idealized nudes to mighty and meaty images of unprimed human flesh.

Pushing the Boundaries (50–71)
At times you have to shake things up in order to make a change. From acts of defiance to the use of revolutionary artistic devices, the works of art in this chapter challenged the status quo.

Gods and Mythical Creatures (72–93)
Religion and myth are threaded through art history, presenting viewers with origin stories as well as cautionary tales. The paradox? Looking at images of beautiful goddesses and unbridled centaurs reminds us what it is to be human. And no, you don't have to be religious to appreciate religious art.

Troubled Dreams (94–113)
Dreams are a tantalizing subject for artists – and no wonder, with their imaginative possibilities. This chapter unveils what happens during our sweet seconds of shut-eye, and the fantastical beasts that might be lurking beneath your bed.

Out of the Ordinary (114–133)
Many artists have made their mark picturing or pilfering commonplace things, people and places. Of course, the effect is quite the opposite – the ordinary made extraordinary.

To the Barricades (134–155)
Art is a soft-power superpower – a mirror to society and a battle cry for change. Whether created in response to a historic event, or to convey the injustice of contemporary life, these works call for social and political upheaval.

Natural Wonders (156–177)
Just as artists scavenge their own lives for inspiration, so too do they borrow from the natural world. From a lamb in a formaldehyde-filled tank to a twitchy-nosed hare, these subjects are sourced from the great outdoors.

The Balance of Power (178–197)
Some artworks shine a light on the relationship between sitters; others turn their lens towards the viewer. Either way, what we have here is a case of power play. Your challenge? Not to look away when you become the subject of a disconcerting stare.

Change of Scene (198–219)
Art has the ability to immortalize not just a moment in time but also a particular place. The landscapes and cityscapes in this chapter capture grassy fields, crashing waves and quiet moments of urban isolation.

OH, WHAT A FEELING!

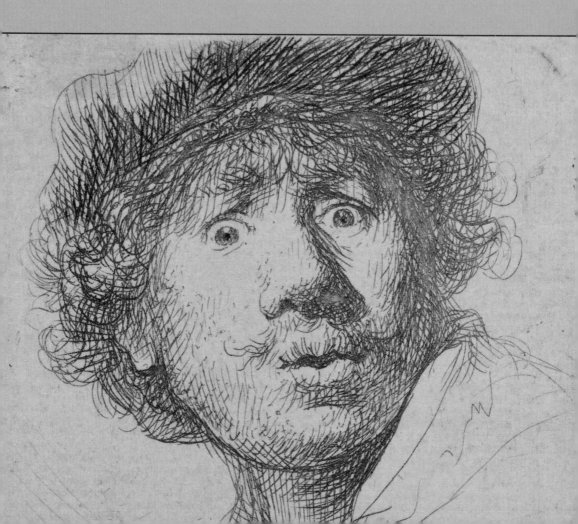

Rembrandt van Rijn

Self-Portrait in a Cap, Wide-eyed and Open-mouthed

1630

First-time writers are often told to write what they know and it's the same for artists. This poignant yet playful etching – one of a quartet the young artist created in Leiden, the Dutch city where he was born and raised – was one of Rembrandt's earliest attempts to record his own likeness.

The artist recoils, staring at us with wide eyes, upended eyebrows and an open pout; it's hard to tell whether he's taking a deep, sharp inhale of breath or about to yell. His tousled hair – sticking out from beneath his folded cap – falls to just above his eyes and adds to the sense of unease, as does the brisk crosshatching around his jawline and neck. This is the look of someone who's well and truly startled.

Except, of course, he isn't – because Rembrandt drew this study while pulling a face in front of a mirror. The young man who went on to become the greatest of all Dutch masters used his own bank of facial expressions to build up a repertoire that he could later borrow from when working on larger canvases of religious or mythical characters. He also went on to create dozens of self-portraits, which in turn display various emotions. It's up to you to decide if you think this obsessive focus on his own face is practical or self-indulgent.

Inevitably, when you learn that Rembrandt posed for this etching, the feeling it sparks inside you changes. Yes, the human emotion he sought to create in this informal study was surprise – and that remains the case. But when you picture the artist pulling a face at himself in a mirror – and trying desperately to ignore the itch above his left eyebrow, his heavy eyelids or the quiver of his lower lip – it's easy to spot a touch of humour, too.

+ ARTIST BIO
Dutch, 1606–69

+ SEE THIS
Just over ten years later, Rembrandt painted a very different self-portrait. In *Self-Portrait in a Flat Cap* (1642), the artist looks out at us confidently from beneath a wide-brimmed hat.

+ VISIT THIS
See this work and many more by Rembrandt at the Rijksmuseum in Amsterdam, where the Dutch artist rose to fame.

+ READ THIS
Simon Schama's *Rembrandt's Eyes* (2014) is a beautifully unconventional biography of the artist.

Like This? Try These

→ Hendrick ter Brugghen

→ Carel Fabritius

→ Jan Lievens

Gustave Courbet

The Desperate Man

1843–45

What does desperation look like? For Courbet, who painted this overwrought self-portrait when he was just twenty-four and hurriedly trying to build a reputation for himself, it's this. He claws at his thick, dark hair as he stares out at us in a frenzy, brown eyes bulging, cheeks burning red. Veins bulge on the underside of his wrist – his blood is pumping hard and fast.

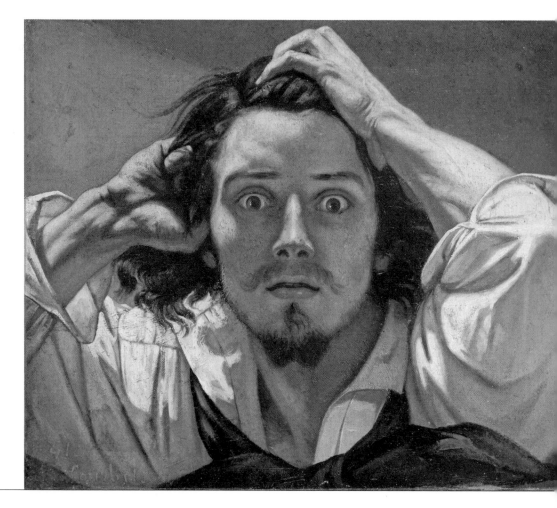

Like the young Rembrandt (see page 11) his lips are parted, as if he wants to say something but can't get the words out. This is a young man panicky with ambition, frantic for success. The tightly packed canvas, together with the stark contrast of light and dark, adds to the sense of claustrophobia.

Courbet was born in 1819 into a prosperous farming family in Ornans, a village in the Jura mountains of eastern France. In 1839 he moved to Paris and found a room in the Latin Quarter, where he mingled with bohemian artists and writers. Here he presents himself as the archetypal Romantic artist – a tortured genius striving for recognition in his puffy white shirt and navy-blue smock.

Courbet painted *The Desperate Man* together with several other self-portraits in the early 1840s. Searching for artistic standing, he decided quite literally to inject himself into art history. There may be something dandyish about this young man with muscled arms and a forked beard, but in other works – from *The Wounded Man* (1844–54), which shows him heroically suffering with a bloodstain on his shirt, to *The Man with the Leather Belt* (1845–46), in which he gazes at the viewer while brushing a lock of hair from his cheek – he's a veritable heartthrob.

This particular self-portrait remained in the artist's studio until his death in 1877, which suggests it was personal. Courbet went on to describe himself as the 'proudest and most arrogant man in France'. He sought to capture scenes from modern life and, like Caravaggio (see page 26), boldly inserted ordinary folk into vast canvases usually reserved for history painting. This early image of an insecure young artist, however, reveals some vulnerability. This is Courbet, staring – like us all – into an unknown future.

+ ARTIST BIO
French, 1819–77

+ SEE THIS
The Paris Salon of 1844 accepted *Courbet with a Black Dog* (1842–44), a haughty self-portrait of the artist in a wide hat and black cape, pausing on a hillside.

+ VISIT THIS
The Musée Courbet in Ornans, France, is dedicated to the French painter.

+ READ THIS
Courbet's desperate man is a close relative of the crazed character who narrates Fyodor Dostoevsky's *Notes from Underground* (1864).

Like This? Try These

→ Jean-Baptiste-Camille Corot

→ Honoré Daumier

→ Jean-François Millet

+ ARTIST'S BIO
Danish, 1864–1916

+ SEE THIS
In *Interior with a Standing Woman* (undated), Ilsted is glimpsed through an open door, while *Interior with a Windsor Chair* (1913) sees her replaced by a chair.

+ VISIT THIS
Rest resides in the Musée d'Orsay in Paris.

+ READ THIS
So much of the novelist Elizabeth Strout's success comes from her ability to render narratives quietly and convincingly. Start with *Olive Kitteridge* (2008).

Like This? Try These

→ Anna Ancher

→ Carl Holsøe

→ Peter Ilsted

Vilhelm Hammershøi
Rest
1905

If it's a sense of calm you're searching for, park yourself in front of a painting by Hammershøi. Take *Rest*, which shows a woman with her back to us, slouched in a chair, right shoulder dipped lower than left. She's indifferent, unfazed by our presence, and yet there's also something sensual about the wisps of hair brushing her neck. Hammershøi's art is meditative, hazy with absence and anonymity, and often with the silence comes something more unsettling.

While his contemporaries were splashing colour onto loud canvases in Paris, the Danish painter was quietly working away in his native Copenhagen on small paintings of tranquil interiors bathed in a fine mist of moody greys. He hated the cluttered homes of the bourgeoisie, preferring his interiors sparse and fuss-free. When he and his wife, Ida Ilsted, moved into their apartment at Strandgade 30, he employed decorators to paint it plainly and furnished it minimally. The stillness in *Rest* is accentuated by the subdued palette and distinct patches of colour: tawny chair, grey wall, white skirting board, dark floor.

It may be Ilsted who's facing that wall, simply dressed in a bunched-up smock and skirt, her hands out of sight. She could be reading a letter, knotting her fingers or resting her eyes. Her eggshell complexion echoes that of the shallow scalloped dish on the table, a milky white. Standing behind her, you can almost feel the hair tickling her neck. She has her back to us in a number of her husband's paintings.

Hammershøi's art is as tantalizing as it is calming. His bare interiors, with their open and shut doors, sway between intimacy and claustrophobia – the world closing in. In his work, time is suspended and what we're left with is an impression of a private life played out in gently graduated shades of grey. And therein lies the mystery. The artist's paintings may be quiet, but they also exude a quiet power.

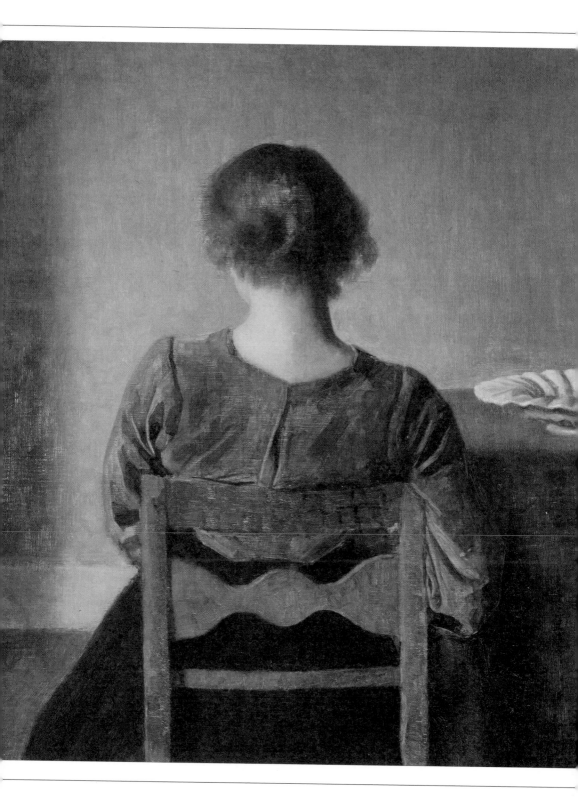

Amrita Sher-Gil

Three Girls

1935

There's something deeply despondent about this painting. The three girls avert their eyes, staring down at the ground or straight ahead, eyebrows furrowed, lips pressed together. Their solemn expressions are juxtaposed with the vibrant reds, oranges and minty greens of their clothes, which again contrast with the murky background. With one hand resting on her knee and the other upturned beside it, the girl in red looks as if she might be about to speak. Are they waiting for someone who hasn't appeared? Is it now time to leave?

With her paintbrush, Sher-Gil gave a voice to ordinary Indian women in the 1930s – even if that voice was downbeat. A pioneer of modern Indian art, she called attention to the daily lives of women, depicting them at home or running errands at the local market. But unlike traditional portraits, which presented Indian women as content and compliant, Sher-Gil hinted at their sense of loneliness and the silent resolve that kicks in after being forced to submit and make personal sacrifices.

Sher-Gil understood the raw emotions of the *Three Girls* because she had experienced them herself. These girls are on the cusp of adulthood and most likely marriage, dejected but resigned to their future (the dejection is coupled with infinite patience). It was the first painting Sher-Gil made on returning to India in 1934, following studies at the École des Beaux-Arts in Paris and a five-year stint living among the city's bohemian crowd. She travelled around the country and rebuilt relationships and connections with its people, whom she painted from life. In her own words, 'I am personally trying to be, through the medium of line, colour and design, an interpreter of the life of the people, particularly the life of the poor and sad.'

+ ARTIST BIO
Hungarian-Indian, 1913–41

+ SEE THIS
The Little Girl in Blue (1934) captures two sides to Sher-Gil's personality: outgoing and reserved.

+ VISIT THIS
The National Gallery of Modern Art in New Delhi is home to more than 100 of her works.

+ READ THIS
Dalmia Yashodhara's *Amrita Sher-Gil: A Life* (2013) traces the life and work of the artist.

Like This? Try These

→ Marie-Louise Chassany

→ Eva Frankfurther

→ Vivan Sundaram

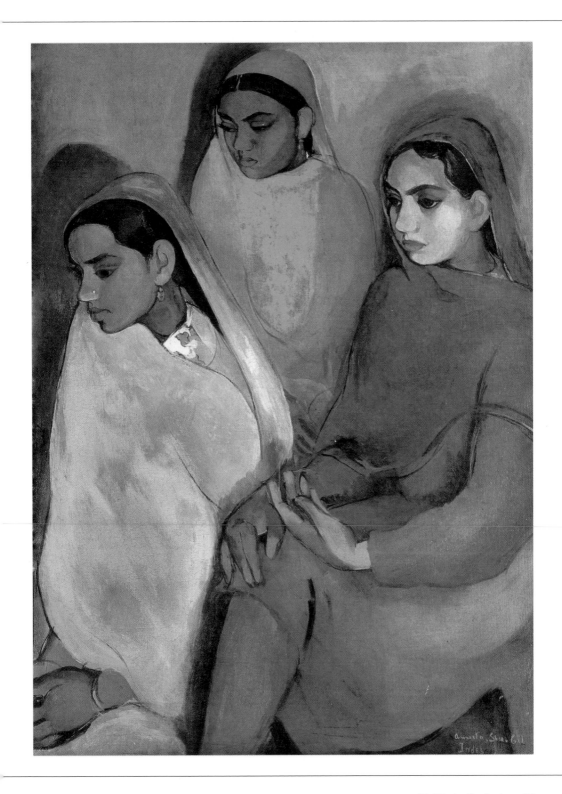

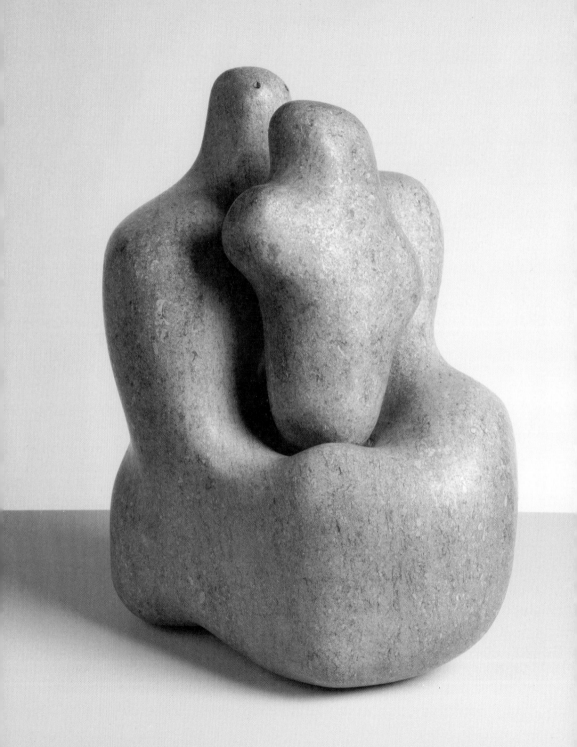

Barbara Hepworth
Mother and Child

1934

Motherhood was a popular motif among early twentieth-century sculptors in Britain, in part because it allowed them to explore the tender relationship between two forms within one slab of stone or wood. What Hepworth did differently was visualize her protagonists as two independent bodies, set apart but intimately linked – her sculptures celebrate women's independence as well as the close bond that endures between mother and child.

The Yorkshire-born and raised sculptor was expecting what turned out to be triplets with her second husband – the British painter Ben Nicholson – when she made this small abstract statue in pink Ancaster stone. The first maternal work she created from two separate forms, it shows a child nestling into the hollow of its mother's stomach. The surface of the stone is smooth, its edges rounded, evoking the naturalness of birth and the vulnerability of both mother and infant. To some, the gentle curves also evoke the hills and dales of Yorkshire.

Hepworth spent much of her fifty-year career in St Ives – the pale cliffs and blustery harbours of the Cornish coast influenced her art, too. With four children by the middle of the twentieth century, she had to set aside small pockets of time to continue her work as an artist. 'I had triplets by Ben Nicholson, and then it was do or die!' she said in an interview in 1964. 'But being a mother enriches a sculptor's experience. I decided I must do some work each day. It went on in my head even when I was doing the chores. The result was fewer sculptures, but I believe more triumphs.' And if she was in the middle of a work and a child started crying? She would simply pause, deal with the crisis, then pick up where she left off.

+ **ARTIST BIO**
British, 1903–75

+ **SEE THIS**
In the sunny lithograph *Genesis* (1969), Hepworth suspends a pair of circles in space, ringed by lines and arcs.

+ **VISIT THIS**
The Hepworth Wakefield in Yorkshire is home to forty-four plaster and aluminium prototypes by Hepworth, while her studio remains intact in St Ives.

+ **READ THIS**
To learn more about the artist, pick up a copy of *Barbara Hepworth: Writings and Conversations* (2015), edited by Sophie Bowness.

Like This? Try These

→ Jacob Epstein

→ Henry Moore

→ Winifred Nicholson

Egon Schiele
The Scornful Woman

1910

This confrontational portrait is one of many by the great Austrian modernist Schiele, whose frank and erotic art shocked his audience in turn-of-the-century Vienna.

+ ARTIST BIO
Austrian, 1890–1918

+ SEE THIS
Compare Klimt's graceful *Standing Female Nude (Study for the Three Gorgons, 'Beethoven Frieze')* (1901) with Schiele's more sexually frank *Seated Female Nude, Elbows Resting on Right Knee* (1914).

+ VISIT THIS
The Austrian art collector Rudolf Leopold's vast collection of Schieles resides in the Leopold Museum in Vienna.

+ READ THIS
'Hell hath no fury like a woman scorned.' It's a theme that has cropped up in literature across the ages, from *Medea* (431 BC) by Euripides to Gillian Flynn's *Gone Girl* (2012).

Like This? Try These

→ Ernst Ludwig Kirchner

→ Oskar Kokoschka

→ Maria Lassnig

His scornful woman leans forward in her seat and turns to scowl at something or someone to her left. If she wasn't topless, her nipples a lurid red, or wearing a view-blockingly-big hat, you might imagine her in a theatre, brashly rebuking a noisy neighbour. Her eyebrows are furrowed, her long-lashed eyes narrow. Her nose wrinkles as she opens her mouth and lets out a snarl. The effect is candid, even primal.

A student of the prestigious Akademie der Bildenden Künst, Schiele caught the eye of Gustav Klimt – leader of the Vienna Secession movement, which rejected Beaux-Arts Classicism and the oh-so-stuffy establishment in favour of everything avant-garde. Both artists depicted figures who were either partially clothed or fully exposed. Schiele's early works show the influence of his new mentor's concise style, but soon the young protégé was ratcheting up what he'd learned.

Schiele went on to become a pioneer of Expressionism, twisting and distorting his figures to dramatic effect. Adding to the sense of unease here are the patchy brushstrokes, which have been rapidly applied on top of the original drawing. The bright-white outline around the sitter's body, as well as the bare backdrop, gives the impression she could turn on us at any moment.

You can't help but pity the object of her burning gaze, but there's also something vulnerable about the scornful woman herself. With each hand she grips onto the opposite arm, her knuckles wrinkled and her bony shoulders raised. Her face and chest are ashen white, which only highlights the shock of her red-raw lips and those nipples. Hacked off at shin height, her missing legs shift the focus back to her face. She may be scornful, but surely something – or someone – has prompted her to behave this way.

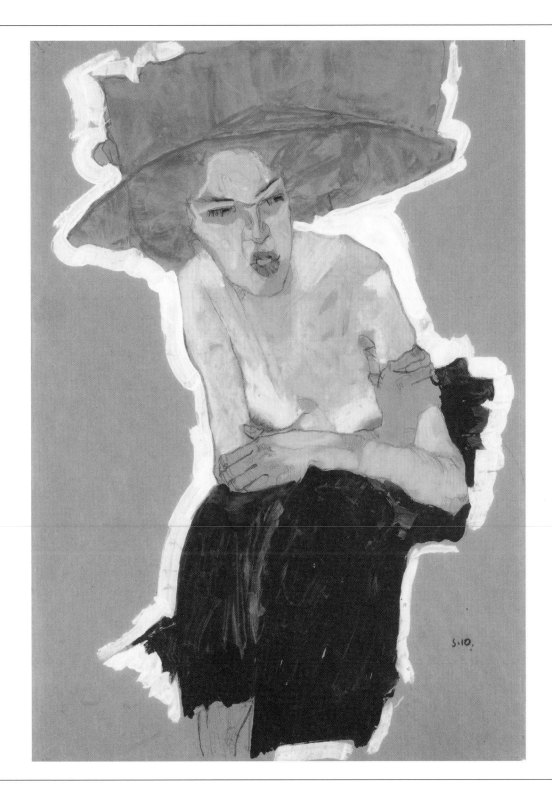

Gluck

Medallion (YouWe)

1936

From aversion to affirmation: with their upright posture and composed expressions, Gluck's parallel pair are a world away from Schiele's scornful woman. In unison, they turn their heads. Their lips are pressed together, their brows fixed in place. Their close-cropped hair rises and falls in soft, sculptural waves. Gluck herself is in the more shadowed foreground; bathed in light behind is her lover, the American socialite Nesta Obermer. Intimate and unwavering, this double portrait is a radical declaration of their love affair.

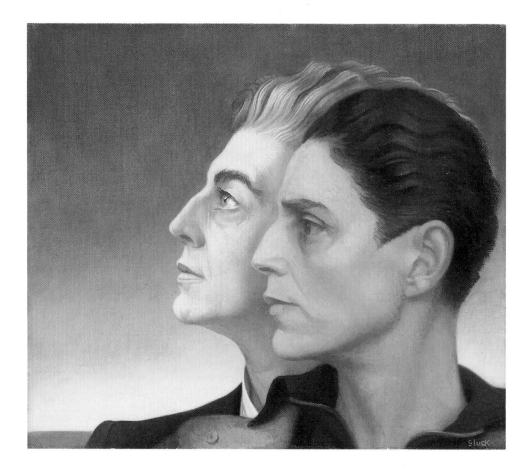

Born Hannah Gluckstein, to the London Jewish family behind the catering empire J. Lyons and Co., the artist refused early on to identify as either a woman or a man. She became an artist – again, declining to identify with a specific school – and joined a colony in Cornwall. By her mid-twenties she'd taken the genderless name Gluck, with no 'suffix, prefix or quotes'. She cut off her hair, wore suits and smoked a pipe. All her adult relationships were with women, among them Obermer, who had a flush older husband. Shortly before she painted *Medallion (YouWe)*, Gluck and Obermer had been to a production of Mozart's *Don Giovanni*. Her biographer, Diana Souhami, writes: 'They sat in the third row and she felt the intensity of the music fused them into one person and matched their love.'

Once you know the backstory, you realize that the statuesque painting of these two twinned souls is charged with passion. But even stripped of context, the image is electric. There's great love here, but also a steeliness that shines through in the contoured cheekbones, stiff collars and Gluck's razer-sharp sideburns. Obermer's chin is raised, her sage-green eyes glistening as she looks towards a bright and hopeful future. Gluck is more rooted in reality. Her knitted brow hints at the anxiety surrounding same-sex unions: in 1936, homosexuality was illegal and there was no acceptable language for being lesbian or transgender. That tension raises the stakes, making this deeply personal portrait all the more poignant as it immortalizes lesbian love in paint.

+ ARTIST BIO
British, 1895–1978

+ SEE THIS
Gluck and Obermer reappear in *The Punt* (c. 1937), a fleeting image of the couple in a slender boat on an inky-black lake near the Obermers' country house in Sussex.

+ VISIT THIS
In a 1942 self-portrait hanging in London's National Portrait Gallery, the artist turns her gaze towards the viewer.

+ READ THIS
Eight years before Gluck painted *Medallion (YouWe)*, Radclyffe Hall's novel *The Well of Loneliness* (1928) had been censored for being about a same-sex relationship.

Like This? Try These

→ Romaine Brooks

→ Tamara de Lempicka

→ Lotte Laserstein

Mark Rothko
Untitled (Black on Maroon)
1958

They may not show a snarling face or a twirling body, but Rothko's abstractions ooze emotion. Even when viewed on a screen, the brooding veils of colour and blurry outlines draw you in. Take a seat in front of one of his doomy canvases in real life and, by the time you're able to tear yourself away, you'll feel uplifted, cleansed, stunned, stumped or simply sapped of energy.

It was in 1958 that the Abstract Expressionist began his Seagram murals, a series of bruised-purple and blood-red works that resemble windows and doors. Through the glass, oblivion calls. Although each canvas eschews representation it's tempting to think that, if you squint, you might glimpse someone lurking in the shadows. The ragged edges add a touch of urgency and the idea that, if you take your eye off the work, the illusory portals might melt away. Even as you blink – go on, try it – the dusky planes of colour appear to oscillate.

Rothko sought to establish a pure form of painting that blurred the boundaries between both artist and idea, and idea and viewer. He wanted to capture stillness and, at the same time, spark a potent response in his audience. For him, colour was an expression of emotion, and the multilayered hues within his art reflect the complex feelings within us all. It's no coincidence that the artist's early works, which glowed orange and yellow, later gave way to sombre shades of sooty black and deep maroon. In 1970 he killed himself.

Rothko was commissioned to make the Seagram murals by the Four Seasons restaurant in New York's Seagram Building, but he later decided that his haunting pieces would be better off with Tate. They now reside in a room of their own in London's Tate Modern, where the solemn canvases envelope viewers in their magnetic swathes of colour. So go on, take a seat and give yourself over to them – dark, luminous, palpable.

+ ARTIST BIO
American, 1903–70

+ SEE THIS
In the 1950s the artist visited the House of Mysteries in Pompeii and felt 'a deep affinity' between his murals and the ancient Roman frescoes there.

+ VISIT THIS
For an immersive experience, head to the Rothko Room at London's Tate Modern or the Rothko Chapel in Houston.

+ LISTEN TO THIS
Put on Franz Schubert's 'Death and the Maiden' (1824) and watch the colours of Rothko's canvas come alive.

Like This? Try These

→ Anni Albers

→ Barnett Newman

→ Jackson Pollock

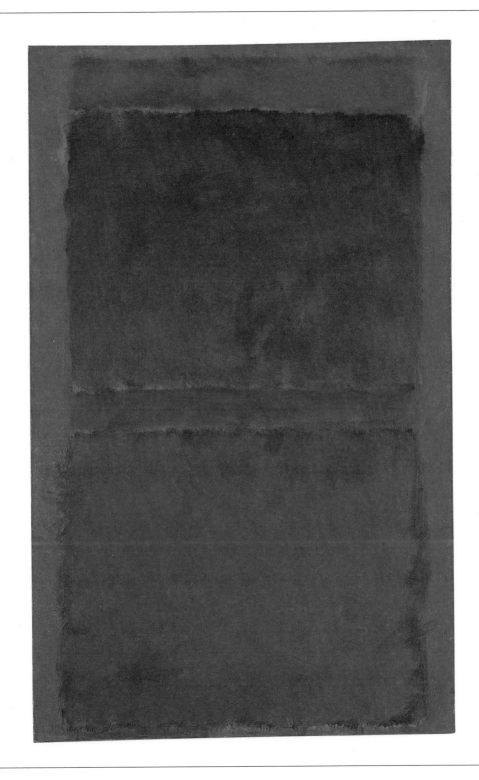

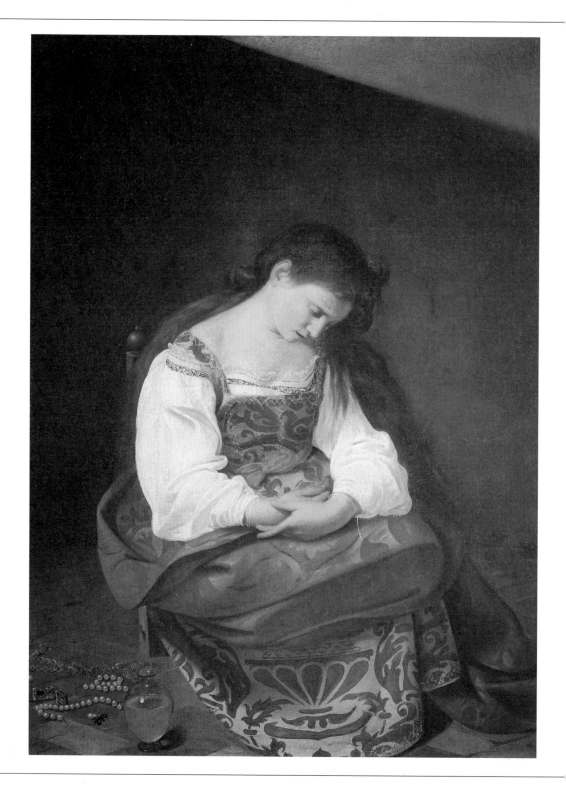

Michelangelo Merisi da Caravaggio
Penitent Magdalene
c. 1597

No painting is quite as honest and direct as Caravaggio's *Penitent Magdalene*, a melancholy portrait that hangs in the Galleria Doria Pamphilj in Rome. There, a short walk away from the camera-toting crowds congesting the Piazza di Trevi, you often have the place to yourself – and what a place it is, piled high with more canvases than there are people gawping at them.

Caravaggio shows a young girl sitting on a low-slung chair in an unadorned room. Her long auburn hair is brushed back off her pale face, drawing attention to a single tear trickling down her nose. But she's more than a weepy individual: this is Mary Magdalene, a sinner who became a saint. On her cheeks is a touch of rouge that hints at her sense of shame and on the floor is a trail of discarded jewels, a broken string of pearls and a carafe of oil (with which she would later anoint Christ's feet) – the iconography of the Bible's best-known 'fallen woman'.

Caravaggio's art is a mixture of tradition and transformation. The former comes via his adherence to religious subject matter. Slumped with her hands in her lap and her head lowered, Christ's new and now most faithful follower appears to bow down to the blade of light slicing across the back wall. Known for his nifty handling of light and dark, the artist often dramatized it with the hope of persuading the masses of the divine's physical presence.

And yet, the portrait is painted with a humble palette of ordinary colours. Mary Magdalene is dressed in contemporary garb – a white blouse worn beneath an earthy tunic swirling with floral motifs. Caravaggio got into trouble when he depicted peasants in his altarpieces, allowing the poor to star in a drama normally associated with sacred figures, and his contemporaries balked at this portrait too, regarding it as a statement about the treatment of prostitutes in the seventeenth century. Whatever the artist's intention, there's no questioning the clarity of emotion – which, like that blade of light, cuts straight through you.

+ ARTIST BIO
Italian, 1571–1610

+ SEE THIS
For a stark contrast, check out Caravaggio's *Mary Magdalene in Ecstasy* (1606), which is exactly what it says on the tin and was only discovered in 2014.

+ VISIT THIS
In the Galleria Doria Pamphilj you'll find Caravaggio's *Rest on the Flight into Egypt* (1597), which features the same model in a similar pose.

+ READ THIS
Eimear McBride's *A Girl is a Half-Formed Thing* (2013) plunges the reader into the guilt-filled mind of another vulnerable protagonist.

Like This? Try These

→ Annibale Carracci

→ Correggio

→ Guercino

Édouard Manet

A Bar at the Folies-Bergère

1882

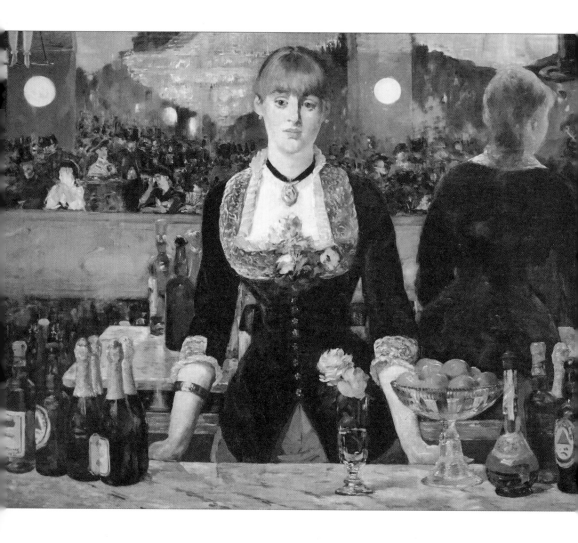

Some people say they're no good with faces, but how could you forget that blushing barmaid painted by Manet? Her head's tilted to the left. Below her rough-cut fringe her blue eyes don't blink. In contrast to her porcelain chest her cheeks are flushed, her lips pursed. She's leaning on the bar at the end of a long, tiring shift, disillusioned, trying to ignore the merry crowd in the gaslit interior (not to mention the slippery clientele). Here, Manet – the painter of modern life – introduces us to a modern woman and the obstacles she navigates every day.

Stand in front of this canvas and you'll feel like you're waiting to be served by the barmaid – her name was Suzon – in the tightly buttoned, lace-trimmed bodice. Between the two of you is a marble counter topped with champagne wrapped in golden foil and clementines in a crystal bowl. Behind her is the all-important mirror, in one corner of which a pair of legs balances on a trapeze, a reminder that the Folies-Bergère was a café-concert with light entertainment – that night it was gymnastics. Then there's a more common spectacle: to the right a mustachioed man is staring intently into Suzon's eyes.

But all is not as it seems: the reflections are dislocated, askew. In the mirror Suzon leans eagerly forward, but we see her standing bolt upright, wearing that enigmatic expression. She's alienated, something Manet conveys not just through her vacant gaze but by depicting the crowd mingling in the mirror, most of them no more than fleshy smudges of paint.

The skewed reflection is intentionally disorientating. Manet's message? Modern life is unpredictable and strange. The daily grind is hard, cities are lonely as well as lavish, gender relations precarious. Our modern world is a puzzle that each of us tries to piece together.

+ ARTIST BIO
French, 1832–83

+ SEE THIS
Modern life meets classical art in Manet's *Lunch on the Grass* (1863).

+ VISIT THIS
Park yourself in front of *A Bar at the Folies-Bergère* at The Courtauld Gallery in London's Somerset House.

+ READ THIS
T.J. Clark's *The Painting of Modern Life: Paris in the Art of Manet and His Followers* (1999) explores how Parisian painters represented modernity in the mid- to late-nineteenth century.

Like This? Try These

→ Henri Fantin-Latour

→ Max Liebermann

→ Berthe Morisot

YOU CAN LEAVE YOUR HAT ON

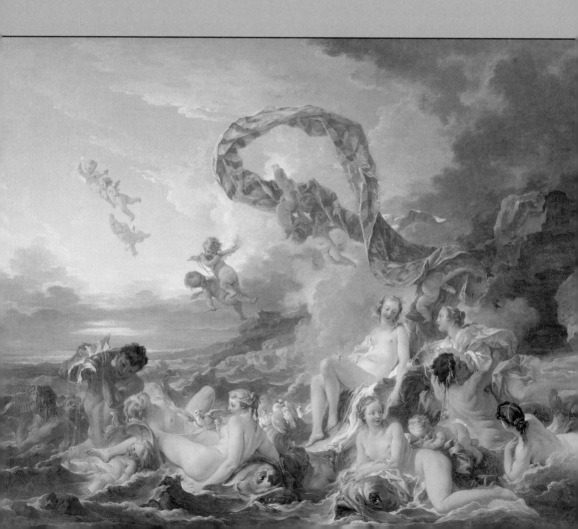

François Boucher

The Triumph of Venus

1740

In typical Rococo style, this seascape froths with sensuality. Waves lap against milky-white flesh while loosely spun clouds and luxurious silks twirl with bare-bottomed putti. Rococo originated in early eighteenth-century Paris and Boucher, who made art in the French capital for most of his life, was one of its leading lights. Here, he takes the birth of Venus and turns it into a triumph.

The goddess of love lounges at the centre of the composition, an idealized nude modelled on the artist's wife, back curved, head tilted to one side. Surrounding her are sharp-toothed sea creatures with glistening eyes and rosy-cheeked naiads (water nymphs) dripping with pearls. Tails and legs intertwine, and one reclining figure has a dove perching suggestively between her open legs. To Venus's right, a pale-skinned admirer carried in the muscular arms of a bronzed triton (a mythological creature that's part man, part fish) offers up a gleaming shell. In the sky, winged cherubs toss and turn, one pair clutching a bow and a quiver of arrows, others tussling with the makeshift awning.

Fifteen years after he created *The Triumph of Venus*, Boucher – now at the height of his career – was made first painter to King Louis XV, whose powerful mistress, Madame de Pompadour, commissioned him to create several pieces. When the neoclassical style championed by Jacques-Louis David (see page 142) took hold in the second half of the eighteenth-century, and pastoral escapism was shoved aside by revolutionary fervour, Boucher's popularity waned. And yet, his ability to combine the natural and the artificial, the mythical and the erotic – all in a cool palette whipped up with plenty of pinks and creams – makes him an art-history mainstay.

+ ARTIST BIO
French, 1703–70

+ SEE THIS
Boucher's painting inspired *The Birth of Venus* (1753–55) by Jean-Honoré Fragonard (see page 186), an equally fleshy display.

+ VISIT THIS
The Triumph of Venus is housed in the National Museum in Stockholm.

+ LISTEN TO THIS
Arcade Fire's 'Rococo' (2010) sets a self-indulgent style to a solemn beat.

Like This? Try These

→ Nicolas Lancret

→ Giovanni Battista Tiepolo

→ Jean-Antoine Watteau

Titian
Venus Rising from the Sea

c. 1520

We're all born naked and apparently it's the same for gods and goddesses, except that this one emerged fully formed from a scallop shell. It was the Greek poet Hesiod who first described the birth of Venus, ancient Greek goddess of love and beauty, and in his retelling of the myth the great Renaissance painter Titian made the mythological real.

Titian's voluptuous Venus fills the canvas, gracefully twisting her body to the right as she glances back over her left shoulder and wrings the spray out of her wavy auburn hair. Like a classical nude sculpture, her skin is pearly white – except for those rosy cheeks. Water laps against her thighs and bobbing beside her is the small shell from which she was born, with its fan-like interior. The soft-hued sky and sea would merge into one hazy blue backdrop were it not for the delicate pink line of the horizon.

Titian's may be a more modest depiction of the goddess than Sandro Botticelli's (see page 76) famous *The Birth of Venus* (1485–86) – which captures the moment the goddess rides to shore on her shell, blown by Zephyr, god of the winds – but it's also more intimate. Venus is neither framed for our viewing pleasure, nor about to be covered in a cloak by one of the Hours, spring-like in her floral dress. Instead, we're glimpsing a primal moment – no different than if we'd stumbled upon a young woman bathing.

Titian combines the serene beauty of a classical nude – a stark white goddess – with everyday realism. His painting is less a portrait of a newly born goddess than a woman absorbed in her thoughts. Ideals of feminine beauty were as rife in the sixteenth century as they are now, and while Titian doesn't throw them out, he does bring them down to earth. In his painting, a goddess becomes a mortal. After all, maybe the shell – the only reference to her mythical status – is just a shell.

+ ARTIST BIO

Italian, *c.* 1490–1576

+ SEE THIS

Just over a decade later, Titian returned to the same subject matter with his *Venus of Urbino* (1534–38).

+ VISIT THIS

Titian's *Venus Rising from the Sea* hangs in the Scottish National Gallery in Edinburgh.

+ READ THIS

Sarah Dunant's *The Birth of Venus* (2003) tells the story of a young girl in fifteenth-century Florence and explores issues of gender, work and identity.

Like This? Try These

→ Giovanni Bellini

→ Tintoretto

→ Paolo Veronese

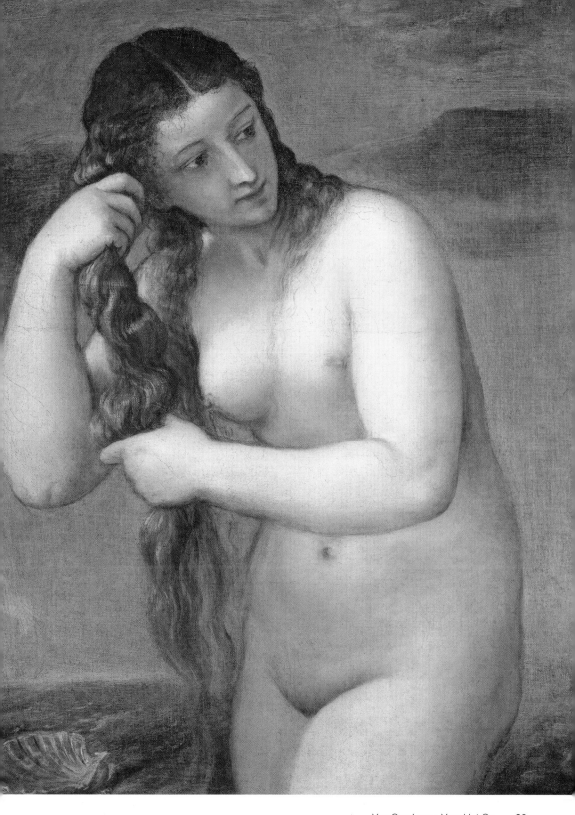

Marie-Guillemine Benoist
Portrait of a Black Woman

1800

A young black woman sits in an armchair with golden trim and a vibrant blue shawl draped over its back. She's wearing a bright-white dress that, despite being belted with a red ribbon, has slipped off her shoulders to reveal her right breast. Most of her hair is covered in a white headscarf and she turns to the viewer with a composed look on her face. Though it's anomalous in her oeuvre, this stunning portrait is Benoist's most well-known work.

She trained under the French portrait painter Élisabeth Louise Vigée Le Brun before entering the studio of Jacques-Louis David (see page 142), both of whom encouraged her to present her work at the annual Paris Salon. In 1791 she made her debut with two ambitious history paintings – generally considered a man's subject – and in 1800 she exhibited *Portrait of a Black Woman*.

During the 1800s the artist was commissioned to paint several official portraits, including one of Napoleon. Here she uses portraiture to make a political statement: created between the abolition of slavery in 1794, during the French Revolution, and the reinstatement of slavery in 1802 by the Napoleonic regime, Benoist's painting should be viewed in light of emancipation. Here the viewer comes face to face with an equal whose expression is ultra-engaging.

It wasn't unusual for artists not to name their sitters, but the absence of a name makes it easy for individuals to slip through the cracks. In 2019 the Musée d'Orsay rectified the problem by temporarily renaming several paintings in its exhibition *Black Models: From Géricault to Matisse*. Benoist's work became *Portrait of Madeleine*, recovering the biography of the sitter – a freed slave from Haiti hired as a servant by the artist's in-laws. It makes sense to shine a light on the identity of Benoist's sitter – after all, positioned in front of a plain beige backdrop, the portrait is all about her. And yet, she and many other black subjects in canonical French paintings have long been overlooked. It's time they were reinstated into the narrative for good.

+ ARTIST BIO
French, 1768–1826

+ SEE THIS
Another work included in the exhibition at the Musée d'Orsay was Édouard Manet's (see page 28) *Olympia* (1863), which was temporarily renamed *Laure* after the black model who posed as the maid.

+ VISIT THIS
Portrait of a Black Woman hangs in the Louvre in Paris.

+ READ THIS
Reni Eddo-Lodge's *Why I'm No Longer Talking to White People about Race* (2017) is essential reading.

Like This? Try These

→ Frédéric Bazille

→ Élisabeth Louise Vigée Le Brun

→ Lynette Yiadom-Boakye

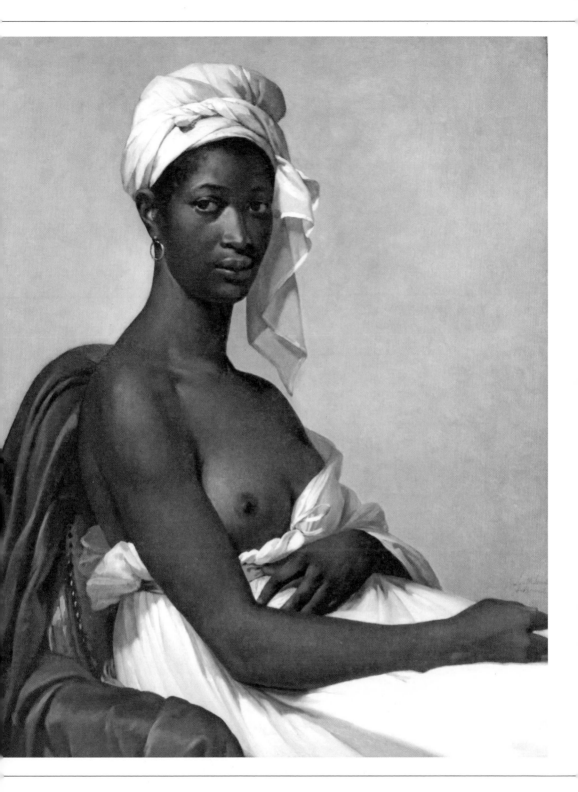

Jean-Auguste-Dominique Ingres
The Turkish Bath

1862

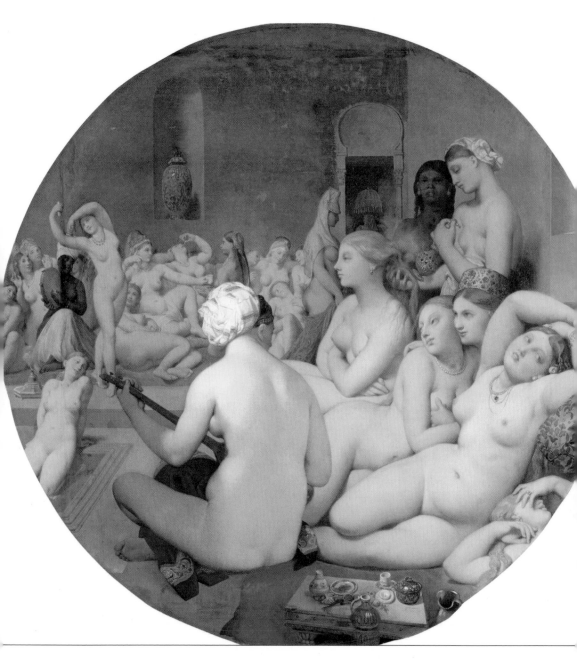

Ingres waited until he was eighty-two years old to make his most erotic painting. Until then, the French classicist had been regarded as almost blandly upright, a pillar of academic respectability – at least until his *Odalisque and Slave* (1839), a female nude accompanied by a musician and a eunuch, both fully clothed, was exhibited in the 1840s. Some twenty years later he painted this imaginary harem, drawing on studies of women bathing that he had produced since 1807. *The Turkish Bath* is the culmination of a lifelong fascination with flesh – a teeming sexual fantasy.

Dozens of women stand, sit and sprawl in a pared-back interior centred on a pool. Some towel off or lay themselves out like clothes to dry, while others sip coffee and chat. In the foreground a woman in a cream-coloured turban strums a lute, while in the background another dances, standing on her tiptoes and raising her arms elegantly above her head. Aside from the profusion of porcelain skin, the main erotic element comes via the two women to the right of the lute player, who embrace and fondle each other's breasts.

A student of the neoclassical artist Jacques-Louis David (see page 142), Ingres too was inspired by the art of ancient Greece and Rome and the Italian Renaissance. Yet he added his own stamp by introducing more exotic subjects and experimenting with the female body, which he famously distorted. Here, he places the nude in an Eastern setting.

It was the letters of a Lady Montague that gave Ingres the idea for this heady scene. In them, the wife of an English ambassador describes visiting a women's bathhouse in Istanbul in the early eighteenth century. From that starting point, the artist used his imagination. And so, just as he creates an atmosphere of overt voyeurism in his painting – the circular frame is like a keyhole – he also provides us with a glimpse into the inner workings of his mind.

+ ARTIST BIO
French, 1780–1867

+ SEE THIS
Ingres borrowed figures from earlier works, including *The Valpinçon Bather* (1808). The lute player here is inspired by that seated woman, bathing with her back to us.

+ VISIT THIS
Head to the Louvre in Paris to see both *The Turkish Bath* and *The Valpinçon Bather* in, ahem, the flesh.

+ READ THIS
Turkish author Elif Shafak's *10 Minutes 38 Seconds in This Strange World* (2019) is a structurally daring and sensuous tale about the trauma inflicted on a woman's body and mind.

Like This? Try These

→ Jean-Léon Gérôme

→ Pierre-Auguste Renoir

→ Alison Watt

Félix Vallotton

Bathing on a Summer Evening

1892–93

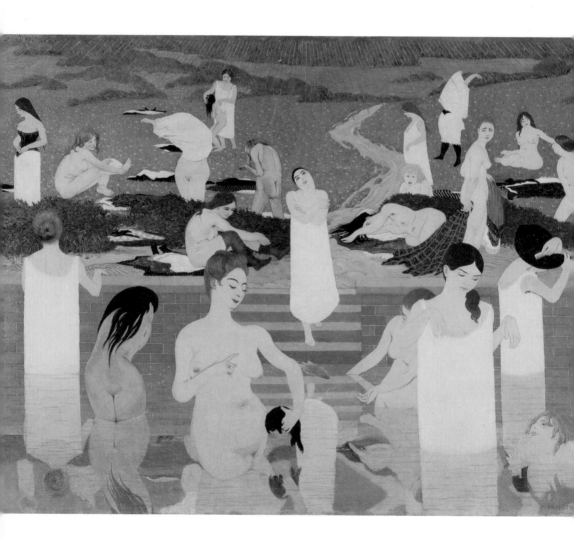

A very different kind of bathing scene comes courtesy of Vallotton, who in fact revisited several of Jean-Auguste-Dominique Ingres's (see page 36) most well-known subjects. When the Swiss painter exhibited this Arcadian scene at the Salon des Indépendants in Paris in 1893, it was greeted with derision.

Before us is a crowd of women, of all ages and in various stages of undress. Some are washing in the shallow water of a red-brick swimming pool, while others are drying themselves and struggling in and out of their undergarments, pulling on stockings and underwear in a lush green meadow. Most seem to be taking their time, kept warm by the razor-sharp rays of sun beaming down from the top of the canvas. It's only the central figure walking down the steps – ghost-like in her slip – who's holding her arms tight across her chest.

Vallotton arrived in Paris at the age of sixteen and in the 1890s became briefly associated with a group called the Nabis. Along with his contemporaries he was influenced by the Post-Impressionist style of Paul Gauguin (see page 42), as well as Japanese *ukiyo-e* (woodblock prints), which were popular at the time and inspired his pancake-flat paintings. This ethereal group portrait is a case in point, with its extreme colour contrasts and linear composition. The women are stylized, with their arched eyebrows and peach-tinted pouts. The bucolic meadow – Hockney-esque in its graphic rendering – has the appearance of a floral carpet furnished with little white flowers and fluffy green hedges.

Vallotton's painting isn't arousing like Ingres's. In fact, there's something clinical about the artist's treatment of female flesh. Instead, the best thing about it is its cut-and-paste amalgamation of different periods, styles and cultures.

+ ARTIST BIO
Swiss, 1865–1925

+ SEE THIS
For a close-up nude by Vallotton, look no further than his *Study of Buttocks* (c. 1884) – an astonishingly realistic depiction of a bum.

+ VISIT THIS
To learn more about this little-known Swiss artist, take a trip to the Fondation Vallotton in Lausanne, where he was born.

+ WATCH THIS
In Merchant Ivory's 1985 film *A Room with a View*, there's an equally fleshly (but rather more male) scene featuring three men cavorting in a lake.

Like This? Try These

→ Maurice Denis

→ Ferdinand Hodler

→ Édouard Vuillard

Camille Claudel
The Waltz

1889–93

+ ARTIST BIO
French, 1864–1943

+ SEE THIS
Claudel's *The Abandonment* (1905) is a more immediately sensuous sculpture.

+ VISIT THIS
The Musée Camille Claudel opened in Nogent-sur-Seine, a small town southeast of Paris, in 2017.

+ WATCH THIS
Bruno Dumont's *Camille Claudel 1915* (1913), starring Juliette Binoche, is a deeply moving film inspired by the sculptor's life.

Like This? Try These

→ Alfred Boucher

→ Auguste Rodin

→ Luisa Roldán

Claudel took classical sculpture and injected it with passion. In 1889 she began working on *The Waltz*, which she hoped would become a large-scale public monument carved from marble. An early, entirely nude, version was rejected as too sensual. In this bronze variation, the sculptor has rescued modesty with drapery, which falls from the woman's waist and covers the man's genitals. It was nonetheless censored.

The waltz was the dance of choice in the nineteenth century, but the partial nudity of Claudel's pair makes them hard to fix in time. The couple sway in a tangled embrace. There's a tenderness to the pose, man and woman hand in hand, his right arm wrapped around her waist, her left arm curled around his back. As she leans to one side, he kisses her neck.

The French sculptor studied at Paris's Académie Colarossi, one of the few art schools in the country to admit women, and by the mid-1880s she had been introduced to Auguste Rodin. She soon became his model and muse, as well as his mistress; for a decade, they were involved in a tumultuous affair. He promised to leave his wife but never did, and when their relationship deteriorated Claudel suffered a breakdown. In 1913 her family had her committed to an asylum, where she remained for the last thirty years of her life.

Claudel's work is frequently judged alongside Rodin's and regarded as a creative reimagining of their affair. And indeed, it's hard to look at *The Waltz* and not read into the diagonal reach of the bodies, dangerously off balance. Claudel, however, sought to distance her art from that of her tutor/lover. The relationship ended in part because she was tired of being referred to as his protégé. So for now, just appreciate the sculpture before you for what it is: a dance so dizzying that the drapery could fall at any minute.

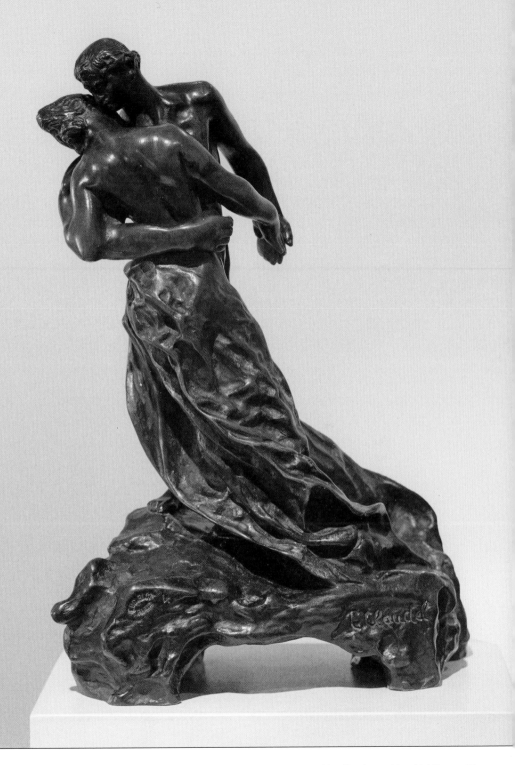

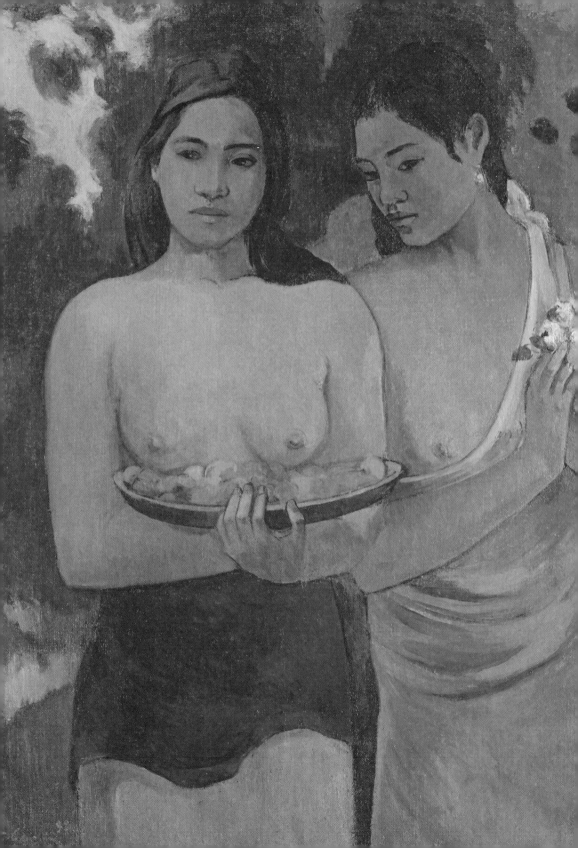

Paul Gauguin
Two Tahitian Women

1899

This double portrait by the French Post-Impressionist is as bold as it is intimate. It's also troubling, especially in an age of anxiety about depictions of race and gender.

+ ARTIST BIO
French, 1848–1903

+ SEE THIS
Gauguin appears to acknowledge the troubling nature of his gaze in the painting *Barbarian Tales* (1902), which shows a devilish European crouching behind two Polynesians.

+ VISIT THIS
This intimate portrait hangs in the Metropolitan Museum of Art in New York.

+ READ THIS
Joseph Conrad's *Heart of Darkness* (1899), which was inspired by the author's voyage up the Congo in 1890, has divided readers with its depiction of colonial brutality.

Like This? Try These

→ Pierre Bonnard

→ Edvard Munch

→ Henri Rousseau

In the 1890s, Gauguin travelled to Tahiti to escape the conventions of nineteenth-century European society and seek inspiration for his art. Despite the fact that what he saw as paradise was already colonized by Christian missionaries, he found joy in this new world, with its tropical flora and fauna and in particular in its native women. One of the final works he created there, *Two Tahitian Women* reflects his pleasure in witnessing their culture, as well as their brown skin.

Two women, beautiful and serene, stand in front of a dusky blue-green backdrop swirled up, like a tie-dye T-shirt, with canary yellow. The figure on the left stands square on, arms crossed under her bare breasts, holding a plate of luscious red mango blossoms that contrast with her sunlit body. Her friend clutches a bunch of pinky-white flowers and tilts her head – as if she's trying to get a better look at the artist looking at her. Her lobe is pierced with a golden earring and her sky-blue dress hangs off her shoulder.

However striking Gauguin's portrait may be, it's also troubling – a colonial and misogynist fantasy, and just one of many works the European voyeur created in Tahiti that reveal his fascination with 'exotic' female flesh. Gauguin immersed himself in the South Pacific in order to add meaning and myth to his art. His sensuously painted portraits of Polynesian girls in their teens, objectified by his lust, are undoubtedly problematic.

And yet, with *Two Tahitian Women*, perhaps the artist was doing more than enjoying the peep show. There's something defiant in the stance of this pair, who stand together – statuesque – in spite of the interloper. They're confident nudes, goddesses, and Gauguin painted them at a time when very few European artists were showing an interest in non-western art. Whatever your feelings about him, his work sparks debate – and what else can art do?

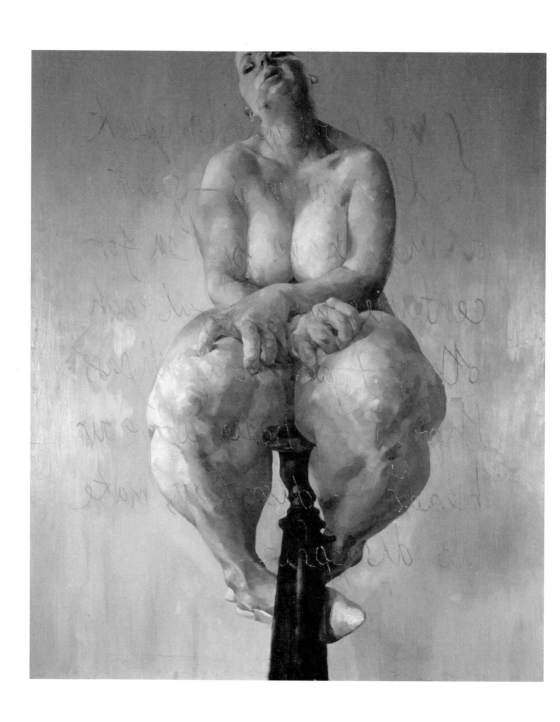

Jenny Saville

Propped

1992

Saville's mighty images of female flesh force us to rethink the way we perceive women's bodies. Far from the conventional ideal of feminine beauty, her subjects are meaty and raw, naked rather than nude. In her art, she explores what the body truly amounts to when it's stripped bare of clothes and context.

Propped shows the young Saville eyeing up her reflection in a steamy mirror. (Like many artists, she started with self-portraits; unlike many artists, she wasn't the least bit interested in self-flattery.) Scored across glass and skin is a paraphrased quote from an empowering essay about the roles of men and women by the Belgian-born feminist theorist Luce Irigaray. The writing is intended for the subject – and almost illegible to the viewer, for whom it's inverted – and yet Saville's figure appears to be full of anxiety as well as resilience.

She perches on a phallic black stool, her feet – clad in white sling-backs – curled fretfully around it, mirroring her crossed wrists. Though she's alone, with ample space on either side, her body is dramatically foreshortened and seemingly squeezed. The effect is a swelling of both the lower body and those fingers whose nails jab into her thighs like incisors biting down on fatty bits of meat. Her knees jut towards the viewer; her shoulders are hunched and her upper arms close in on her breasts. This is a woman struggling to cope with her prescribed role and society's suffocating beauty standards.

Saville painted *Propped* when she was still a student at Glasgow School of Art; some thirty years later it became the most expensive work by a living female artist when it sold at Sotheby's in London for $12.4m. It's a painting that takes you by surprise, that gets under your skin – and that of the subject. This is female flesh from a woman's perspective: real and raw, with neuroses bubbling beneath the surface.

+ ARTIST BIO
British, b. 1970

+ SEE THIS
Saville smears oil paint over her canvases in heavy layers, an approach that recalls the work of artists like Lucian Freud (see page 176).

+ VISIT THIS
Saville got her break when the collector Charles Saatchi, of the Saatchi Gallery in London, began to buy and exhibit her pieces.

+ READ THIS
Novelist Ottessa Moshfegh portrays the body of her protagonist in *Eileen* (2015) as radically imperfect.

Like This? Try These

→ Cecily Brown

→ Marlene Dumas

→ Alina Szapocznikow

David Hockney

Domestic Scene, Los Angeles

1963

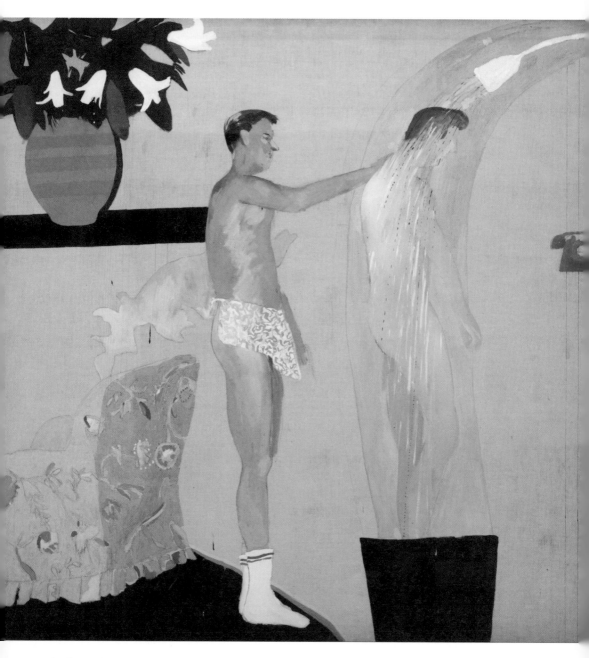

It's almost impossible to settle on one artwork when it comes to Hockney. From vast paintings of crystalline swimming pools and earthy ploughed fields to fine-line pencil portraits and still lifes drawn on an iPad, the creative output of the UK's best-known living artist is prodigious. For the purpose of this chapter, though, what better work to choose than *Domestic Scene, Los Angeles* – an image that drips with desire and is as political as it is personal.

Hockney had always known that he was gay, and art soon became a way for him to inhabit his feelings. Despite the fact that homosexuality wasn't decriminalized until the 1967 Sexual Offences Act, while he was a student at the Royal College of Art in London he produced gutsy works that celebrated queer love and comradeship. He made this painting before he had ever visited Los Angeles, a place that would become his home and a major subject in his art. Inspired by a picture in the Athletic Model Guild's *Physique Pictorial* magazine, he imagines California as a utopian world of sexual openness.

A pink naked man in white socks and a patterned pinny rubs the back of another even pinker man who's showering in a swoony wash of blue. The idealistic nature of the image is evident in the strangeness of the surroundings: the floral armchair suggests we're in a living room, while the showering man appears to be standing in a bucket. Hovering in mid-air against the raw canvas is a red telephone, which has been interpreted by some as a reminder that the intimate moment could possibly be interrupted by a call to serve in the Vietnam War. For now, though, what we have is a blissfully naked afternoon. Gay domesticity playing out charmingly and innocently – in spite of the fact that homosexual acts were a criminal offence, even in your own home.

+ ARTIST BIO
British, b. 1937

+ SEE THIS
Californian swimming pools were a perfect setting for the naked male body, as shown in Hockney's *Peter Getting Out of Nick's Pool* (1966).

+ SEE THIS
Luca Guadagnino's *A Bigger Splash* (2015), a sensuous drama set at a sun-soaked villa off the Sicilian coast, is named after Hockney's 1967 painting.

+ READ THIS
On Earth We're Briefly Gorgeous (2019) by Ocean Vuong is a beautiful coming-of-age story featuring a gay love affair.

Like This? Try These

→ Peter Blake

→ Pauline Boty

→ Richard Hamilton

Anne-Louis Girodet de Roussy-Trioson

The Sleep of Endymion

1791

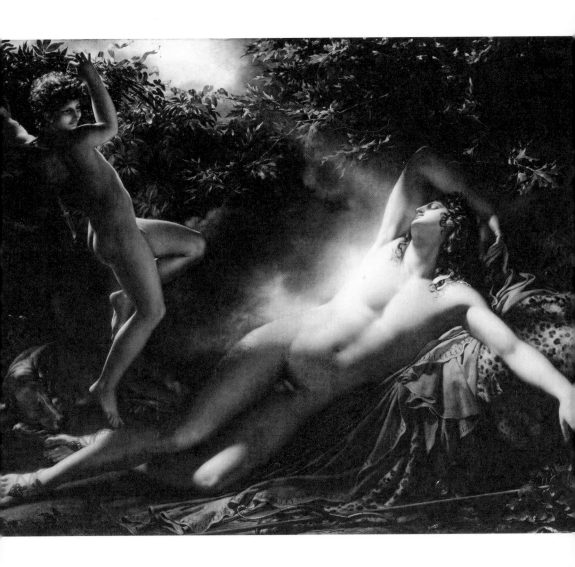

Girodet's swoony Endymion shines an uninterrupted spotlight on the male form and male sex. The myth that the artist conjures in paint recalls the relationship between the Roman goddess of hunting, Diana, and the young shepherd Endymion, yet in Girodet's painting the goddess is absent, signified instead by a moonbeam slicing through the foliage. Endymion is left with the winged figure Cupid, the god of love, in the guise of the god of wind Zephyr; the men are the only two players in the scene, meaning the emphasis falls on masculine eroticism.

The femininity that is stripped away by eliminating the goddess re-emerges in the androgynous body of Endymion himself – a swerve away from the heroic male nude that Girodet's mentor, the history painter Jacques-Louis David (see page 142), was keen to promote. The languid youth's milky skin, soft curls and pale flesh fizz with feminized sexuality, which is used by the artist to create a sense of disempowerment; the graceful and womanly quality of Endymion's body emphasizes his vulnerability and presents him as a passive recipient of the viewer's gaze.

And gaze we do – because as well as ridding the scene of Endymion's intended lover, Girodet makes room for us to assume the role. Together with Zephyr, we take in the shepherd as he reclines on a leopard-skin bed, a well-trained dog curled up at his feet. The shepherd twists towards us, his left arm outstretched, his right arm raised and bent behind his head. Like a shop window, the painting puts his nudity on display. *The Sleep of Endymion* brought Girodet instant fame – and no wonder, heralding as it did the emergence of a romantic sensibility. It's also no wonder that when Honoré de Balzac saw the painting, he asked to be left alone with it.

+ **ARTIST BIO**
French, 1767–1824

+ **SEE THIS**
Girodet's *The Burial of Atala* (1808) shows a bent-over monk and a burly man carrying the pale corpse of a maiden.

+ **VISIT THIS**
Both *The Sleep of Endymion* and *The Burial of Atala* are on show in the Louvre in Paris.

+ **READ THIS**
Abigail Solomon-Godeau's *Male Trouble: A Crisis in Representation* (1997) explores the masculine ideal and masculinity itself.

Like This? Try These

→ Hubert Robert

→ Jean Joseph Vaudechamp

→ Marie-Denise Villers

PUSHING THE BOUNDARIES

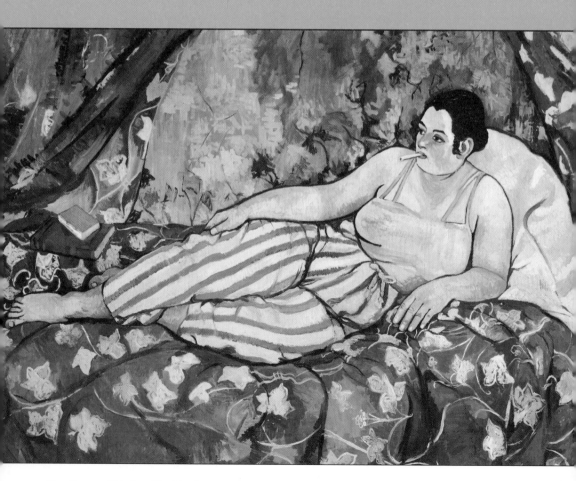

Suzanne Valadon
The Blue Room
1923

Even if you're not familiar with the reclining nudes of art history, you'll most likely recall the moment in *Titanic* (1997) when Kate Winslet looks at Leonardo DiCaprio and says: 'I want you to draw me like one of your French girls.' Over the centuries, women have been portrayed (by men) as passive objects to look at and lust after. In *The Blue Room*, that classic reclining nude – and the male gaze that comes with it – is subverted.

Valadon may portray herself lounging on a bed, fitted with bright-blue sheets swirling with a floral design, but she's not concerned with our presence. Unlike the female nudes painted by men, she's avoiding us – looking away, pensive. She's wearing comfortable green-and-white-striped trousers and a pink camisole – perhaps even violet nail polish on her toes – and smoking a cigarette. She's full figured, with broad shoulders and strong arms and legs. Beside her feet are a couple of books. Casually propping herself up against a squashy pillow, she appears relaxed and confident.

Valadon had firsthand experience of what it felt like to be a model, and it was partly by observing the technique of other artists that she taught herself to paint. When she was fifteen she started to pose for artists such as Edgar Degas (see page 132), to whom she sold her first artwork in the early 1890s and who became an avid supporter of her career. In 1894 she became the first woman to be admitted to Paris's Société Nationale des Beaux-Arts.

Here Valadon borrows the traditional pose associated with Renaissance nudes – and the titillating device of drawn-back curtains, providing us with a better view – and turns it on its head. Far from an idealized nude laid out for a male viewer, her sitter is a modern woman who smokes, reads and, most importantly, isn't always naked and sexually available.

+ ARTIST BIO
French, 1865–1938

+ SEE THIS
Jean-Auguste-Dominique Ingres's (see page 36) *Grande Odalisque* (1814) is the kind of classic reclining nude Valadon is trying to subvert.

+ READ THIS
What Valadon did in paint, American author Meg Elison does with words in her short story, 'If Women Wrote Men the Way Men Write Women' (2016).

+ WATCH THIS
Go on, put *Titanic* (1997) on already.

Like This? Try These

→ Sylvia Sleigh

→ Florine Stettheimer

→ Henri de Toulouse-Lautrec

Artemisia Gentileschi
Self-Portrait as Saint Catherine of Alexandria
c. 1615–17

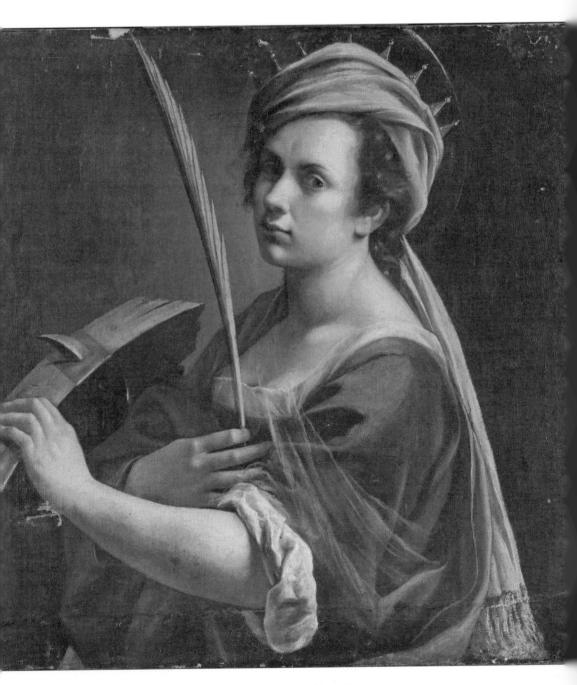

This rare self-portrait shows Gentileschi – one of the most progressive and expressive painters of the Italian Baroque – in the guise of Saint Catherine of Alexandria, who was martyred in the early fourth century AD. The outline of a halo is visible above her head; with her left hand she clutches a broken wheel studded with sharp spikes.

The only daughter of a renowned painter, Gentileschi initially learned her trade in her father's studio before being sent to another artist, and family friend, Agostino Tassi, for further training. In 1612, Tassi raped her, and during the seven-month trial that followed Gentileschi was subjected to torture to ensure that she was telling the truth. Tassi was found guilty and banished from Rome, though the sentence was never enforced.

The trauma Gentileschi experienced as a seventeen-year-old girl had a lifelong effect on her art, with many of her paintings shining a light on toxic masculinity and sexual abuse. Here the artist aligns herself with the Christian saint, who was bound to revolving wheels covered with iron spikes and nails for refusing to abandon her faith. Unlike Saint Catherine, who was eventually beheaded after escaping through divine intervention, Gentileschi survived. In this close-up she stares out at the viewer – resilient and resolute – while clasping a martyr's palm to her chest. Life-size, commanding the space, her strength visible in her left arm, she displays the instrument of her torture. The theatrical lighting adds to the drama.

In 2020 the work was the focal point of *Artemisia*, the first solo show of a female artist to be held at London's National Gallery in its almost 200-year history. Despite her suffering, Gentileschi went on to enjoy a fruitful career at a time when female artists weren't readily accepted. Today museums and galleries – like Gentileschi – are trying to redress the gender imbalance.

+ ARTIST BIO
Italian, *c.* 1593–*c.* 1652/53

+ SEE THIS
Similar proto-feminist undertones are at play in Gentileschi's *Susanna and the Elders* (1610), which illustrates Susanna's anguish at being accosted by the two men.

+ VISIT THIS
After the trial Gentileschi married and moved to Florence. You'll find two of her works in the Gallerie degli Uffizi.

+ READ THIS
Helen Lewis's *Difficult Women: A History of Feminism in 11 Fights* (2020) is an inspiring exploration of the brave and wild women who have fought for equal rights.

Like This? Try These

→ Ginevra Cantofoli

→ Barbara Longhi

→ Elisabetta Sirani

Kazimir Malevich

Black Square

1915

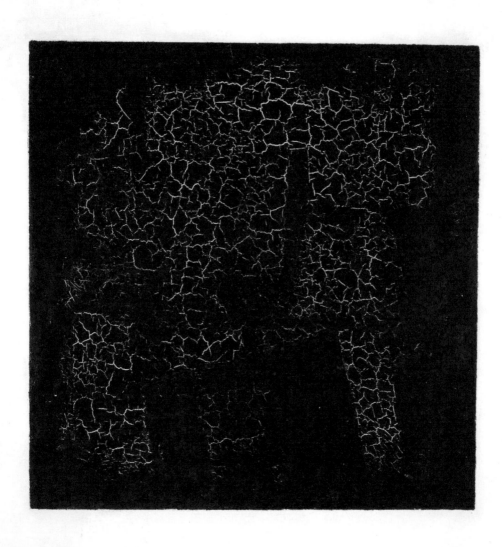

We've all overheard someone standing in front of a work of abstract art say that their child could have made it. Malevich's enigmatic *Black Square* almost begs us to repeat the slander. In 1915 the Russian artist painted a white border on a medium-sized canvas, then applied black paint within it. A simple act, a childlike act, and one that changed the art world forever.

Malevich sought to liberate painting from representation and, in his words, reduce everything to the 'zero of form'. In his black square he achieved something utterly new: a painting of nothing. He dubbed his new art form Suprematism, an abstract approach in which shapes and colour reign, well, supreme. Free from the distractions that come with depicting a person or landscape, he was able to focus on essential forms and the act of painting itself.

There are four versions of Black Square, the first dated 1913, though the actual year was 1915 – it seems the artist was trying to backdate his already radical artwork. It was exhibited at *The Last Exhibition of Futurist Painting 0.10* in St Petersburg that December, by which time the First World War and social unrest in Russia were raging. Malevich may not have meant for his canvas to mean anything, but its call for an artistic revolution reflected a revolution of a different kind bubbling on the streets.

Today the paint has faded and fine white cracks skulk across the black surface, a reminder that the work was hidden away when Socialist Realism became the official art form in the Soviet Union. When first exhibited in 1915, the painting was pitch black. Malevich displayed other works on the walls, but this one he hung in the corner just below the ceiling – a spot usually reserved for Russian Orthodox icons. And there we have it: a modern blessing.

+ ARTIST BIO
Russian, 1879–1935

+ SEE THIS
The artist turned from black to red in his 1915 painting *Red Square (Painterly Realism of a Peasant Woman in Two Dimensions)*.

+ VISIT THIS
The Tretyakov Gallery in Moscow refuses to lend *Black Square* because it's so fragile.

+ READ THIS
Malevich's *The Non-Objective World* (1927) charts the evolution of Suprematism.

Like This? Try These

→ Sonia Delaunay

→ Wassily Kandinsky

→ Ad Reinhardt

Cy Twombly

Untitled

1967

Do you recognize them? The charismatic scribbles of the American abstract artist who spent most of his life in Italy. Twombly was one of the US's most talented and intelligent postwar painters and what sets him apart is his ability to combine the ordinary, and at times vulgar, with the outright lofty.

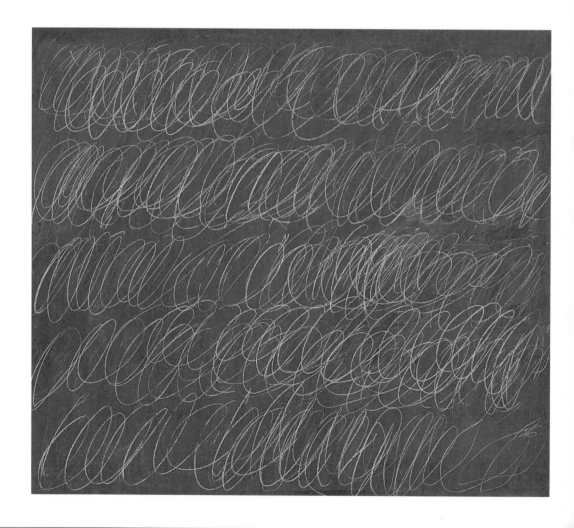

Take the humble blackboard, scrawled with chalk. For some, it evokes memories of drowsy afternoons listening to a lecturer waffle on for too long. For Twombly it's a source of creativity and a fountain of knowledge. Here, the artist replicates the look in oil paint and wax crayon on canvas. His cursive script unfurls from left to right with convincing urgency and meaning that's hard to fathom. These are thoughts and dreams running riot, the markings both elegant and erratic.

Twombly's doodles have been described as a somewhat irritable and graffiti-like version of Abstract Expressionism, the strain of abstract art characterized by gestural brushstrokes and artists such as Willem de Kooning and Jackson Pollock. Pollock's works may have hinted that painting is akin to writing, but it was Twombly who made the idea stick. Like his contemporaries in the US, he focused on the physical process of mark making. But the horizontal bands and looping shapes cutting across his composition nod to another, admittedly older, art form: the classical frieze.

His scribbles could be just that – scribbles, inane and incomplete – except they're not. Stare at them long enough and, even if you can't decipher their meaning, you'll sense that it's there, lurking beneath the surface. Because although at first the script appears to unspool from left to right, in places the markings are dense, in others sparse. Like so many of Twombly's works, *Untitled* flits between grace and disarray, light and dark, happy and sad. His art may be wordless, but its message is rich and urgent.

+ **ARTIST BIO**
American, 1928–2011

+ **SEE THIS**
Twombly's 2008 painting *Untitled (Bacchus)* marries abstraction and myth.

+ **VISIT THIS**
The Metropolitan Museum of Art in New York has a big stash of the artist's works.

+ **READ THIS**
To learn more about the man behind the scribbles, seek out the profile penned by Dodie Kazanjian for a 1994 issue of *Vogue*.

Like This? Try These

→ Anselm Kiefer

→ Arshile Gorky

→ Mira Schendel

Masaccio

The Tribute Money

1425

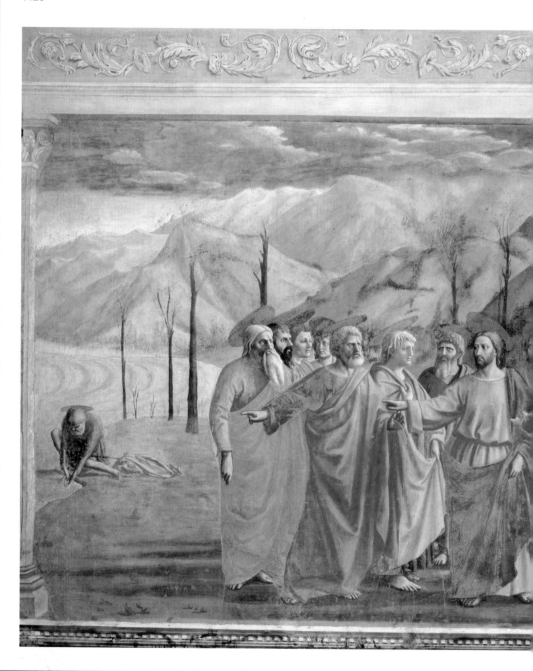

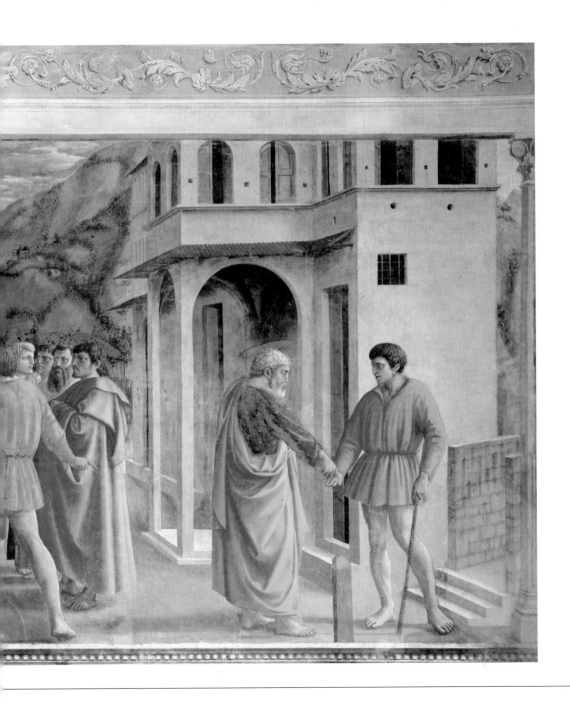

+ ARTIST BIO
Italian, 1401–28

+ SEE THIS
Masaccio's frescoes were a big influence on Michelangelo (see page 190), who learned from his predecessor's advancement in perspective.

+ VISIT THIS
See *The Tribute Money* in the Chiesa di Santa Maria del Carmine in Florence, then nip across the Arno for Masaccio's fresco the *Holy Trinity* (1427) in the Basilica di Santa Maria Novella.

+ READ THIS
In *The Lives of the Artists* (1550), Florentine biographer Giorgio Vasari claims that Masaccio is the best painter of his generation.

Like This? Try These

→ Fra Angelico

→ Andrea del Castagno

→ Giotto

A leading light of Renaissance Florence, Masaccio pretty much invented Western art as we know it. Before he came along, paintings were flat. In his wake they provided a window onto another world, as real as our own.

The Tribute Money depicts three different moments from one story, which is told in the Gospel of Matthew. It begins in the centre, with an impatient Roman tax collector in a somewhat skimpy orange tunic holding out his empty palm and demanding that Christ and the twelve apostles pay him. With no money to hand, Christ, imperious in pink and blue, gestures towards the lake and tells Peter where he can find some. On the left we see Peter retrieving a coin from the wide-open mouth of a fish; on the right he's shown again, this time paying the tax collector in front of his house.

But Masaccio did more than tell a tale via one continuous narrative – he also set the religious drama within the Tuscan countryside and furthered the sense of familiarity by creating the illusion of a three-dimensional space. He did so by fashioning a circular crowd of lifelike figures, with the tax collector facing away from us and two of the apostles side on, and paying attention to shadows. The mountainous backdrop has an earthy presence, morphing from the green plains in the foreground, threaded with hedges, to the snow at the summit. The trees add to the linear perspective, as do the ripples on the lake, and the weather conditions are evoked by the blue sky, laced with clouds.

In this fresco and others, Masaccio conjured a sense of perspective to tell a more convincing story and create a continuation of the world in which we live. By doing so, he changed the course of Western art and, what's more, he did so in an extraordinarily short space of time – the young artist, born in 1401, died when he was just twenty-six.

Gustave Caillebotte
The Floor Scrapers

1875

You'd be astounded at the sheer number of naked female bodies on display at art exhibitions in nineteenth-century Paris, acres of painted female flesh offered up to the public gaze. The difference in Caillebotte's canvas is the gender of the nude. In this respect, *The Floor Scrapers* was a scandal.

Caillebotte's half-dressed workmen are on display, subjected to a microscopic examination that gives them a specimen-like quality. Daylight floods through a window, piercing an otherwise gloomy room and making the bodies gleam – much like the wetted floorboards, the wedding ring of the central figure and the bottom edge of the glass half-filled with wine. (Drinking on the job, then.)

In the nineteenth century it was generally women who were relegated to the domestic interior, but the figures Caillebotte crams into this bourgeois apartment are men: the diagonal reach across the floor of the worker on the left flattens his back to match the studio's baseboard and wedges him into the corner. On all fours, with backs hunched, the workmen use two hands to scrape when one isn't enough to advance the blade. The sacks in which they lug around their tools, collapsed in the top right-hand corner of the studio, allude to the pressure exerted on their bodies, as do the tightly wound coils of wood.

By making scantily clad men his primary subject, Caillebotte defied the prevailing gender politics of nineteenth-century Paris and threw into question the tradition of a male gaze directed at a naked woman. The plunging perspective gives the impression that the scene might spill over the picture frame – these buff bodies are within touching distance – and the workmen appear to be unaware of the spectacle they offer, which encourages the viewer to enjoy the sight freely. Caillebotte's contemporaries may have found it hard to look, but today it's harder to look away.

+ ARTIST BIO
French, 1848–94

+ SEE THIS
Nine years after *The Floor Scrapers*, Caillebotte challenged the viewer with an even more unconventional depiction of male flesh: *Man at His Bath* (1884).

+ VISIT THIS
The Floor Scrapers is in the Musée d'Orsay in Paris.

+ READ THIS
Carol Duncan's essay 'The MoMA's Hot Mamas' (1989) tells a gendered story of the history of modern art.

Like This? Try These

→ Léon Bonnat

→ Édouard Manet

→ Pierre-Auguste Renoir

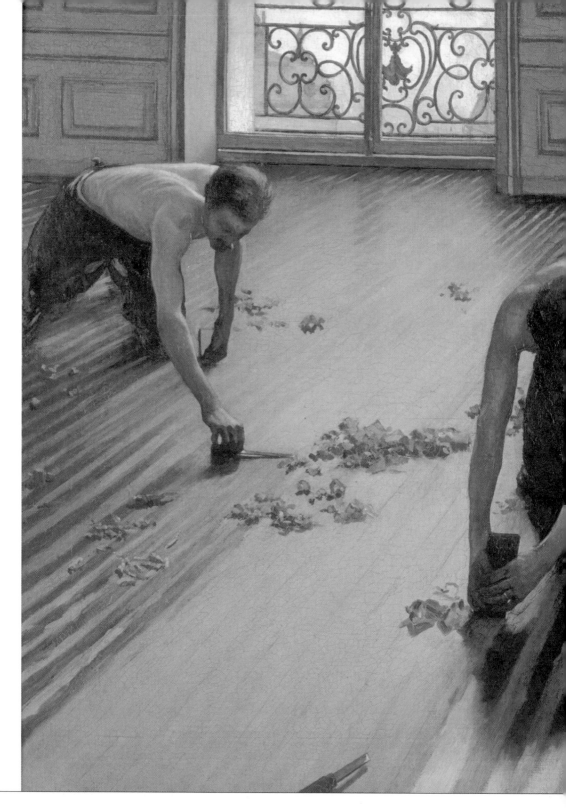

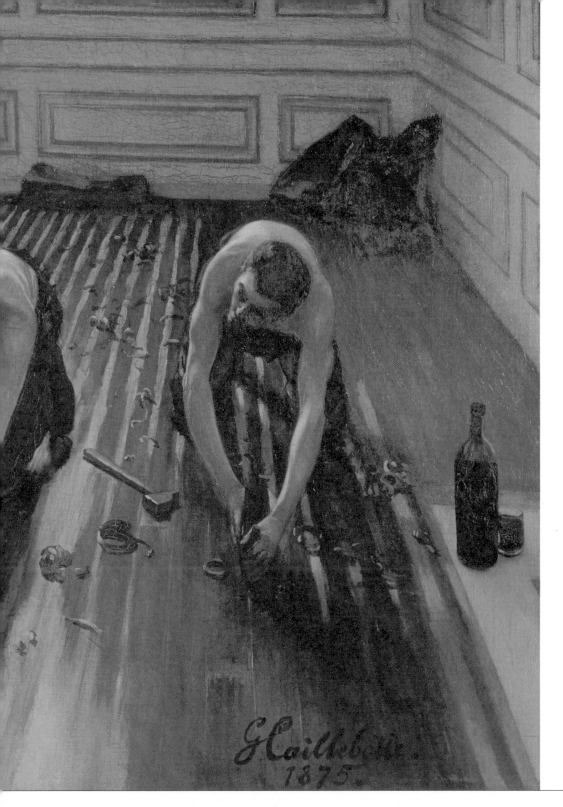

G. Caillebotte
1875.

Like This? Try These

→ Ghislaine Howard

→ Ishbel Myerscough

→ Alice Neel

Chantal Joffe
Self-Portrait Pregnant II

2004

Joffe stands with her weight on one leg, the
other bent at the knee. Her hand rests on her
hip and she turns her head, not quite to face us
but in our general direction. Her belly swells and
her back arches. The artist is pregnant, that
rapidly shifting state that sees a woman's body
morph at first imperceptibly and then violently,
day by day.

The portrait has an unfinished look that evokes a state of flux: her
skin tone fluctuates and there's a malleability to her frame. Even her
mismatched polka dot pants and bra suggest there's no use in trying
to control – or prettify – the transformation she's experiencing.

Pregnancy, that fundamental part of life, is strangely absent from
art history. What's more, when it is present it's often idealized and
glossed over with sweetness and serenity. It has also, historically,
been mostly depicted by men – which makes works like this,
by women artists such as Joffe, all the more essential, because
procreation isn't always pleasant. Giving birth isn't sweet and
serene; it can be gruelling, both physically and emotionally.

The London-based artist works quickly, applying paint in broad
brushstrokes, which results in an impression that's raw and rough
around the edges; colours change as liquid pigment dries and
drips trickle down the surface of the canvas. The swirls of cream
on the apple-green background may look like little shoots – signs
of life – but they also evoke chromosomes in primal ooze and the
overwhelming sense that an existing body is being taken over by
another in the making. The closely cropped composition adds to the
claustrophobic impression.

Joffe's self-portrait – like her portraits of others – is ruthlessly honest,
intimate and fresh. Throughout her career, she's returned again and
again to the changes inflicted on women's bodies by motherhood
and ageing, and here she gives us pregnancy – extraordinary, yes, but
also awkward and uncomfortable.

Frida Kahlo
Self-Portrait with Cropped Hair

1940

Kahlo chopped off her hair a month after she and her husband – fellow artist Diego Rivera (see page 110) – divorced. She painted this self-portrait soon after, and while it's certainly suggestive of the pain and anguish involved in the separation, it's also a powerful declaration of autonomy and self-transformation.

(see page 110)

The artist has shrugged off the traditional Mexican dresses in which she regularly depicted herself. Instead, her tiny frame is engulfed in a man's square-shouldered suit. The masculine attire contrasts with her petite heels and the single earring dangling from her earlobe. She sits on a simple wooden chair against a nondescript backdrop, a pair of scissors in one hand, a clump of hair in the other. Shorn locks twist and turn around her, seemingly alive as they skulk across the floor and creep up the chair legs; beside her is a severed braid. Running along the top of the canvas are musical notes and a line from a Mexican folk song that reads, 'Look, if I loved you it was because of your hair. Now that you are without hair, I don't love you anymore.'

Isolation is a theme that runs through Kahlo's work, especially her penetrating self-portraits. She once explained that she painted them because she was so often alone, as she was at this moment. She experienced pain physically as well as mentally – after a terrible traffic accident as a teenager she underwent dozens of operations, experienced chronic pain and suffered dangerous miscarriages. Still, there's a determination in her steely gaze and open-legged pose. And what about those scissors, strategically placed near her crotch? Kahlo was bisexual and liked to cross-dress. She channelled her pain into powerful art. This is the portrait of a woman who shows you can be whoever you want to be. She didn't so much push the boundaries as cross them.

+ ARTIST BIO
Mexican, 1907–54

+ SEE THIS
Kahlo's *Self-Portrait as a Tehuana* (1943) features the artist in an otherworldly headdress with a portrait of Rivera on her forehead.

+ VISIT THIS
The artist was born and died in what's now the Museo Frida Kahlo, also known as the *Casa Azul* (Blue House), in Mexico City.

+ READ THIS
In *Orlando* (1928), Virginia Woolf tells the story of a young man who wakes up one morning to find that he's a woman.

Like This? Try These

→ Gluck

→ Marlene Dumas

→ Toyin Ojih Odutola

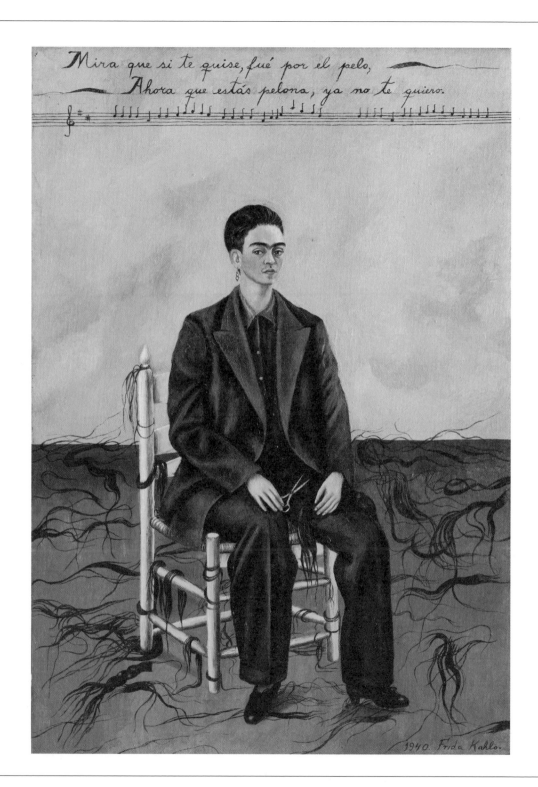

Pierre Bonnard

Dining Room in the Country

1913

Although the title of this painting is *Dining Room in the Country*, the real subject is colour. The figurative structure of the work wavers – like the sunken fabric of the golden-yellow chair on the right, the edges of the door, window and walls bend and blur.

Spaces are delineated less by line and more by hue, the exterior a mottled mass of pastel blues, greys and yellows, the interior a fuzzy wash of saturated apricots and reds. The lone figure in the scene – Bonnard's wife, Marthe de Méligny, leaning lazily over the windowsill in a crimson blouse – acts as a bridge between the dining room and wild garden of the couple's country house at Vernonnet.

Bonnard's handling of colour was as controversial as it was innovative – while Henri Matisse (see page 92) called him 'a rare and courageous painter', Pablo Picasso (see page 96) described his paintings, with skies that pulsed from blue to mauve to pink, as a 'potpourri of indecision'. Colour was a tool with which Bonnard attempted to piece together his past; his paintings are hot and cold time warps. Working largely from memory, with the odd sketch for reference, he didn't feel obliged to replicate reality. Instead, he used colour subjectively to capture time, emotion and the spirit of a moment.

In his art, Bonnard gave us many glimpses of his married life with De Méligny. Here we see only her torso; elsewhere she's semi-submerged in the bath or partially reflected in a mirror. The moment depicted in *Dining Room in the Country* is sunset, the foliage infused with an evening glow that's filtering through the thrown-open window and door, the white tablecloth just out of reach. We can almost smell the herbs, hear the mewing cats, feel the warmth of a summer evening at Vernonnet. It's through colour that we navigate the composition, and it's through colour that Bonnard makes a mood.

+ ARTIST BIO
French, 1867–1947

+ SEE THIS
In Bonnard's *Nude in the Bath* (1925), De Méligny's translucent legs are on the brink of dissolving in the lavender water of the half-filled tub.

+ VISIT THIS
Dining Room in the Country can be found in the Minneapolis Institute of Art.

+ READ THIS
The catalogue to Tate Modern's 2019 exhibition, *Pierre Bonnard: The Colour of Memory,* further explores the artist as colourist.

Like This? Try These

→ Maurice Denis

→ Paul Sérusier

→ Édouard Vuillard

Lubaina Himid

A Fashionable Marriage

1986

When Lubaina Himid won the Turner Prize in 2017, she was the oldest artist to have done so. She was also the first winner to be a non-white woman. Best-known for her politically driven and poignant paintings, prints, drawings and installations of the African diaspora, the Zanzibar-born, Lancashire-based artist and cultural activist has devoted her forty-year career to celebrating black creativity and challenging issues of racism, marginalized histories and migration.

A Fashionable Marriage is a satirical pastiche of the British artist William Hogarth's *Marriage A-la-Mode* (*c.* 1743–45) – a six-part series that tells the story of an arranged marriage and exposes the greed and excess of the 18th-century aristocracy. Himid reworked Hogarth's fourth scene, *The Toilette*, to create a scathing critique of 'The Art World' (the cliquey London art scene) and 'The Real World' (conservative British politics). Her installation replaces his stock characters with contemporary cut-outs, among them a flirtatious Margaret Thatcher in a string of pearls and Ronald Reagan reclining beside her in a starry cape.

Much of Himid's work is bright and exuberant, but the more you look, the more you see troubling details laced through the light. In past interviews, she has said that when she started out she was told 'black people don't make art': in *A Fashionable Marriage*, a dithering arts funder on a flimsy fence nods to the lack of support given to artists of colour. Himid was a pioneer of the 1980s British black arts movement, which sought to make black people visible in art and show how creativity could spark social engagement and change. Here, as in Hogarth's scene, the black characters are onlookers – but Himid replaces the two slave-servants with a towering woman artist in a blowsy dress and a dignified young girl she refers to as 'Ka – the spirit of resistance'. Her art is a rally cry for black belonging, representation and survival.

+ ARTIST BIO
British, b. 1954

+ SEE THIS
In *Naming the Money* (2004), the artist explores the history of slavery through 100 life-size cut-out figures.

+ VISIT THIS
Seek out Himid's artwork *We Will Be* (1983) in the Walker Art Gallery, Liverpool.

+ READ THIS
In 2007, Himid began to doctor pages from the *Guardian*, which she said 'has this extraordinary habit of placing negative texts … next to images of black people'.

Like This? Try These

→ Sutapa Biswas

→ Sonia Boyce

→ Njideka Akunyili Crosby

GODS AND MYTHICAL CREATURES

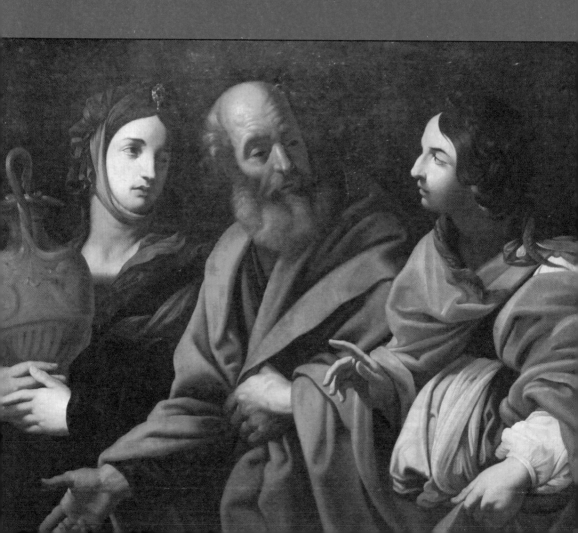

Guido Reni

Lot and His Daughters Leaving Sodom

1615–16

Several tales in the Old Testament are high on shock factor, and this is one of them. After being warned of Sodom's destruction by God, Lot and his daughters fled the sinful city and headed to the mountains. Lot's wife, so the story goes, ignored instructions not to look back at the burning city and was promptly turned into a pillar of salt.

Reni's painting is a beauty, perhaps in part because – unlike other artists attracted to the moralizing tale – he left out the city engulfed in flames. Later, Lot's daughters are said to have plied their father with wine and seduced him in a desperate bid to continue the family bloodline, yet this trio are clothed – Lot clutching his red robe rather tightly around his chest – and without a hint of wine on their lips. The antique vase held by the daughter dressed in olive green may allude to the events to come (most likely it's filled with wine), as might the bunched drapery around the middle of her sister, who could be pregnant. Still, the instant Reni chose to depict is a brief pause, a moment of reflection.

The family of three are caught in conversation, planning their next move. Lot gestures with his open palm – suggesting a certain route – while his daughter interjects with her index finger, offering an alternative. Like his contemporary Michelangelo Merisi da Caravaggio (see page 26), Reni was a master at handling light and dark, and by shrouding the background in shadows and illuminating the three life-size figures he concentrates on the action.

Other seventeenth-century artists homed in on the erotic nature of the tale, which gave them a good excuse to paint a racy scene under the guise of a moral context. And yet, what we have from Reni is a family portrait. Free from drama, the focus is entirely on a father and his two daughters. The effect? We're free to contemplate their characters without distraction.

+ ARTIST BIO
Italian, 1575–1642

+ SEE THIS
A more lustful version of the tale comes courtesy of the Flemish artist Peter Paul Rubens, whose *Lot and His Daughters* (1613–14) depicts the seduction taking place.

+ VISIT THIS
This piece and Reni's *Susannah and the Elders* (1620–25) have long been regarded as companion pieces. Both hang in London's National Gallery.

+ READ THIS
Daphne du Maurier's *Julius* (1933) is named after the incestuous father in her novel who ends up drowning his daughter to prevent her from marrying.

Like This? Try These

→ Philippe de Champaigne

→ Nicolas Poussin

→ Simon Vouet

Kara Walker

Fons Americanus

2019

Do you ever pause in front of a public monument and contemplate who or what it celebrates? The Victoria Memorial in London – featuring Queen Victoria and allegorical statuary representing Truth, Justice and more – is an ode to the fact that Britannia rules the waves. But what about those who aren't in positions of power? Who commemorates their history?

That's precisely the question that Walker – who has long explored themes of race, slavery and identity – confronts in the installation she created for Tate Modern's 2019 Hyundai commission.

From afar, *Fons Americanus* could almost pass for the public monument it subverts: the fountain features four elegant tiers filled with symbolic sculptures. Look closer, though, and you'll see something more mythical at play. Instead of a celebration of empire, Walker's fountain is an allegory of the Black Atlantic; with violent imagery and art-historical references, it visualizes the transatlantic slave trade.

The centrepiece nods to Thomas Stothard's *The Voyage of the Sable Venus from Angola to the West Indies* (1801), a propagandist etching that presents the Middle Passage as euphoric. Holding up her arms, Walker's Venus – who spurts water from her nipples and slit jugular – is a liberated priestess. On the second tier is a satirical Queen Vicky, tossing her head back as she laughs while a melancholic figure crouches at her feet. Nearby is a caricature of the West Indies Governor Sir William Young – who enslaved labourers in the Caribbean – begging on his knees.

Walker's fountain explores the tangled histories of Africa, the US and Europe, as well as the tragic journeys made between them by the enslaved. In the lower basin, sailors in sinking ships are encircled by sharks, as in Winslow Homer's *The Gulf Stream* (1899). A splayed tree with a noose hanging from one branch alludes to lynching. Walker shines a light on the black men, women and children who were exploited, their histories erased by those who exploited them.

Sandro Botticelli
Pallas and the Centaur

c. 1482

Half-human, half-horse, the centaur is a mythological creature that symbolizes unbridled chaos and the base instincts of humanity. Here, Botticelli – one of the most esteemed artists of the early Renaissance – depicts the beast being brought down to size by the beautiful Pallas Athena, goddess of wisdom. And there we have it: mind over matter.

+ ARTIST BIO
Italian, *c.* 1445–1510

+ SEE THIS
Centaurs crop up throughout art history, including in the sculpted metopes on the Parthenon in Athens.

+ VISIT THIS
The Gallerie degli Uffizi in Florence is home to some of Botticelli's most famous mythological paintings.

+ READ THIS
Virgil's *Aeneid* tells the story of Aeneas, a Trojan hero who founded Rome, and features a cyclops, a trip to the Underworld and more.

Like This? Try These

→ Donatello

→ Filippo Lippi

→ Dante Gabriel Rossetti

Our red-haired heroine – some early sources suggest she could also be Camilla, a virgin warrior who died fighting for her country in Virgil's *Aeneid* (19 BC) – stands on a grassy ledge a foot above her captive. Her left arm is woven around her golden battleaxe in the same way that the delicate greenery encircles her body and, halo-like, her head. With her right hand she clutches the centaur's hair, dragging him to his fate. Her translucent dress catches the light and her green cloak billows out behind – much like the sail of the ship in the background.

The double portrait belonged to the Medici, a wealthy banking family that rose to power in Renaissance Florence and was a proud sponsor of the arts – which explains the presence of its three-ring insignia on Athena's dress. It's thought that the work may have been painted on the occasion of the marriage between Lorenzo di Pierfrancesco de' Medici and Semiramide Appiano – a lesson in self-control for the newlyweds?

Although they're foes, Botticelli – a Florentine himself – establishes a bond between his painted pair. The centaur's front hooves mirror Athena's turned-out toes and his curved bow echoes her elegant pose. Plus, the look on her face isn't fury so much as fatigue. As his angst-ridden face twists towards her and his eyes lock with her breasts, her expression says: not this again.

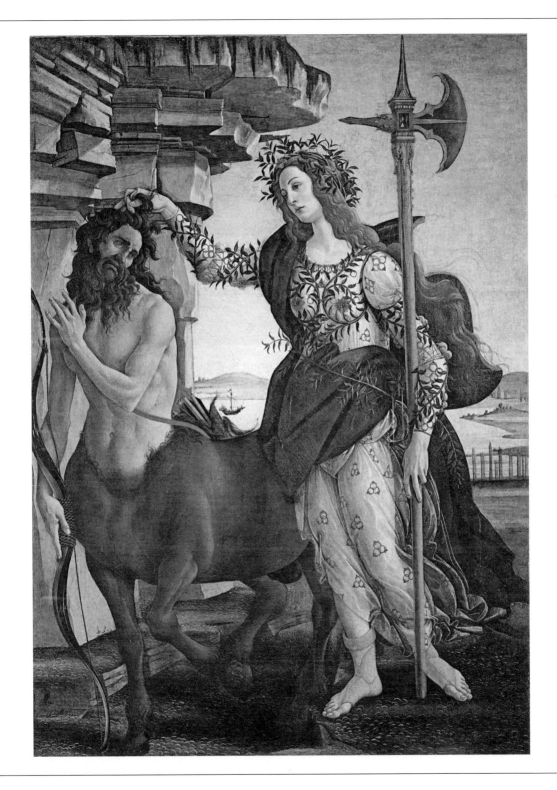

Leonora Carrington
The Giantess

c. 1947

'I am as mysterious to myself as I am to others.' So said Carrington, and her creations are as enigmatic as she was. Take *The Giantess*, also known as *The Guardian of the Egg*, a painting that merges myriad worlds in an attempt to shake up our understanding.

A monumental moon-faced woman in a russet robe and a pearly-grey cloak stands barefoot on the edge of a cliff. Her tiny pale face is encircled by a golden mane and in her dainty hands – far too dainty for her enormous frame – she cradles an egg, a symbol of new life (egg tempera was also one of the British Surrealist's favourite mediums). Geese flock around her, while a hunting party of tiny men, women, children and dogs scurry past her toes like insects. On and in the water are white-sailed ships and ghostly sea creatures, somehow visible beneath the surface. In the distance, far beyond this towering figure, mountains rise and rain lashes down from a cloudy sky.

Within one work, Carrington flits freely between the fantastical and the everyday, marrying influences from Celtic folklore (her mother was Irish), literature (Dante, for one) and Flemish masters such as Pieter Bruegel the Elder (see page 89). In life, too, she roamed around, fleeing first from the straitlaced British countryside to bohemian Paris with her mentor and lover, the Surrealist Max Ernst. In Spain during the Second World War she was briefly hospitalized for acute anxiety and depression. It wasn't until she moved to Mexico that she found peace and prominence.

Although busy with incident, *The Giantess* is a peaceful painting. Somehow its wildly off-kilter sense of scale – with the all-conquering female figure dwarfing everything and everyone around her – results in a formal harmony. And the meaning? Another mystery. Like her fellow Surrealist Dorothea Tanning (see page 107), Carrington often drew on witches, fairies and other mythic female figures who could outwit her male kin.

+ ARTIST BIO
Mexican, 1917–2011

+ SEE THIS
In *Self-Portrait* (c. 1937–38), the artist features in a trancelike scene alongside a rocking horse, a real horse and a prancing hyena.

+ VISIT THIS
The Museo Leonora Carrington has two venues in the state of San Luis Potosí in Mexico.

+ READ THIS
Carrington was a writer as well as a painter. Read her eerie tales in *The Complete Stories of Leonora Carrington*, published in 2017 by the small feminist publishing project Dorothy.

Like This? Try These

→ Marion Elizabeth Adnams

→ Eileen Agar

→ Ithell Colquhoun

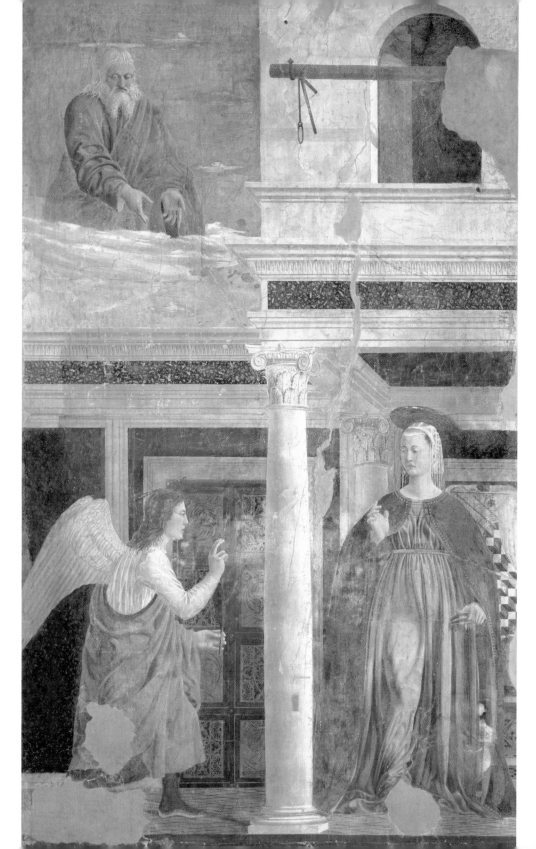

Piero della Francesca
Annunciation
1464

There's a meditative mood to the works of Piero. Stand in front of them and you feel like you're in safe hands. Perhaps it's the fifteenth-century painter's subdued colour palette and orderly compositions, or even his deferential treatment of religious subject matter – in this case the Annunciation, the moment the Virgin Mary is visited by the angel Gabriel and told she's going to bear the child of God.

The fresco is sliced into quarters, with a gently tapered Corinthian column standing tall in the centre. The classical architecture provides a sense of stability – the message being delivered may be entirely unexpected, but the setting is assured.

Gabriel approaches the portico from the left, holding what's most likely a lily (the symbol of the Virgin's purity) in one hand and raising the other in blessing. Mary raises her right hand in turn. It's hard to decipher her expression, but she doesn't look entirely at ease – her eyelids are heavy, the corners of her lips curl downwards. Surprise, concern, acceptance: we see glimmers of all three emotions flit across her face. Watching the action unfold from above is God, whose fingertips are generating fine golden rays.

The fresco may be neat and tidy, but that's not to say it's dull. Along with a biblical story, Piero throws us snippets of artistic virtuosity. Look at the way the light catches on Mary's veil, and the cleverly modelled folds of her robe, which looks a little too long as it bunches on the floor and conceals her feet. Gabriel's curls and God's bushy beard receive as much attention as the capitals of the two marble columns, with their acanthus leaves and scrolls. And then there's the vanishing point, behind Mary, which severs the symmetry.

The Annunciation was a subject taken on by artists across Europe and, like any story, each time it was retold it took on a new life. Piero's masterpiece presents this shocking encounter as a meditative moment in time.

+ ARTIST BIO
Italian, c. 1416/17–92

+ SEE THIS
Painted eight years after Piero's fresco, Leonardo da Vinci's (see page 182) *The Annunciation* (c. 1472) places the event in an earthly setting and pays particular attention to corporeality.

+ VISIT THIS
Piero's fresco, which is part of a cycle called *The Legend of the True Cross*, remains in situ in the Basilica di San Francesco in Arezzo, Italy.

+ READ THIS
Colm Tóibín's *The Testament of Mary* (2012) tells the story of a highly ambivalent mother of Christ.

Like This? Try These

→ Cimabue

→ Andrea Mantegna

→ Gentile da Fabriano

Lavinia Fontana

Minerva Dressing

1613

Fontana is one of the most significant women artists of the Renaissance, and some say the first woman in Western art history to paint nudes from life. The mythological title and attributes of her last-known painting hardly disguise the fact that the subject is a contemporary Italian woman, but the allusion to the Roman goddess of wisdom and war lends the artist a nifty excuse to paint her without any clothes.

Minerva is recognizable by her gleaming shield and pieces of armour, as well as the feathered helmet, which is being admired by a cherub. The owl peeking through the open door from its perch on the balustrade is a symbol of wisdom; nearby is the goddess's spear. Remove those props, though, and we're left with a young naked woman reaching for her robe. There's nothing hurried about her gesture; she lazily turns to us, a soft look on her face. Her fingers delicately clasp onto the fabric, which is tantalizingly translucent.

The daughter of a prominent painter, Fontana started out in her father's studio in Bologna and later became the first woman to gain a place at the Accademia di San Luca in Rome. She painted dozens of portraits before turning her attention to altarpieces and mythological compositions – work favoured by her male counterparts. She would have been achingly sensitive to the issue of respectability when it came to women artists painting nudes from life, and the curtain at the top of the canvas – which is drawn back but appears to be so heavy that it could fall in front of Minerva at any moment – plays with the question of what's appropriate and what's not. This is an artist who delighted in painting everything around her – lush fabrics, delicate pearls, flushed skin – and to make the latter an acceptable topic she drew on the mythological. Fontana conjures the goddess to overcome the limits imposed on women.

+ ARTIST BIO
Italian, 1552–1614

+ SEE THIS
One of Fontana's more overtly erotic mythological paintings is *Mars and Venus* (c. 1595), which shows the god of war clutching the goddess's bum.

+ VISIT THIS
Minerva Dressing hangs in the Galleria Borghese in Rome, where Fontana moved to in 1603.

+ READ THIS
Pat Barker's *The Silence of the Girls* (2018), a feminist retelling of Homer's *Iliad* (8th century BC), focuses on the effects on women of the war being fought by mortals and gods.

Like This? Try These

→ Fede Galizia

→ Barbara Longhi

→ Elisabetta Sirani

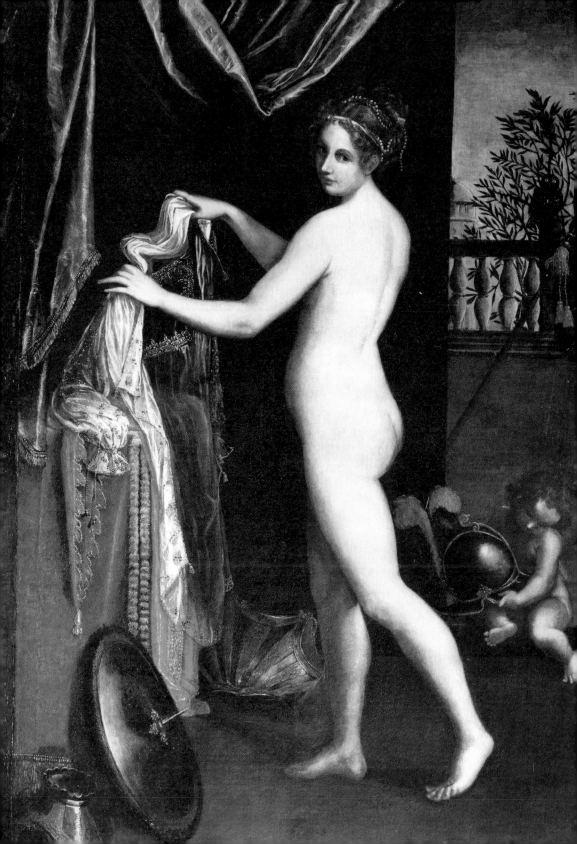

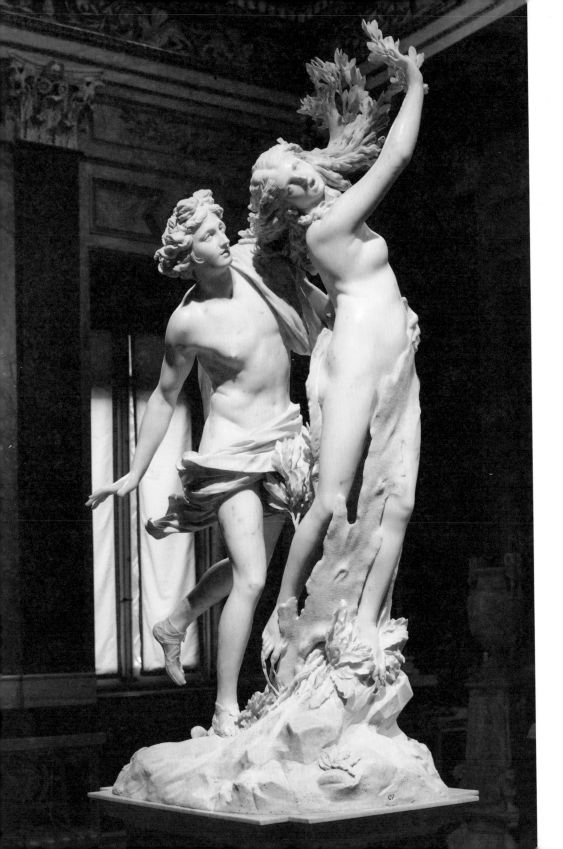

Gian Lorenzo Bernini
Apollo and Daphne

1622–25

Bernini's *Apollo and Daphne* is a marvel in more ways than one. The master of the Italian Baroque captures a moment of metamorphosis and, in doing so, transforms the medium of marble itself.

The action is lifted from Ovid's *Metamorphoses* (AD 8). Apollo – a great warrior, as well as god of the sun – mocks Eros, god of love, for his use of a bow and arrow. Eros gets his own back by shooting Apollo with a gold arrow of passion and the chaste water nymph Daphne with a lead arrow of hatred. After being relentlessly pursued by the now lustful Apollo, Daphne calls for help from her father, the river god Peneus, who answers by turning his daughter into a laurel tree. Sadly, Apollo doesn't take the hint and, from this moment on, he cherishes laurel and even fashions a crown from its branches.

Bernini depicts the act of transformation, as Daphne's flowing hair and outstretched fingers sprout into twigs, her toes root into the earth and a wafer-thin bark begins to wrap itself around her lower body and legs. Apollo reaches out with his left hand – having caught up with her at last – but his palm lands on a piece of bark rather than skin. He lunges towards her as she, his prey, twists away from him.

Bernini handled marble as if it were plasticine, manipulating it to create a life-size masterpiece. He renders the lightning-fast metamorphosis with such intricate details and material vividness that you would think he'd studied it for years. As the pair spiral skywards, it's not always clear where one figure ends and the other begins. Again, this work is a marvel – both in terms of the act it represents and the way in which that act is represented. Oh, and a moral couplet at the foot of the sculpture prevents onlookers from misinterpreting the message: 'The lover who would fleeting beauty follow, plucks bitter berries, and leaves his hands hollow.'

+ ARTIST BIO
Italian, 1598–1680

+ SEE THIS
The other mythological sculpture that made Bernini famous is *The Rape of Proserpina* (1621–22), in which the maiden attempts to counter the attack of Pluto, god of the underworld.

+ VISIT THIS
Head to Rome's Galleria Borghese to appreciate Bernini's masterpiece from all angles.

+ READ THIS
Will Boast's debut novel *Daphne* (2018) flips Ovid's poem on its head and recasts the myth from Daphne's point of view. A retelling ripe for the #MeToo era.

Like This? Try These

→ Filippo Brunelleschi

→ Antonio Canova

→ Nicola Salvi

Hieronymus Bosch
The Garden of Earthly Delights
1503–15

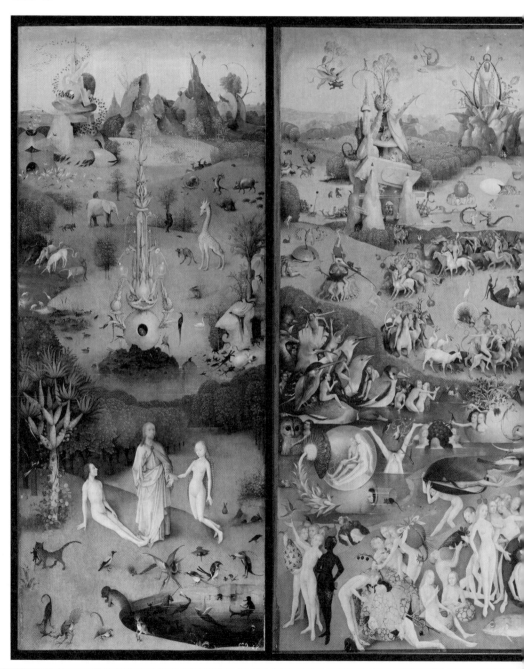

+ ARTIST BIO
Dutch, c. 1450–1516

Like This? Try These

→ Salvador Dalí

→ Jan van Eyck

→ Remedios Varo

This psychedelic work is about new beginnings – the beginning of the world, that is. *The Garden of Earthly Delights* is populated with creatures real and imagined, inflated pieces of fruit, a hell of a lot of nudity and, of course, the monstrosities of hell itself.

The chock-a-block triptych comprises three wooden panels that close like a cabinet. When shut, it presents the creation of the world in a palette of greyish-blue, with God – sealed inside a bubble – peering down at his handiwork from his lofty perch. When open, one world becomes three, in a rainbow of colours. On the left, God makes the necessary introductions between Adam and Eve in the Garden of Eden, surrounded by wildlife that ranges from the everyday (a cat chewing a mouse) to the fantastical (a unicorn lapping water from a lake). On the right is hell, with a human bird, a pig in a nun's habit and a pair of ears sandwiching a blade. But the most spellbinding scene is the cosmic central panel, where – among other things – naked men and women ride bareback on giant robins and ducks, a pale-legged person is trapped in a giant mussel shell and bubblegum-pink palaces sprout like mushrooms from the leafy-green land.

Bosch's triptych is as mystifying as it is hypnotic. From the 1960s it was celebrated as an early iteration of free love and festivals, a window onto the artist's wild imagination, but recent readings are more sobering: Bosch was a conservative Christian and his trio of landscapes is a glib lesson in the consequences of earthly sin. You need only glance to the right to see what will happen if you succumb to temptation. Nonetheless, painted at the heart of the Renaissance, a period of enlightenment and discovery, *The Garden of Earthly Delights* is a tour de force in freedom of thought and curiosity.

Pieter Bruegel the Elder
Landscape with the Fall of Icarus

c. 1555

We're all familiar with the fable of Icarus, the boy who flew too close to the sun. But Breugel's oil painting is less about his suffering than the idea that, when something bad happens, life continues.

+ ARTIST BIO
Dutch, *c.* 1525–69

+ SEE THIS
In *Icarus and Daedalus* (1869), Frederic Leighton depicts an intimate moment as father offers son a word of warning.

+ VISIT THIS
Landscape with the Fall of Icarus hangs in the Musée des Beaux-Arts in Brussels.

+ READ THIS
Read W.H. Auden's shrewd poem, 'Musée des Beaux Arts', for yourself.

The story goes that Icarus and his father, Daedalus, were imprisoned on the island of Crete. Daedalus created a pair of wings; Icarus put them on and aimed too high. As the wax holding together his flight gear melted, he plunged into the sea and drowned. Breugel's painting captures the splash – look to the lower right-hand corner of the canvas and you'll see two pale legs kicking about in the green water. But that's it. Icarus's demise is no more than an embellishment, a blot on the landscape.

In his famous poem 'Musée des Beaux Arts' (1939), W.H. Auden describes the Old Masters' understanding of suffering: 'How it takes place / While someone else is eating or opening a window or just walking dully along.' In Breugel's painting, no one reacts when the boy plummets from sky to sea. The ploughman continues to plough, reminding his horse to walk on with a tickle of his whip, treading carefully. The shepherd takes a break, leaning on his staff with his dog by his side, his flock surrounding him. Even the figure closest to Icarus seems absorbed in some other activity, perhaps scouting for fish. Likewise, the men tending to the mast of the closest ship – a fancy vessel with big creamy sails – are oblivious.

Did they not hear the splash? The boy's cry? It would appear not, and Auden isn't surprised. He, like the Old Masters, recognized that pain happens while others get on with their daily lives or, quite casually, turn away – 'Where the dogs go on with their doggy life and the torturer's horse / Scratches its innocent behind on a tree.'

Like This? Try These

→ Jan Brueghel the Elder

→ Pieter Brueghel the Younger

→ Lucas van Leyden

Henri Matisse

Icarus

1947

Nearly four centuries after Breugel painted the fall of Icarus, tucking the untidy incident away in the corner of his canvas, Matisse turned it into a main event. The limbs of his Icarus – a flat, abstract figure with winged arms, chunky legs and shoulders hunched up towards his pin head – stretch to the outer edges of the plate. Caught in freefall, his body commands the space. In fact, his right toes even teeter on the edge.

Matisse's Icarus may be floundering through a night-time sky, but take away the title and he could just as easily be throwing shapes on a dance floor surrounded by flashing lights. The work is bold and playful, the royal-blue backdrop pinpricked with spiky yellow stars. The blazing red circle on the boy's chest refers to his passionate heart. In many ways this is a tragic moment: Icarus's dreams are crushed, death inevitable, and yet the image Matisse gives us is dazzling and bright.

Icarus is one of twenty plates the artist made to illustrate *Jazz* (1947), a book about the theatre and circus. It started as a cut-out – a new art form that Matisse invented in later life when his health declined and he could no longer wield a paintbrush. He cut sheets of painted paper into various shapes, then arranged them in a lively composition. The publisher then transferred the prototypes to the printed pages of a book using a stencil technique called *pochoir*.

Most of Matisse's contemporaries dismissed his cut-outs, regarding them as childlike or even jokes. In fact, what the artist achieved was something radical – ignoring the rules of realism and distilling the essence of a story.

+ **ARTIST BIO**
French, 1869–1954

+ **SEE THIS**
Los Angeles-based artist Chris Burden recreated Icarus's fall in his performance piece *Icarus, April 13, 1973*.

+ **VISIT THIS**
The Chapelle du Rosaire de Vence in the French Riviera was decorated between 1947 and 1951 according to plans formulated by Matisse.

+ **WATCH THIS**
Amateur cyclist Bryan Fogel's revelatory documentary *Icarus* (2017) examines how Russia corrupted the Olympics with its state-sponsored doping programme.

Like This? Try These

→ Alexander Calder

→ André Derain

→ Frances Hodgkins

TROUBLED DREAMS

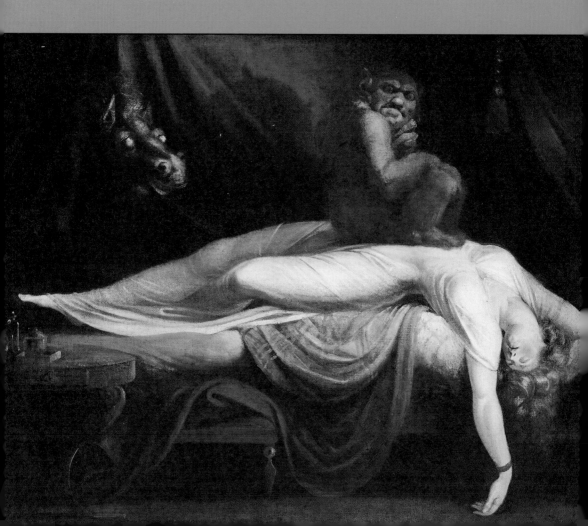

Henry Fuseli

The Nightmare

1781

A sleeping woman in a virginal white nightgown is sprawled out on a bed. An incubus with the face of a gargoyle squats on her belly and turns to look at the viewer, stroking its chin. Peering through a gloomy gap in the crimson curtain behind them is a demonic black stallion with ghostly white eyes and flared nostrils. This is the worst nightmare in art history, and surely the most famous depiction of a nightmare in art.

The bad dream here is a violation. It's impossible to look at Fuseli's painting without imagining what will happen next. Murder? Rape? There's something sacrificial about this sleeping beauty laid out like a lamb on an altar, throat exposed. The red curtain and the matching bed sheet, which falls off the edge of the bed, resemble a river of blood.

Fuseli was among the first artists to deem the world of dreams a fit subject for art. The Swiss-born artist first exhibited *The Nightmare* at the Royal Academy of Arts' Summer Exhibition in London in 1782 and the unprecedented subject matter titillated, stunned and scared viewers. No wonder. Like all Gothic works of art and literature, which railed against the rationalism of the Enlightenment and instead sought inspiration from fantastical themes, Fuseli's painting couples the monstrous with the sensuous. There's an erotic charge to the nightgown clinging to her skin, the arch of her back.

However you choose to interpret this painting's heady mix of horror and perverse sexuality, there's no avoiding the dark undertones. Fuseli heightened the drama by bathing the woman in a bright-white light and casting the rest of the room in ominous shadow. Towards the end of his life, the artist returned to the subject. In the later version, he added an owl and some fairies, dialling down the dreadfulness.

+ ARTIST BIO
Swiss, 1741–1825

+ SEE THIS
Fuseli's contemporary James Gillray satirized his painting in *Duke William's Ghost* (1799).

+ READ THIS
If it's a Gothic novel you're after, look no further than Mary Shelley's *Frankenstein* (1818), a masterpiece of the macabre.

+ WATCH THIS
Circumstances and execution are different, but it's hard to forget that memorable scene in *The Godfather* (1972) when a man wakes up with a horse's head in his bed.

Like This? Try These

→ William Blake

→ Fortunato Duranti

→ Theodor von Holst

Pablo Picasso

Minotaur Caressing a Sleeping Woman

1933

It's quite a feat that this closely cropped etching by Picasso
manages to be both tender and terrifying. A minotaur crouches over
a sleeping woman and gently nuzzles the side of her face with his
snout. The minotaur is on his knees, his feet flexed, his palms pressing
against the mattress. The object of his affection – if we can call her
that – is serene, her eyelids shuttered, her heart-shaped lips pursed.
Then again, she also appears to be scratching at her cheeks. Is she
aware of the intruder?

Picasso repeatedly returned to the theme of the minotaur as part of his exploration of classical art. This mythical creature – half man, half bull – was an alter ego for the artist, who saw it as a symbol of passion, violence and guilt. He often depicted himself as a bull or a minotaur and regarded bullfighting – of which he was an avid admirer, a testament to his Spanish heritage – as a sexual ritual. Here the minotaur's carnal desires are reflected in the raw style with which Picasso rendered his hairy head and chest. Although his caresses appear to be gentle, his horns pose an ever-present threat and his teeth are bared.

The artist's minotaurs appear as heroes (saving drowning women) and victims (afraid of being seen by little girls), as well as monsters. Picasso's relationship with women was famously turbulent; he too could be a monster and must have known that by donning a bull's head, which he often did, he was in some sense confessing to his wrongdoings. The subject of one figure watching over a sleeping other also crops up throughout his career, most likely the result of his working late into the night and observing his lovers as they dozed and dreamed. For Picasso, sex was inseparable from art, which is both thrilling and troubling.

+ ARTIST BIO
Spanish, 1881–1973

+ SEE THIS
The minotaur appears in one of the artist's most famous paintings, *Guernica* (1937).

+ VISIT THIS
There are major museums dedicated to Picasso in Barcelona and Paris.

+ READ THIS
Picasso's friend and biographer, John Richardson, wrote a definitive, multi-volume biography of the artist: *A Life of Picasso*, the first part of which was published in 1991.

Like This? Try These

→ Georges Braque

→ Henri Gaudier-Brzeska

→ Henri Laurens

Madge Gill

Untitled

undated

Gill first said that she was possessed by Myrninerest – a spirit
guide who sparked in her an irrepressible rush of creativity –
on 3 March 1920. She had already lost one of her three sons to
influenza and, after giving birth to a stillborn daughter and going
blind in her left eye, had spiralled into depression. From that day
on, she made thousands of feverishly detailed works – mostly ink
on paper or calico, but also hand-embroidered rugs and clothes.

Like other spiritualist artists, she believed that the dead could communicate with the living and sought to connect with her lost children through art. Looking at the self-taught spiritualist artist's hallucinatory drawings is what it must feel like to tumble into a silken web. This particular work – undated and unsigned, as they all are – flirts with abstraction without fully yielding to it. Repetitive patterns evoke feathered wings, pearl necklaces, chessboards and looming staircases. In the centre, a circus character emerges from the overlapping layers, with a pointed hat and a lolling tongue. All around it are various iterations of a woman's face: doll-like with button nose and doe eyes lined with kohl, yet also ghostly. In places it's tethered to a flowing robe; elsewhere it perches atop a spine-like

rod; and at times it floats, eerily detached yet seemingly alive. Whether this young woman is Gill's lost daughter, Myrninerest or the artist herself is open to interpretation.

Gill often exhibited her work at the Whitechapel Gallery in London, but she attributed it to Myrninerest and – reluctant to part with it – priced it so highly that it wouldn't sell. When she died in 1961, her son found her life's work stashed under her bed and in the back of her wardrobe. Today her frantic scribbles are resurfacing and, once again, offering viewers a chance to get caught in her mystical webs.

+ ARTIST BIO
British, 1882–1961

+ SEE THIS
Gill was continuing in the vein of pioneering women artists such as Anna Howitt-Watts, who sketched several portraits of the spirits with whom she interacted.

+ VISIT THIS
Gill was born in the northeast London borough of Walthamstow, home to the William Morris Gallery, which hosted an exhibition of her work in 2019.

+ READ THIS
Madge Gill by Myrninerest (2019) is a collection of interviews, essays, letters, photographs and works of and about the artist, edited by graphic designer and curator Sophie Dutton.

Like This? Try These

→ Marian Spore Bush

→ Georgiana Houghton

→ Pamela Colman Smith

Kiki Smith

Sky

2012

Stare at Smith's towering twenty-first-century tapestry for long enough and you'll feel as if you – along with the nude woman with the detached expression – are floating in the sky. Keeping you company is a constellation of stars and migrating birds. Below are craggy mountains with pointed peaks. But wait: if you're floating in the sky, what is it those upside-down butterflies are clinging to along the top? All of a sudden, the composition seems crowded, the sky closing in. Smith's art hints at the fragile state of the universe.

The New York-based artist's works are rich in storytelling. No matter the media, Smith brings together beings and creatures from disparate cultures to create new worlds that defy time and space. Here the horizontal layers are suggestive of the heavens, Earth and the underworld – in which case our nude woman could be a spirit or a goddess.

Smith turned her attention to textiles around 2011, sending 3-metre (10-foot) high collages to the Oakland-based fine-art studio Magnolia Editions, which works with a Belgian weaving studio to transform them into tapestries using a computerized Jacquard loom. She has also, since rising to prominence in the early 1990s, moved away from the physical – namely her figurative sculptures that challenge bodily taboos – and towards the celestial. It may not be overtly political, but her work has gone from responding to the Aids crisis to expressing the relationship between humans and animals and the mutual respect required to ensure the survival of both.

In *Sky*, our habitat is full of both wonder and instability. There's something precarious about the way the floating nude curves to fit within the frame, the heavens pressing down on her, the underworld rising up. The snow-capped mountains on the right – another slice of the natural world on the brink of being eclipsed – echo the diagonal reach of her legs. Smith's work may be dreamlike, but its message is troublingly real.

+ ARTIST BIO
American, b. 1954

+ SEE THIS
Smith also created the tapestries *Earth* (2011) and *Underworld* (2011).

+ VISIT THIS
In her thirties, the artist saw the *Apocalypse Tapestry* (1377–82) at the Musée de la Tapisserie in Angers.

+ READ THIS
Sky nods to the biblical story of Adam and Eve, whose transgression against the natural world has dire consequences.

Like This? Try These

→ Louise Bourgeois

→ Eva Hesse

→ Shirin Neshat

Francisco de Goya
The Sleep of Reason Produces Monsters
1799

+ ARTIST BIO
Spanish, 1746–1828

+ SEE THIS
Goya's series *The Disasters of War* (1810–20) presents an unflinching view of suffering during the Napoleonic invasion of Spain.

+ VISIT THIS
The permanent collection of the Museo Nacional del Prado in Madrid is home to myriad works by the Spanish master.

+ WATCH THIS
Stanley Kubrick's *The Shining* (1980) is a living nightmare.

Like This? Try These

→ Francisco Bayeu

→ José Luzán

→ Diego Velázquez

There's something unsettling about the idea of 'succumbing' to sleep – as though slumber is something we submit to, an act that demands our surrender. No matter how rational we are, when we close our eyes we lose control. Goya captures that tension terrifically in this disturbing eighteenth-century etching, which also holds up a mirror to his contemporaries' questionable morals.

The Spanish master depicts himself slumped at his drawing table, fast asleep with his head in his hands. Swooping around him against a grainy backdrop is a dizzying flock of nocturnal creatures associated with mysterious and evil forces in Spanish folklore – from shadowy bats to wide-eyed owls. To the right, an alert lynx with pricked ears watches powerlessly as the monstrous forces prowl around their prey. Some stare at the artist, others out at the viewer, drawing us into the disturbing dream.

Part of a series called *Los Caprichos* (1799), this is one of eighty aquatint etchings that convey Goya's criticism of society in pre-enlightenment Spain. Superstition was rife, as was arranged marriage and an all-too-powerful clergy, which supplied the artist with plenty of subject matter to play with – and poke fun at. In *The Sleep of Reason Produces Monsters* he takes up the follies and prejudices of his contemporaries and presents them as nightmares.

The work has been interpreted in various ways: some see it as a declaration of Goya's belief in the capacity of reason to ward off ignorance, while others regard it as a metaphor for reason's irreversible failure. An epigraph printed alongside the etching reads: 'Imagination abandoned by reason produces impossible monsters; united with her, she is the mother of the arts and source of their wonders.' In other words, for Goya, art is the result of both careful consideration and unchecked fancy.

René Magritte

The Lovers

1928

Thwarted desires crop up again and again in the work of Magritte, the Belgian Surrealist, whose witty paintings push and pull the mind in weird and wonderful directions. In the first of four variations of *The Lovers*, all painted in 1928, he takes a moment of passion and turns it into an unsettling image of sexual frustration.

Two lovers are caught in an intimate embrace – or at least they would be, were it not for the grey-white hoods on their heads. Their lips lock, but only from behind the dry sheets of fabric, which threaten to suffocate them at any minute. Magritte gives us a melodramatic close-up of the action but dispels any hint of pleasure we might get from it by keeping it quite literally under wraps. The only skin on show is the tanned arm of the woman, who wears a red vest.

Though the setting is ambiguous the cornice running along the top of the right-hand wall hints at a bourgeois sensibility, as does the man's suit and tie. Could the couple also be feeling stifled by their conservative middle-class life? The lovers are physically together yet psychologically alone, which points to our inability to ever truly understand the inner workings of our loved ones. When he was a teenager, the artist's mother drowned herself, and some speculate that the enshrouded faces hark back to the moment he saw her being pulled from the water, her dress clinging to her face.

Magritte has taken an everyday act – a loving act – and injected it with mystery. The Surrealists were fascinated with masks and disguises, and here we're left to wonder what lurks behind them. The other mystery: why Magritte chose to keep his couple apart. They can't see or feel each other, and the stony look of their hoods suggests the affliction isn't temporary. The artist has denied them love.

+ ARTIST BIO
Belgian, 1898–1967

+ SEE THIS
Compare Magritte's representation of forbidden love with *The Kiss* (1908) by Austrian painter Gustav Klimt, an ethereal impression of an everlasting embrace.

+ VISIT THIS
For a roll call of the Surrealist's work, head to the Musée Magritte in his native Brussels.

+ READ THIS
Thwarted love is a common theme in fiction. Start with Nell Stevens's *Mrs Gaskell & Me* (2018), which combines it with thwarted scholarship.

Like This? Try These

→ Marc Chagall

→ Max Ernst

→ Stella Snead

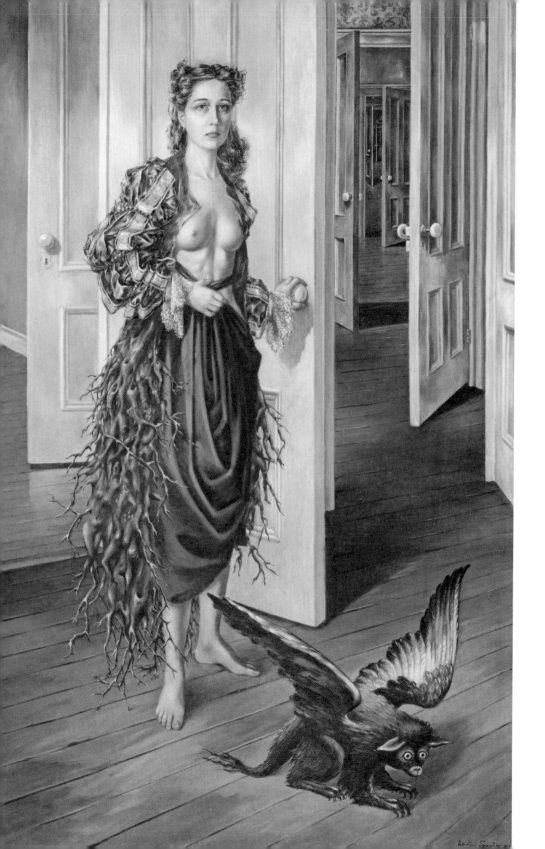

Dorothea Tanning
Birthday

1942

The infinite recession of open doors in this strange and sensual self-portrait suggests that, like Lewis Carroll's Alice, we've tumbled into a dream world.

+ ARTIST BIO
American, 1910–2012

+ SEE THIS
The doors are numbered and closed in *Eine Kleine Nachtmusik* (1943), Tanning's Surrealist impression of a hotel corridor.

+ VISIT THIS
Birthday hangs in the Philadelphia Museum of Art.

+ READ THIS
Tanning was a writer as well as an artist, the author of a novel, two collections of poetry and two memoirs, the first of which was *Birthday* (1986).

The portals may be ajar, each one casting a sliver of shadow on the wooden floorboards, but any minute now they could close. In fact, as Tanning clutches one round handle, it seems that all might be capable of shutting in unison. Even if you haven't dreamed of open doors slamming in your face, you've surely witnessed them rattling in a horror film.

The Surrealist appears triumphant, a sorceress, a female warrior. Her ruffled violet jacket is open, like the doors, revealing her toned stomach and pert breasts. On top of a draped grey skirt is a green robe of what look like pieces of seaweed but are, in fact, writhing nude bodies. Her wavy hair is twisted back off her pale face; her expression is still but strong. At her feet is a fantastical winged creature with bat-like ears, sharp claws and beady yellow eyes.

It was with *Birthday* that Tanning, then thirty-two years old, made her mark. The self-portrait was an announcement, hailing the arrival of an artist and her rebirth from the real into the surreal; she had been inspired by the revolutionary 1936 exhibition *Fantastic Art, Dada, Surrealism* at New York's Museum of Modern Art. Max Ernst, who was at the time married to Peggy Guggenheim, encountered the canvas in Tanning's studio while prospecting for pieces to include in his wife's show of women Surrealists; he gave the work its name and persuaded Guggenheim to include it. Within three weeks he had moved in with Tanning, and three years later they were married. Which is why, until recently, Tanning has been known, simply, as 'Max Ernst's wife'. She deserves better, and this self-portrait is a striking portal to her inner vision.

Like This? Try These

→ Leonor Fini

→ Dora Maar

→ Margaret Macdonald Mackintosh

William Blake

Pity

c. 1795

It's hard to choose just one image by Blake when selecting art for
a chapter on troubled dreams. The British painter, printmaker and
poet – who rejected the establishment and science, and regarded
himself as a craftsman rather than an artist – had a wild
imagination and witnessed scenes coming together in his mind,
visions he saw, but not with his eyes. The result: golden angels,
monstrous creatures, inky-black voids and radiant dawns. Blake's
art is as beautiful as it is bizarre.

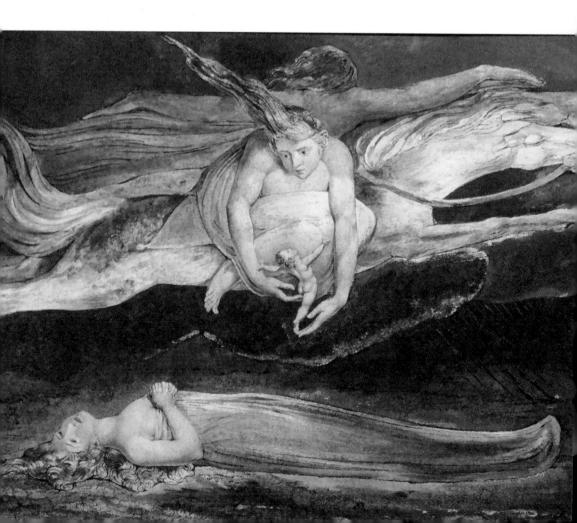

Pity was inspired by the following lines in act one, scene seven of Shakespeare's *Macbeth* (1606):

'And pity, like a naked new-born babe,

Striding the blast, or heaven's cherubin, horsed

Upon the sightless couriers of the air,

Shall blow the horrid deed in every eye,

That tears shall drown the wind.'

A tiny baby (a 'naked new-born babe') with outstretched arms leaps from his mother towards an angel ('heaven's cherubin') riding a blind horse (one of two 'sightless couriers in the air'). The robed mother lies rigid on her back; her eyes open but her expression blank. Her legs are pressed together and she clasps her hands across her chest like a knight in effigy. Blonde curls pool around her head like blood. Utterly still, she could be dreaming, but she could also pass for dead – perhaps the unhappy outcome of childbirth.

The grey steed on the other hand – in fact, there are two – gallops on, the speed suggested by its extended limbs and the swoosh of its tail. The golden hair of the angel stands on end, swept up in the wind. The figure on the second horse is recognizable as Urizen, the embodiment of reason. During the Enlightenment, Blake railed against reason and instead celebrated freedom and the imagination. In his case imagination was something richer and more vivid than usual, and entirely strange.

+ ARTIST BIO
British, 1757–1827

+ SEE THIS
The tiny baby in *Pity* recalls Blake's *Albion Rose* (c. 1793), which also shows a naked figure with outstretched arms, this time surrounded by a kaleidoscope of colour.

+ VISIT THIS
The Flea (c. 1819–20), inspired by one of Blake's most unsettling visions, is on view at London's Tate Britain.

+ READ THIS
Start with Blake's *Songs of Innocence* (1789) and *Songs of Experience* (1794).

Like This? Try These

→ Edward Dayes

→ Henry Singleton

→ John Varley

Diego Rivera
Dream of a Sunday Afternoon in Alameda Park
1946–47

This Surrealist tableau cobbles together dreams and nightmares from several periods of Mexico's history. The ghostly gathering takes place in Alameda Park, a popular spot built on the site of an ancient Aztec marketplace that's vividly portrayed with a lush Latin American palette of yellows and greens. Assembled in the park is an assortment of political figures and those Rivera held dear.

The mural unravels a complex and turbulent history, beginning on the left with the conquest and colonization of Mexico and moving through years of Spanish rule, war, dictatorship and the revolution of 1910 until, at last, on the right we reach the stability of the mid-twentieth century. Among the historical figures present are the Spanish conquistador Hernán Cortés (clapping his hands on the far left), the long-term dictator Porfirio Diaz (to the right of the hot-air balloon, with snow-white hair and a matching beard) and the liberal Francisco I. Madero (visible between the branches on the right, tipping his hat).

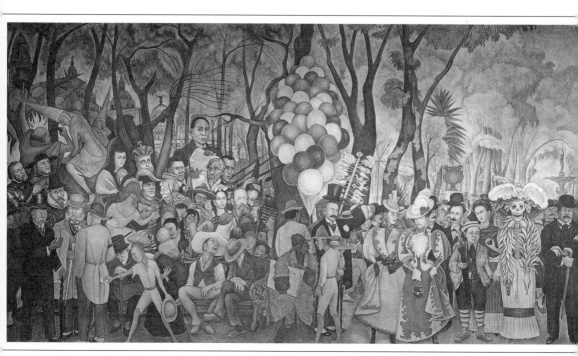

'The mural is about my memories,' said Rivera, who stands at the centre as a young boy, wearing striped socks and a straw boater. Behind him is his wife, Frida Kahlo (see page 66), resting one hand on his shoulder and clutching in the other a yin-and-yang object – a symbol of her rocky relationship with the renowned muralist and philanderer. Looming large beside them both is La Calavera Catrina, the dapper skeleton used to mock Mexico's fin-de-siècle elite, created by the political cartoonist José Guadalupe Posada (to the right, dressed up in a suit and bowler hat).

Rivera's mural was commissioned for Mexico City's Hotel del Prado, where it remained for forty years; in 1985 an earthquake destroyed the hotel but somehow spared the mural. It's a tribute to the country's past that twists and travels in time and, despite the setting, it's hardly a walk in the park.

+ ARTIST BIO
Mexican, 1886–1957

+ VISIT THIS
Rivera's mural now resides in Mexico City's Museo Mural Diego Rivera.

+ READ THIS
Hugh Thomas's *The Conquest of Mexico* (1993) charts how and why the conquest happened.

Like This? Try These

→ Gerardo Murillo

→ David Alfaro Siqueiros

→ Remedios Varo

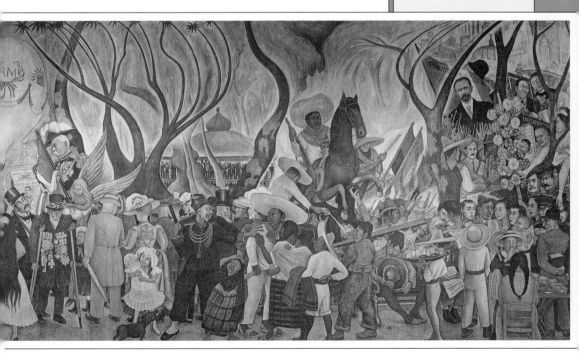

Like This? Try These

→ Émile Henri Bernard

→ Eugène Carrière

→ George Frederic Watts

Odilon Redon
The Eye Like a Strange Balloon Mounts Toward Infinity
1882

One of the great skills of any artist is to imagine a new world – and what a world Redon, the mystical French painter, dreamed up. He was fascinated with darkness and the unseen forces bubbling away beneath the surface of our daily lives. In his art, he untangled and laid bare a mysterious web of shadows concealed in the waking hours.

A globular eye floats in mid-air, its cornea trained on the heavens above. The upper lashes resemble a soft halo, while those below are stretched taut and attached to a what looks like a basket but is in fact a skull. The single eye is an age-old symbol with roots in Christian iconography: traditionally it represents the all-seeing eye of God. Enlarged and ferrying the dead, Redon's weightless organ is a spirit rising up from a dank swamp.

An individualist in nineteenth-century Paris, Redon rejected the realism of his Impressionist contemporaries and instead relied on his own imagination to create ghostly works. He seemed to exist in his own realm – far away from that of Claude Monet (see page 211) and Edgar Degas (see page 132), with their ballerinas and boats – and yet there remains some realism in his otherworldly handiwork. The modelling of his eye is convincingly three-dimensional, and a sense of perspective is achieved via fauna in the foreground and rolling clouds on the horizon.

It was in the 1860s that Redon began making lithographs, composing images with swathes of light and dark. Here the floodlit sky evokes the supernatural, while the darkness below nods to a shadowy underworld. Lithographs were easy to reproduce, and therefore distribute, allowing Redon to spread his dream worlds far and wide.

L'œil, comme un ballon bizarre se dirige vers L'INFINI.

OUT OF THE ORDINARY

Mary Cassatt

Little Girl in a Blue Armchair

1878

This was one of ten paintings that Cassatt – an American artist and another pivotal figure of the Impressionist movement – displayed in her debut at the Impressionist exhibition of 1879. It's a tour de force that captures both stasis and movement, as well as the natural experience of being a child.

A little girl in a white dress and tartan shawl is slouched in an armchair – either bored or worn out – with her feet dangling well above the floor. Fast asleep on the chair beside her is a fuzzy black-and-tan dog. In contrast, the room is full of energy, the texture and floral pattern of the turquoise upholstery brought to life by light filtering in through glass doors. Even the pebble-grey carpet is enlivened by brisk brushwork.

It was Edgar Degas (see page 132) who invited Cassatt to join the Impressionists after her work was rejected by the Paris Salon of 1877. In fact, he supposedly contributed to this canvas, and the girl was the daughter of one of his friends. Both were fond of Japanese prints, the influence of which can be seen in Cassatt's asymmetrical arrangement of furniture – which adds to the sense of discord – and the elevated vantage point. She went on to become one of the first Impressionists to exhibit in the US, extending the movement's reach abroad.

In this one image, Cassatt illustrates the peaks and troughs of childhood. The pose of the little girl, who slumps with her legs spread, pays tribute to a young person's lack of self-consciousness. The casual brushwork could nod to a similar sense of ease, or might its brisk application – and that jumble of oversized furniture – hint at the girl's fast-approaching and unavoidably awkward adolescence? Either way, although her hair is neatly tied in a bow and her buckles are polished to a shine, Cassatt's little girl is anything but doll-like.

+ ARTIST BIO
American, 1844–1926

+ SEE THIS
Thérèse Dreaming (1938) by the French artist Balthus presents a more controversial – and sexualized – image of a young girl.

+ VISIT THIS
Several works by Cassatt, including *Little Girl in a Blue Armchair*, reside in the National Gallery of Art in Washington, D.C.

+ READ THIS
Marieke Lucas Rijneveld invites us to view the world from the perspective of a vulnerable ten-year-old girl in *The Discomfort of Evening* (2020).

Like This? Try These

→ Marie Bracquemond

→ Eva Gonzalès

→ Childe Hassam

Rachel Whiteread
House
1993

Whiteread has devoted her artistic practice to exploring the utterly familiar yet frequently overlooked, from everyday items (a hot-water bottle) and architectural features (a staircase) to an entire property. She casts the spaces in and around the objects rather than the objects themselves, and by doing so creates a ghostly record of their existence. In this case, the existence of the cast itself was short-lived: *House*, her best-known work, stood for roughly three months.

The site was Wennington Green, a patch of grass in Bow, east London. In the early 1990s the Conservative government was intent on creating a green corridor around the newly constructed Canary Wharf and the Blitz-scarred terraced houses here were among the first to be demolished. By the time the British sculptor got to it, there was only one still standing, and it too was condemned. Together with Artangel, an organization that inserts art into unexpected places, she was searching for a house to cast – and now she had found one at 193 Grove Road.

The three-storey property was pumped full of liquid concrete, then the external walls were removed to reveal the interior, complete with sealed rooms outlined with fireplaces and blank windows. The result was a weighty inverse representation of the house, an aching impression of domesticity. It was a death mask of sorts, a symbol of upheaval and destruction, but also a reliquary for its inhabitants and a reminder of a certain way of life in the East End.

Naturally, what some critics loved, others loathed, and the local council refused to extend its allotted stay for longer than the agreed eighty days. And so, like the house that inspired it, *House* was demolished. But the impact of this temporary monument still resonates today. By sculpting absence and the space inbetween, Whiteread sparks reflection on things that no longer exist – everyday things that, too often, we take for granted.

+ ARTIST BIO
British, b. 1963

+ SEE THIS
Before *House* there was *Ghost* (1990), a cast of a living room in a north-London bedsit.

+ VISIT THIS
In 2000, Whiteread's Holocaust memorial in Vienna was unveiled. The nameless library sits at one end of Judenplatz.

+ READ THIS
Mark Z. Danielewski's debut novel *House of Leaves* (2000) is a disturbing tale about a couple who move into a house that's larger on the inside than the outside.

Like This? Try These

→ Phyllida Barlow

→ Anthea Hamilton

→ Rebecca Warren

Robert Rauschenberg
Bed

1955

Rauschenberg was the first artist to turn his bed into a work of art. The landmark 'painting' – or so it's called, since it hangs vertically on a wall – is slender, about 2 metres (6 feet) tall and preserved in plexiglass.

A well-worn pillow has been stapled onto a cotton sheet, which is stretched across a wooden frame; the sheet is topped with a patchwork quilt (originally the property of a fellow artist, Dorothea Rockburne), peeled back as if inviting you to slip on in. But you'd probably rather not, partly because all of the above are smeared and splattered with paint – from cheery reds and ochres to drearier blacks and browns – as well as nail polish and what looks like stripy toothpaste.

The boundary-breaking artist got a kick out of creating art from more than oil paint and canvas. He collected mismatched everyday materials – scrap metal, found photographs, newspaper, lightbulbs, dirt, clay – and assembled them on boards. From the mid-1950s to the mid-1960s he took his mixed-media arrangements one step further, merging features of drawing, painting and sculpture and, in the process, changing other artists' ideas of the possibilities of all three. He called these hybrid objects 'Combines'.

Rauschenberg referred to *Bed* as 'one of the friendliest pictures I've ever painted', but there's something sinister about it, too. Some see it as a crime scene – the pulled-back quilt giving the impression that it's been abandoned in a hurry – while others think the crusty blotches of paste and polish make it look soiled and dirty. It's comic, too, referring to the blending of his work and home life – the pencil scribbles on the pillow nod to the work of one past lover, Cy Twombly (see page 56), and the reds, yellows and blues to that of another, Jasper Johns (see page 126). For Rauschenberg, art and life were intricately intertwined, limbs and all.

+ ARTIST BIO
American, 1925–2008

+ SEE THIS
Art history's most infamous bed comes courtesy of British artist Tracey Emin, who covered hers with condoms and cigarettes.

+ VISIT THIS
Rauschenberg studied at North Carolina's Black Mountain College, which is now a museum and arts centre.

+ LISTEN TO THIS
The composer John Cage said that Rauschenberg's all-white canvases inspired his silent piece of music, *4'33"* (1952).

Like This? Try These

→ Josef Albers

→ Marcel Duchamp

→ Susan Weil

Berthe Morisot

The Cradle

1872

Morisot's most famous painting shows one of her sisters, Edma, gazing pensively at her young daughter, Blanche. It's a tender portrait, cleverly composed – look at the diagonal line connecting Edma's gaze and arm with her baby's arm, held to her head in a similar position. There's a subtle sense of melancholy in the way Edma rests her chin in her palm and fiddles twitchily with one of the translucent drapes enclosing the cradle. What Morisot is getting at is the complicated mix of emotions a new mother might contend with.

Like her older sister, Edma was an artist, but when she married a naval officer in 1867, she became a mother and gave up her career. She continued to model for Morisot, who paints her in her bourgeois home, fashionably dressed in a blue frock fringed with feathery white, her hair swept back to reveal a black choker. The brushwork is intricate in places, loose in others, adding to the work's emotional depth and drawing in the viewer.

Morisot was a founding member of the Impressionist movement and a friend and colleague to Auguste Renoir, Edgar Degas (see page 132) and her brother-in-law Édouard Manet (see page 28). Her work was well received during her lifetime, then mostly overlooked – or disregarded as 'domestic' – until a scattering of shows in the new millennium. In 2019 the landmark exhibition *Berthe Morisot: Woman Impressionist* travelled around the world with the aim of reinstating her as an artist to be reckoned with. Now we just need to lose the word 'woman'.

Her work *is* domestic – but what does that mean, other than that it grapples with the pleasures and pressures of everyday life? Far from sentimental, *The Cradle* captures in paint Edma's feelings as she watches over her daughter – full of love, but also fatigue and maybe even boredom. It's an intimate portrayal of the psychological effects of marriage and motherhood.

+ ARTIST BIO
French, 1841–95

+ SEE THIS
Morisot's *Woman and Child on a Balcony* (1871–72) shows her other sister, Yves, with her daughter Paule Gobillard.

+ VISIT THIS
The Cradle and other paintings by Morisot hang in the Musée d'Orsay in Paris.

+ READ THIS
Sheila Heti's novel *Motherhood* (2018) follows the life of a thirty-seven-year-old woman who's tussling with the choice between having a baby and making art.

Like This? Try These

→ Marie Bashkirtseff

→ Henriette Browne

→ Edma Morisot

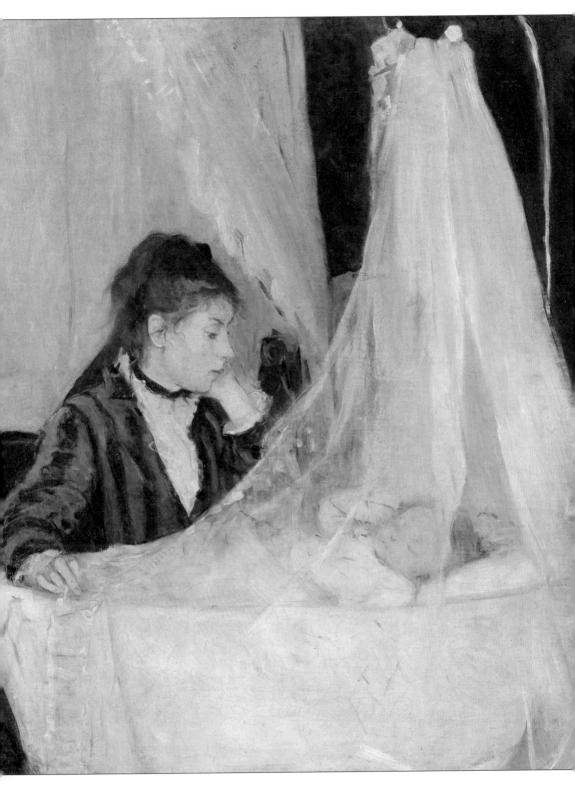

Chaïm Soutine
The Pastry Cook of Cagnes
1922–23

+ ARTIST BIO
Russian, 1893–1943

+ SEE THIS
Soutine's *Head Waiter* (c. 1927) depicts a self-assured maître d'. Working in one of Paris's plush hotels was something to be proud of – and he knows it.

+ VISIT THIS
The Barnes Foundation in Philadelphia houses some of the world's most astounding Impressionist, Post-Impressionist and modern paintings.

+ READ THIS
Ali Smith's novel *Hotel World* (2001) is set in a plush hotel in a northern English town. It's narrated by the ghost of chambermaid Sara Wilby.

Like This? Try These

→ Moïse Kisling

→ Jules Pascin

→ Georges Rouault

The oversized uniform on Soutine's gawky pastry cook hints at the rapidly expanding leisure industry workforce in early twentieth-century France. In the wake of the First World War, the number of international visitors checking into the grand hotels of Paris doubled – and the legion of liveried staff grew in turn.

After getting his big break when the American collector Albert C. Barnes purchased more than fifty of his works, Soutine – who arrived in Paris in 1913 as a penniless Jew from Russia – had his chance to frequent the glitzy piles on the Left Bank. But the painter was less interested in the affluent guests than in the overlooked characters attending to them.

Soutine's pastry cook is an awkward adolescent – this might be his first week on the job. He clasps his childlike hands in front of his milky-white jacket, the baggy chest and bunched-up sleeves of which suggest it was a hand-me-down. The expressionistic brushstrokes evoke the high-pressure environment of a fast-paced hotel kitchen – he's surely nervous about spillages. He perches on the edge of a wonky wooden chair, listening out for orders with his comically big ears.

It's not too much of a stretch to associate the butcher-red cloth in his hands and the bruised pinks and festering yellows of his fleshy face with the recently ended war. Though French commerce was booming, emotionally the country was in recovery. The livery worn by hotel staff at the time was historically inspired – a sign that many sought security in tradition after the brutal chaos of war.

Soutine created more than thirty portraits of the characters behind the classical façades of the fanciest Parisian hotels, and his frank and mysterious canvases reflect both the hotel boom and the anxiety surrounding French identity. By keeping the sitters anonymous, he reminds us that hotel staff, then and now, are asked to be always on hand but never in the way.

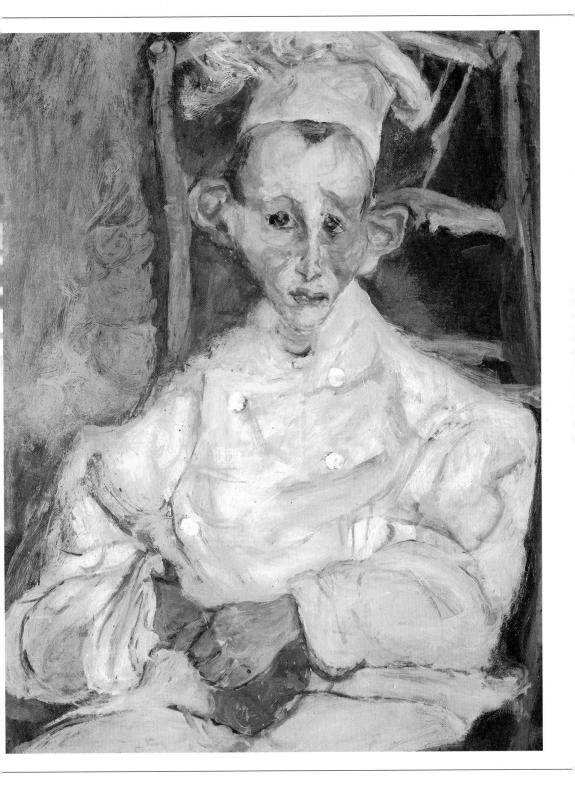

Johannes Vermeer

The Lacemaker

1669–70

+ ARTIST BIO
Dutch, 1632–75

+ SEE THIS
Young Woman Sewing (1655) by Nicolaes Maes also captured everyday life in the Dutch Golden Age.

+ VISIT THIS
For his entire life, Vermeer lived and worked in Delft, a city laced with canals in the western Netherlands.

+ READ THIS
Tracy Chevalier's *Girl with a Pearl Earring* (1999) – which was made into a film in 2003 – imagines the story behind the young woman in another of Vermeer's paintings.

Like This? Try These

→ Gerard ter Borch

→ Gerrit Dou

→ Pieter de Hooch

Vermeer is one of the greatest painters of everyday life. The thirty-five known works he created open a window on ordinary people in ordinary places, from a woman reading a letter to a servant pouring milk out of a jug.

Here a young woman in a buttery-yellow satin dress with a wide lace collar is absorbed in a painstaking task. Hunched over a triangular table, her fingers work away using bobbins, silvery pins and fine white thread. To her right is a small ribboned tome – the Bible, perhaps, or a pattern book.

In the same way that the lacemaker is engrossed in her dainty finger work, Vermeer hones in on intricate details: her plaited hair and loose ringlet, the play of light on her forehead, the red and white threads spilling out of a tasselled blue velvet sewing cushion, and the floral motif on the tapestry beneath it. The pale-grey background is devoid of decoration, which concentrates the focus on our protagonist, as does the scale of the painting, Vermeer's smallest.

He wasn't alone in his appreciation of the everyday. Instead of taking up the often bold and brash subject matter of traditional art, set on bloody battlefields or in fine palaces, he and his Dutch contemporaries depicted radically real domestic scenes. Their quiet and introspective paintings provided a sneak peek behind the façades of canal-side houses in seventeenth-century Holland, transporting the viewer into other people's kitchens and parlours.

Vermeer gives us a glimpse, too, of those people's inner lives. Are the lacemaker's cheeks rosy from her physical exertions or is she daydreaming about a lover – and making herself blush? Her appearance suggests she's a well-to-do young Dutch woman, who would have had to learn to sew and make lace as part of her upbringing. But looks can be deceiving – after all, what we're looking at is an illusion.

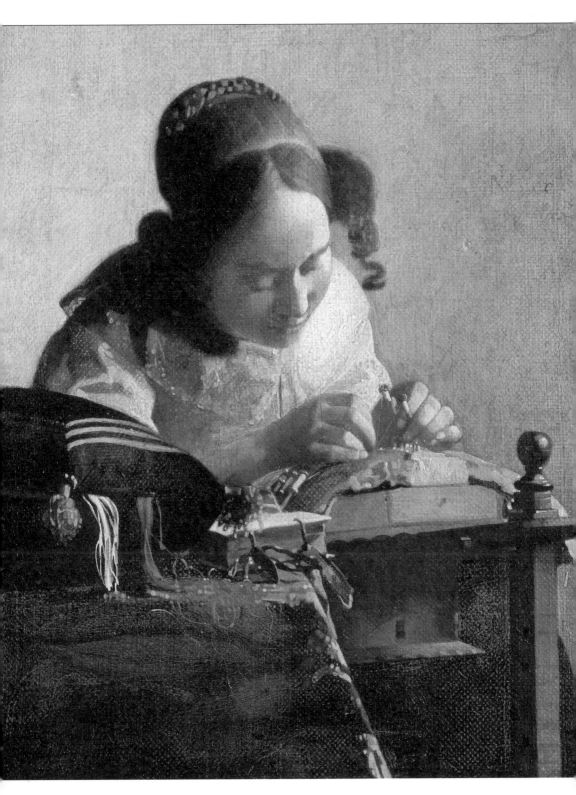

Jasper Johns

Flag

1954–55

Art history has its game-changers and Johns is one of them. One night the artist dreamed he would paint a big American flag, and the next morning he did. Unlike his contemporaries, who were expressing their emotions by splattering canvases with paint, he appropriated everyday objects – flags, targets, maps – and turned them into cultural icons, ushering in movements such as Pop art and Minimalism.

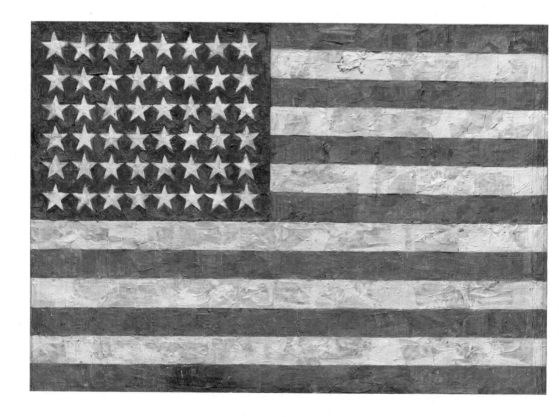

Johns's flag paintings – made using the encaustic method (an ancient art form in which pigment is mixed with molten wax) – are heavily worked visions in red, white and blue. Each painstakingly rendered star is different from the next, some shining brightly on the surface, others muddied beneath brushstrokes. The stripes are rich and creamy. Look closer and you'll glimpse fragments of photographs and headlines: the artist added newspaper clippings to create additional layers and weave day-to-day stories of his fellow Americans into his work.

The meaning is hard to fathom. Are Johns's flags proud banners of patriotism or fraught symbols of oppression? The artist himself was a former soldier and when he created his first flag in the 1950s the Cold War was in full swing. They're more substantial than those flying from front porches in the US, but they're also fixed in time – they'll never flutter in the breeze. In this sense, they have more in common with those draped over fallen soldiers' coffins.

Johns prompts us to think about what's real and what's not. He questions the role of representational art, which treads a fine line between illusion and reality. Whether his works are flags, paintings or sculptures, real or represented, they succeed in making the commonplace complex. They encourage us to see things we thought we knew by heart with a new sense of wonder, including American national identity and the act of making art itself.

+ ARTIST BIO
American, b. 1930

+ SEE THIS
Johns's *Map* (1961), a painted map of the US, is another great political work.

+ VISIT THIS
New York's Museum of Modern Art tried to acquire the artist's first *Flag* (1954–55) as early as 1958; it eventually succeeded.

+ LISTEN TO THIS
'Star-Spangled Banner' (1969), which Jimi Hendrix played at Woodstock, is also both reverent and revolutionary.

Like This? Try These

→ Marcel Duchamp

→ Frank Stella

→ Andy Warhol

Richard Hamilton

Just what was it that made yesterday's homes so different, so appealing? (upgrade)

2004

This 2004 print by the father of British Pop art is based on a collage he created in 1956 for the catalogue of *This is Tomorrow*, an exhibition held at London's Whitechapel Gallery that same year. Hamilton was avidly engaged with popular culture and modern technology, and this image – pieced together from American magazine cuttings – satirizes the consumer society of the 1950s.

Before us is a period suburban living room complete with a coffee table sandwiched between two sofas, a lamp and a few potted plants. The hoover, the tape recorder and the TV – which shows a woman in a pearl necklace nattering on the phone – were at the time state of the art, as was the view of the Earth projected onto the ceiling. On the wall is a framed comic strip and through the window we glimpse an American movie theatre, both also from a bygone era.

Is it such objects of desire that make yesterday's homes so different, so appealing? Or is the answer to Hamilton's question the residents themselves? The muscled man posing in nothing but his briefs, a phallic lollipop jutting from his hips, or his topless companion with a conical lampshade for a hat. Better yet, perhaps it's the uber-efficient housewife, who, together with her vacuum cleaner, has made it beyond the sign on the stairs that reads 'ordinary cleaners reach only this far'.

During his career, which stretched from the late 1940s to his death in 2011, Hamilton took the existing subjects of the day and reshuffled them. He believed that to understand something you had to make it, and here he seeks to comprehend the sudden influx in postwar Britain of manufactured goods from the US. Perhaps his naked bodybuilder and housewife are a modern Adam and Eve, succumbing to temptation. There was bound to be a backlash, and it seems Hamilton saw it coming.

+ **ARTIST BIO**
British, 1922–2011

+ **SEE THIS**
One of Hamilton's most well-known installations is the chaotic and colourful *Fun House* (originally built in 1956 and reconstructed in 1987).

+ **VISIT THIS**
This 2004 print can be found in London's Tate Modern. The original is in the Kunsthalle Tübingen in Germany.

+ **READ THIS**
Hamilton created more than 100 illustrations for James Joyce's *Ulysses* (1922), which he admired for its lack of resolution.

Like This? Try These

→ Roy Lichtenstein

→ James Rosenquist

→ Linder Sterling

Kitagawa Utamaro
Hairdresser

1797–98

The composition of this woodblock print is as beautiful as the subject matter. Cast your eyes over the two women, stacked one above the other, and you'll see smooth lines that sweep and swell across them. The curve of the hairdresser's chest continues down into her client's hair and both women draw their right hands across their bodies. All around them, their kimonos ripple like waves.

What we have here, of course, is a hairdresser standing over a client, craning her neck as she pulls a comb through a mass of fine hair. A master of the exquisite *ukiyo-e* (literally 'pictures of the floating world'), Utamaro created myriad images of women working, washing, waiting – the list goes on. *Hairdresser* is part of a series called *Twelve Types of Women's Handicraft*.

The whitened faces are devoid of detail – apart from angled eyebrows, pencil-straight noses, watchful eyes and little pink lips. Like the empty background, they appear in stark contrast to the vibrant kimonos – grey with floral designs and a hint of rose – and the women's long black hair.

The eighteenth-century Japanese artist portrayed his women – often courtesans and geishas – as pin-ups that command the space. He rose to fame in the west in the nineteenth century, when writers such as Charles Baudelaire began to buy his prints. Artists followed suit, though the prostitutes painted by Henri de Toulouse-Lautrec lacked the dignity that Utamaro afforded his.

His skill as a draughtsman shines through in the small variations that, upon closer inspection, materialize beneath the undulating lines. Look again at the two women and you'll see that the hairdresser's lips are parted, as if she's murmuring something to her client; you can even see a hint of tongue and two rows of tiny teeth. The image is also subtly erotic. As her hair is combed, the client delicately fingers the fabric of her kimono – and peering down at her, it looks like the hairdresser has noticed.

+ ARTIST BIO
Japanese, c. 1753–1806

+ SEE THIS
Eroticism isn't always so subtle in Utamaro's prints. See, for example, *Poem of the Pillow* (1788).

+ VISIT THIS
Utamaro was most likely born in Edo (now Tokyo), if you need an excuse to go.

+ READ THIS
Haruki Murakami's characters often start out in everyday environments before slipping into strange, dreamlike worlds. Begin with *Kafka on the Shore* (2005).

Like This? Try These

→ Torii Kiyonaga

→ Tōshūsai Sharaku

→ Harunobu Suzuki

Edgar Degas

Women Ironing

1884–86

Another man who loved to create images of women – and who, conveniently, collected prints by Kitagawa Utamaro (see page 130) – is Degas. The French artist showed his subjects dancing, bathing and, as seen here, ironing. As well as painting his family and friends, he found inspiration in women at work – from dressmakers to laundresses.

Two women in brown aprons stand behind a counter in a nondescript space. One presses down onto a heavy iron with both hands, using her body weight to exert extra pressure on the swathe of fabric before her, her red hair falling forward in front of her eyes. Her yawning companion, in a short-sleeved shirt and mustard shawl, appears to be taking a break. With her left hand she cradles the back of her head, stretching out a shoulder before stiffness sets in; with the other she clings to a bottle of wine, ready to take a swig.

As with his ballerinas, Degas was inspired by the rhythm of laundresses, who fell into two camps: *blanchisseuses* (the women who washed the clothes) and *repasseuses* (the women who ironed them). Many of his contemporaries were fascinated by the social status of these women, which was called into question by their long hours and loose clothing, not to mention the fact that they delivered freshly laundered clothes to private residences. Degas himself was more interested in the way they stood, the way they moved their bodies.

The speed with which he painted is apparent in the grainy surface – the result of applying oil paint directly onto an unprimed canvas. He sought to capture the fleeting gestures of these women, and by doing so achieved a depiction of the working class that's tender and real. *Women Ironing* pays tribute to the physical demands of the job, as well as the best ways to ease the pain.

+ ARTIST BIO
French, 1834–1917

+ SEE THIS
For a gender reversal, take a look at Gustave Courbet's (see page 12) *The Stonebreakers* (1849), which shows two men toiling at another backbreaking task.

+ VISIT THIS
There are four versions of *Women Ironing*. This particular one hangs in Paris's Musée d'Orsay.

+ READ THIS
In his novel *L'Assommoir* (1877), Émile Zola's working-class heroine Gervaise opens a laundry.

Like This? Try These

→ Jean-Louis Forain

→ Amedeo Modigliani

→ Richard Redgrave

TO THE BARRICADES

Kuzma Petrov-Vodkin

Fantasy

1925

This twentieth-century artwork verges on the ethereal. In front of a moody violet landscape, a scarlet horse gallops – or flies – across rolling hills. Astride the fiery steed is a peasant who, instead of gazing ahead at the dusky horizon, turns back towards the vanished world he's left behind. Petrov-Vodkin, little known outside his homeland, was one of several artists who lived through the turbulent aftermath of the 1917 Russian Revolution.

When Lenin and the Bolsheviks seized power, many artists were buoyed by the belief that the revolution would encourage artistic freedom and joined the cause. But it wasn't long before they realized that, rather than supporting avant-garde expression, the revolutionary idealism of the new government threatened to suppress it. For Lenin – and later Stalin – art was propaganda, a weapon wielded on behalf of the state. And yet there were still those who created works that, however quietly, continued to ask questions.

Petrov-Vodkin may have embraced the revolution, but his art was slyly subversive. Though his muscular horse is revolutionary red and leaping towards the future, it raises its head skywards – perhaps in protest. Its open mouth and turned-back ears hint at its discomfort; if you ignore the perspective, those front hooves appear to be on the brink of trampling the village. The peasant is not only riding bareback, he's also barefoot which, together with the deserted farmland, nods to those left destitute by famine, overwork and civil war.

The making of a new nation was always going to be something that artists wanted to be a part of, not least artists at the forefront of the avant-garde. It may be that Petrov-Vodkin regarded the revolution as a temporary yet tumultuous storm that had to be endured before a better life could be achieved. Nonetheless, there's a sense of nostalgia and despair, as well as hope, in this blazing work of art.

+ ARTIST BIO
Russian, 1878–1939

+ SEE THIS
Kazimir Malevich's (see page 54) *Peasants* (c. 1930) is also both joyful and sinister.

+ VISIT THIS
In 1932 the State Russian Museum in St Petersburg hosted the last major exhibition of the avant-garde before only propaganda was allowed.

+ READ THIS
Published alongside an exhibition at London's Royal Academy of Arts, *Revolution: Russian Art 1917–1932* (2017) charts the artistic landscape of post-Revolutionary Russia.

Like This? Try These

→ Natalia Goncharova

→ Wassily Kandinsky

→ Boris Kustodiev

Paula Rego

Angel

1998

Rego's *Angel* is a protector and an avenger, here to restore balance to the world and bring justice to those who have done wrong. She's beautiful in a rippling gold skirt and gleaming black bodice. She's formidable: in one hand she brandishes a sword; in the other she squeezes a sponge. Her head tilts knowingly to one side as she locks eyes with us, her mouth curled into a wry smile. A smile that will stick in your mind long after you've bid goodbye.

The Portuguese artist makes work that can be hard to look at. Unsettling, visceral, grotesque – any of those adjectives could be used to describe her paintings, prints and drawings. The work deals with knotty issues, including gender discrimination and political oppression, and focuses on painful subject matter, from sex trafficking to female genital mutilation. She explores the trauma and injustice experienced by other women, by herself, and by her country.

Rego was born in Lisbon and grew up under a military dictatorship before moving to London at the age of sixteen to study at the Slade School of Art. She's long been fascinated by fairytales – not those with happy endings, but the thorny kind – and she often uses them as starting points. Her work hasn't always been popular: viewers didn't understand the mix of Surrealism and painterly naturalism, and the painful themes were off-putting. Today she is widely admired and prominent among artists who use the body to highlight the experience of women and the sexism they endure.

Rego has said that she paints to 'give fear a face', and here that face is both bewitching and strange. Might the sponge, clamped tight, be a nod to the cramping wombs of women forced to seek out illegal abortion? Might the dagger reference the violence inflicted upon them? Rego's art lacks a neat and tidy resolution, and that's one reason why it stays with you.

+ ARTIST BIO
Portuguese, b. 1935

+ SEE THIS
With the *Abortion* series (1998–99), Rego campaigned for a change in Portuguese law.

+ WATCH THIS
Rego's son, the film-maker Nick Willing, made a BBC documentary about his mother's struggles with depression: *Paula Rego: Secrets and Stories* (2017).

+ VISIT THIS
The House of Stories in Cascais, a coastal resort on the outskirts of Lisbon, is dedicated to her work.

Like This? Try These

→ Frank Auerbach

→ Balthus

→ Jean Dubuffet

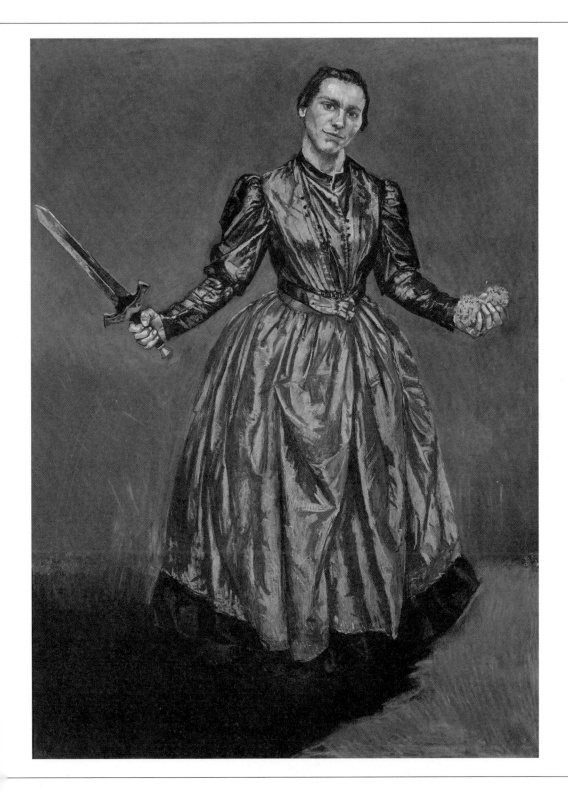

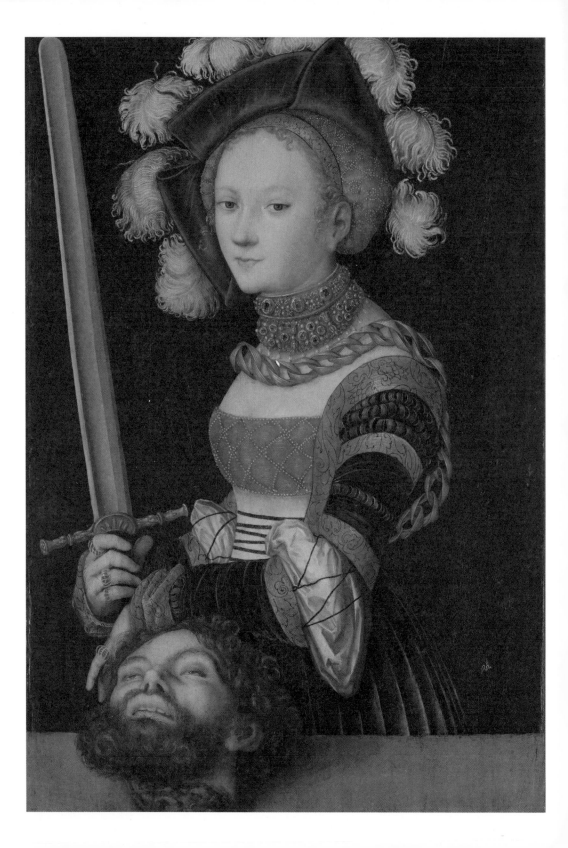

Lucas Cranach the Elder
Judith with the Head of Holofernes

1530

There's something amusing about this gruesome double portrait. Something in the pursed lips of our Jewish heroine, as if she's trying to contain a giggle, and the way she's brushing her fingertips through her victim's curly hair. This is Judith, a noble widow who – in order to save her city and fellow citizens – seduces, intoxicates and decapitates the Assyrian general leading the assault. Here she stands triumphant, presenting his severed head to us like a chef might a tasty plate of food in a restaurant.

The contrast between the biblical heroine (the story is lifted from the apocryphal Book of Judith) and Holofernes is stark. Hers is a serene beauty, marked by her pink cheeks and the golden ringlets poking out beneath her feathered velvet hat. She's finely dressed in emerald green and a tight bodice that was fashionable at the time. Around her neck are three heavily ornate necklaces and her fingers are decked with rings. Supposedly she put on her best clothes before entering the general's tent; you could say that she's 'dressed to kill'.

Holofernes, on the other hand, is a gory mess. His mouth hangs open, his eyes roll back in his head and a bloody tangle of muscles and tubes are visible in his neck. How the entirely unblemished Judith has managed to avoid any blood splatters is a miracle. Even the general's sword, which she used to kill him, is squeaky clean.

Cranach's visualization of this brutal tale is different from earlier depictions of the same subject, which tend to tiptoe around the sexual content. Sandro Botticelli's (see page 76) Judith, for example, is nothing if not demure, while Donatello goes to great lengths to ensure that his heroine isn't showing the slightest bit of flesh. Cranach's Judith is harder to read, which is what makes her such a powerful presence. After all, who knows what she might do next?

+ ARTIST BIO
German, 1472–1553

+ SEE THIS
Artemisia Gentileschi (see page 52) takes the drama one giant leap further in her two mighty paintings *Judith Beheading Holofernes* (c. 1611–12 and c. 1613–14).

+ VISIT THIS
Cranach and his workshop produced multiple versions of the work, one of which hangs in the Metropolitan Museum of Art in New York.

+ READ THIS
Luke Jennings's *Codename Villanelle* (2018), which was adapted for the screen as *Killing Eve* (debuted in 2018), traces the relationship between an MI5 agent and an alluring assassin.

Like This? Try These

→ Hans Cranach

→ Matthias Grünewald

→ Hans Maler

Eugène Delacroix

Liberty Leading the People

1830

Delacroix's *Liberty Leading the People* is the iconic image of the French Revolution – quite an extraordinary feat when you consider that the canvas doesn't actually depict the French Revolution of 1789, but rather a subsequent revolt in July 1830.

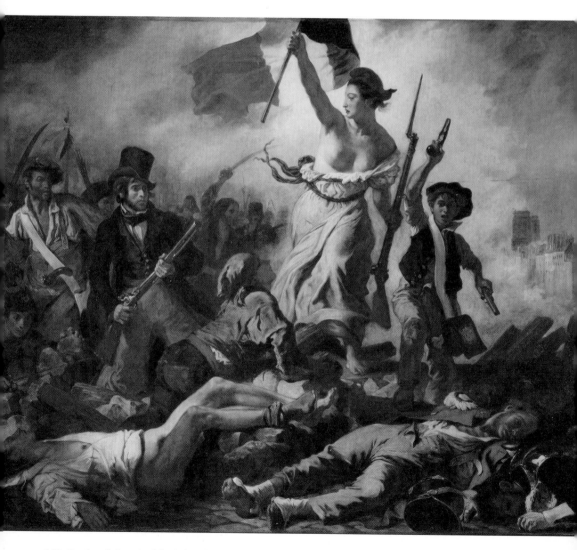

The subject is the Paris uprising that saw the ultra-conservative Charles X, the last Bourbon king of France, overthrown and replaced by the liberal Louis Philippe, Duke of Orléans. Here Delacroix captures the crowd of students, workers, intellectuals and grenadiers breaking through the barricades.

Leading the way is Liberty, personified by a barefoot young woman brandishing a musket and a fluttering French flag. Her yellow dress has slipped off her shoulders to reveal her breasts. Illuminated by natural light, she stands tall among the men, turning her head to encourage them as she strides forward.

Among the others are two street urchins: on the left a wide-eyed boy prepares to clamber over a pile of cobblestones, while on the right, holding a cavalry pistol in each hand, is the lad who likely inspired Victor Hugo to create the character Gavroche in Les Misérables (1862). The more rugged fellow kneeling on the ground, wearing a bohemian coat and top hat and clutching a double-barrelled hunting rifle, may be a friend of Delacroix's or even the artist himself. To his left is a factory worker, recognizable by his apron, and in front is another in a peasant's smock.

The pyramid-like composition seals the victory. At the base are fallen soldiers, lying either face down or flat on their backs. Flashes of blue, white and red flit across the canvas, from several white shirts to a pair of blue socks and a blood-red belt. In the distance are the towers of Notre Dame, the bell of which was rung by the students earlier that day. As the sun sets over the city, light mingles with gun smoke, adding a touch of romance to this political masterpiece that combines reality and dreams and, above all, represents the fervour of revolution and freedom.

+ ARTIST BIO
French, 1798–1863

+ SEE THIS
Théodore Géricault's Raft of the Medusa (1819) adopts a similar pyramidal structure and is also imbued with a mix of allegory and reality.

+ VISIT THIS
Liberty Leading the People hangs in the Louvre in Paris, in a gallery that's devoted to great French history paintings.

+ READ THIS
Notre Dame was established as a symbol of liberty and Romanticism in Victor Hugo's Notre Dame de Paris (1831). For a literary take on revolution, check out Hugo's Les Misérables (1862).

Like This? Try These

→ Caspar David Friedrich

→ Théodore Géricault

→ Francisco de Goya

Jacques-Louis David
The Death of Marat
1793

This image of the French Revolution by the history painter David is a world away from Eugène Delacroix's canvas of camaraderie and a common good (see page 140). Here we have the aftermath of a political assassination – a tragic scene, tender and solitary.

Jean-Paul Marat was an outspoken journalist and a radical political theorist whose attacks on powerful individuals and groups made him a target. He was one of the leaders of the French Revolution and a friend of David, who himself was an active militant and the 'official artist' of the Revolutionary Government. In fact, it was the government that commissioned the artist to paint a commemorative portrait just months after Marat's death.

He lies alone in his tomb-like tub. He's been stabbed by a young woman called Charlotte Corday – also a revolutionary, but a member of another faction. In his left hand he clasps the petition she had handed him just moments before plunging a knife into his chest; in his right hand is a freshly dipped quill. The bath water is blood red.

David was instructed to present Marat as a hero and a martyr who died for his cause and, as a result, the scene is idealized. Light shines on the protagonist, who despite his chronic skin condition (the reason he often soaked in his bath) is blemish free. David eliminated Corday from the scene, despite the fact that she made no attempt to flee, and moved the bloodied knife from flesh to floor.

A bathtub may be a less noble setting for a death than a battlefield, but with his trademark neoclassical style David instills the painting with dignity and grace. The geometrical composition – the white sheet, the green blanket, the makeshift wooden table – creates a sense of order, while the minimalist backdrop mutes the drama. The overall effect: a politically charged portrait that also serves as a memorial.

+ ARTIST BIO
French, 1748–1825

+ SEE THIS
The artist Robert Wilson has recreated several famous paintings with celebrity subjects. In his *The Death of Marat* (2013), Lady Gaga plays the assassinated revolutionary.

+ VISIT THIS
After the defeat of Napoleon in 1815, David moved to Brussels where he died a decade later. *The Death of Marat* resides in the city's Musée Oldmasters.

+ READ THIS
The French Revolution is brought to life in Charles Dickens's *A Tale of Two Cities* (1859).

Like This? Try These

→ Antonio Canova

→ Antoine-Jean Gros

→ Nicolas Poussin

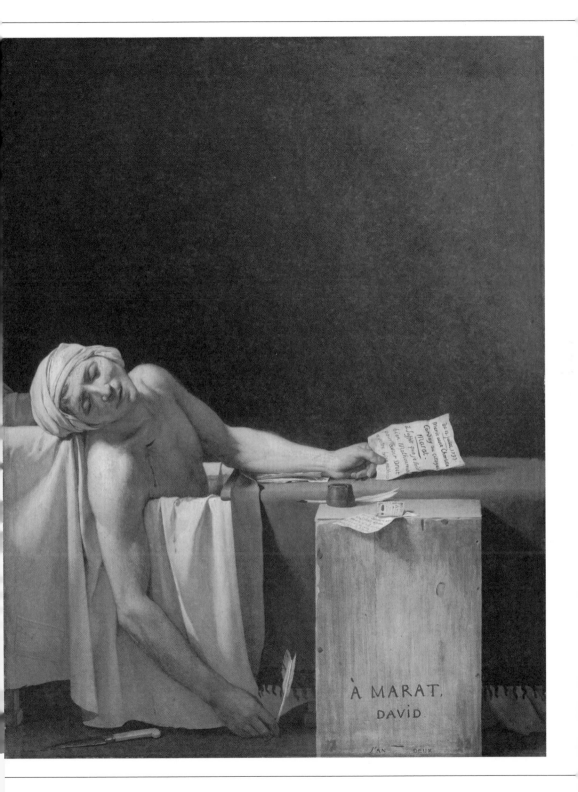

À MARAT.

DAVID.

L'AN DEUX

Hannah Höch

Cut with the Kitchen Knife Dada Through the Last Weimar Beer-Belly Cultural Epoch of Germany

1919–20

Höch's works of art are as beautiful as they are anarchic – and none more so than this, her largest and most famous photomontage. Here the artist splices together images of military leaders, cabaret dancers, acrobats, her fellow artists in Berlin's Dada movement, loaded guns and machine parts to create a jumbled assault on the failings of the Weimar Republic, as well as the role of women in postwar Germany.

Crowded into the top right-hand corner are the malignant forces of 'anti-Dada': moustachioed military men and stern-faced government officials. Below are artists and communists – in other words, radicals. And throughout are celebrated women, from athletes to actresses, who inject the work with energy and movement. Juxtaposition is rife, with the heads and bodies of men, women, animals and machines crossbred. In the bottom right-hand corner is a map of Europe, with the few countries in which women could or would soon be able to vote highlighted; by placing a self-portrait head on the edge of the map, Höch aligned herself with the empowerment of women.

The Nazis branded Höch a 'degenerate' artist and banned her work. Even the Dadaists tried to exclude her, most likely because she was a woman. And yet, she was a pioneer of photomontage, the technique of cutting and pasting together images from mass media that she developed in 1917 together with her lover and fellow Dadaist, Raoul Hausmann. According to their colleague George Grosz, the technique allowed them to say 'in pictures what would have been banned by the censors'.

The Dadaists used photomontage to protest against contemporary cultural politics. They were able to manipulate and dismember bodies and, more importantly, distort and reframe what the establishment did and said. But Höch's art was more than an attack on politics; it was a powerful commentary on family and gender, and an attempt to uproot socially constructed roles of women.

+ ARTIST BIO
German, 1889–1978

+ SEE THIS
The ready-mades of Marcel Duchamp, Dada's forefather, were part of the movement's assault on high culture – *Fountain* (1917) being the most famous example.

+ VISIT THIS
The Berlinische Galerie in Berlin has an extensive collection of Höch's works.

+ READ THIS
Children can enjoy the artist's photomontages in her *Picture Book* (1945).

Like This? Try These

→ George Grosz

→ Raoul Hausmann

→ Kurt Schwitters

Jean-Michel Basquiat
Furious Man
1982

Even without knowing the context of this chaotic work, you can get a rough idea of its meaning. The portrait shows a black figure holding up his hands as he emerges from a fiery blaze into a mass of obscuring grey. Rendered in Basquiat's trademark faux-naïve style, the figure is frantic, with bloodshot eyes, gnashing teeth, sticking-up hair and pitchfork arms. Is this surrender, alarm or aggression? Is this a victim or an antagonist? Crosshatched across the gaunt body are off-white lines that call to mind bones or bars.

Basquiat fought hard to break away from the stereotype of the noble savage and here he projects his fears and anxieties about black identity onto the *Furious Man*. The electric canvas was painted around the time that the underground graffiti artist emerged onto the international art scene as a fêted Neo-Expressionist whose work sold for tens of thousands of dollars; the golden halo, spiked with red, nods to the curator Henry Geldzahler's comment about his work comprising 'royalty, heroism, and the streets'. Basquiat was aware of his identity as a successful black artist within a mostly white history of art, and here he depicts himself as both the contemporary art world's king and mascot. The background is composed of crude lines and graphic markings that echo his feverish mental state.

In each of his anguished figures, he wove together autobiography, black history, popular culture and moral truths. His art holds a mirror up to the traumas of everyday racism and the psychological effects of a rocket-like rise to fame. Basquiat's career was remarkable but also remarkably brief – he died at the age of twenty-seven from an accidental heroin overdose – and even when he had money in his pocket and paintings in galleries, he had trouble hailing a taxi.

+ ARTIST BIO
American, 1960–88

+ SEE THIS
In his politically charged 1983 painting *Defacement (The Death of Michael Stewart)*, Basquiat depicts the untimely death of a fellow artist at the hands of the police.

+ LISTEN TO THIS
Until his art took off, Basquiat played guitar in a band called Gray.

+ WATCH THIS
A jack of all trades, Basquiat also played the lead role in the film *Downtown 81* (2000), which was shot between 1980 and 1981 and loosely based on his life.

Like This? Try These

→ Willem de Kooning

→ Cy Twombly

→ Andy Warhol

Paolo Uccello

The Battle of San Romano

1438–40

Like This? Try These

→ Fra Angelico

→ Masaccio

→ Domenico Veneziano

War can be bloody, but here it's beautiful and bold. In the midst of the Tuscan countryside, lances are raised and trumpets sound. This is, as the title states, the battle of San Romano – an important victory in Florence's war against Lucca, Milan and Sienna. In fact, it's one of three vast scenes painted by Uccello in the 1440s – all of which show episodes from the battle on 1 June 1432 and highlight key moments in the Florentine victory.

The 3-metre (10-feet) wide tangle of action is tricky to follow, but what we have here is the finely dressed Florentine commander Niccolò da Tolentino leading an attack. His white horse rears up and he, finely dressed in a patterned turban, raises his sword. Above him is his personal emblem, the Solomon's knot, embroidered on a banner held high by his standard bearer. All around are heavily armoured troops, as well as a blonde pageboy who carries his master's helmet.

Uccello's war is a work of art. The golden medallions on the horse's harnesses echo the summer fruits and flowers blooming in the hedgerow. In the background, the colourful men with crossbows pop against the faded fields. The slender lances pierce the sky in unison, while the broken ones lie – much like pick-up sticks – at oblique angles on the ground. Even the dead body is neatly arranged.

The painting recalls the processional friezes of ancient temples, including the cavalcade of horses on the north side of the Parthenon. Far from a brutal combat, it's a decorative and courtly scene. The truth is, painted a few years after the battle took place, it was commissioned to showcase the sparkling Florentine victory rather than depict a blow-by-blow account of the conflict. Which explains why the knights and their prancing horses could just as easily be taking part in a tournament and why Da Tolentino, sitting serenely atop his doll-like steed, is wearing a velvet turban trimmed with gold instead of a helmet.

Guerrilla Girls

Do Women Have To Be Naked To Get Into the Met. Museum?
1989

The Guerrilla Girls' most recognizable work was sparked by a survey of New York's most recognizable museum: the survey found that less than five per cent of the artists in the modern galleries were women, while eighty-five per cent of the nudes in those galleries were female.

+ ARTIST BIO
American, group formed in 1985

+ SEE THIS
American artist Barbara Kruger's 1989 work *Untitled (Your body is a battleground)* also uses advertising strategies to draw attention to gender politics.

+ VISIT THIS
The National Museum of Women in the Arts opened at its permanent location in Washington, D.C. in 1987.

+ READ THIS
Art historian Linda Nochlin's landmark essay 'Why have there been no great female artists?' (1971) explores how women have been physically omitted from art history.

The poster features a reproduction of Jean-August-Dominique Ingres's (see page 36) notorious reclining nude *La Grande Odalisque* (1814), her face hidden by a gorilla mask. The work was designed as a billboard for the Public Art Fund but rejected due to its apparent lack of clarity; the group then ran the advert on buses, until the bus company decided it was too suggestive.

There has never been a dearth of female artists; however, until recently they've struggled to achieve recognition. Museums didn't deem it necessary to collect artwork by women; absent from those hallowed halls, their work didn't fetch much money on the market; consequently, museums (once again) didn't feel the need to acquire it. The Guerrilla Girls sought to break this cycle of omission by using the arresting techniques of advertising and propaganda. Their posters combine bold text with hard facts and a touch of humour.

This anonymous group of American female artists and activists first stepped into the spotlight in 1985 with a polemical poster campaign prompted by an exhibition at another New York museum. *An International Survey of Painting and Sculpture*, held at the Museum of Modern Art the previous year, included work by 169 artists, of whom less than ten per cent were women.

Over the past few years, public art institutions and dealers have begun to redress the widespread gender imbalance in their collections, but there's still a way to go before the art world reflects the diverse society we live in. How can we help? Pitch up to a temporary exhibition of a hugely talented but horribly overlooked woman artist – and let the ticket sales speak for themselves.

Like This? Try These

→ Judy Chicago

→ Margaret Harrison

→ Jenny Holzer

ve to be naked to
he Met. Museum?

n 5% of the artists in the Modern
Art sections are women, but 85%
of the nudes are female.

GUERRILLA GIRLS Box 1056 Cooper Sta. NY, NY 10276
CONSCIENCE OF THE ART WORLD

Nancy Spero

P.E.A.C.E., Helicopter, Mother + Children

1968

Spero found inspiration in political causes and global injustices. Some of her best art is filled with fury and furnished with bloody bodies, severed limbs and howling heads. A staunch feminist, she campaigned for greater recognition of women artists and denounced the traditional male medium of oil on canvas in favour of gouache, ink and collage on paper. She was also an anti-war activist who created works that critiqued the US government's military actions in Vietnam, lifting nightmarish images and headlines circulating in the news and incorporating them into her practice.

P.E.A.C.E., Helicopter, Mother + Children is one of many works on paper that Spero made in the 1960s in response to the US involvement in Vietnam. Blazing against a blank background is a burnt-red helicopter and floating dangerously close to its whirring rotor blades is an inky impression of a mother and child. The words 'peace', stencilled around the latter, nod to the double-speak sounding from the Pentagon at the time. 'I thought the terminology and slogans like "pacification" coming out of the Pentagon were really an obscene use of language,' said Spero. 'They would firebomb whole villages and then the peasants would be relocated into refugee camps....'

Spero described *The War Series* (1966–70) as 'a personal attempt at exorcism'. She created more than 150 quick-fire works throughout the war, her rage still fiery, her wit unerring. Later, she made more exuberant art that focused solely on images of women – frieze-like panels feature female figures past and present, from burlesque dancers to sirens and pagan goddesses – but it's these early, public-minded works that stick in the mind. They may not offer much in the way of solutions to the suffering in the world but, much like the horror of war, they're unforgettable.

+ ARTIST BIO
American, 1926–2009

+ SEE THIS
Spero's *Codex Artaud* (1971–72) is a vast work filled with figurative imagery.

+ WATCH THIS
The documentary *Woman as Protagonist: The Art of Nancy Spero, 1993* (1993) explores the artist's life and work.

+ READ THIS
Nancy Spero (1996) by cultural theorist Jon Bird charts her development from the 1950s.

Like This? Try These

→ Antonin Artaud

→ Leon Golub

→ Nalini Malani

NATURAL WONDERS

Anthony van Dyck

Self-Portrait with a Sunflower

1632–33

This self-portrait, one of many Van Dyck created during his short life, is highly theatrical, a study in light and dark.

The Flemish painter stands on the left, expensively dressed (he was the son of a haberdasher) in a shimmering rosy jacket and bright white undershirt. He turns his head towards us, soft curls framing his face, lips unsmiling but moustache curling upwards. With one hand he fingers an opulent gold chain; with the other he points towards a glorious sunflower, its petals kissed by the light. In the background, a second, smaller sunflower closes up beneath clouds that swell against a dark sky.

The meaning of the self-portrait is unclear, as is the question of whether Van Dyck painted it for a patron or, somewhat self-indulgently, for himself. It's one of three self-portraits he made in England, where he lived for seven and a half years. During that brief stint he changed the course of British portraiture, ridding it of the formal approach characteristic of Tudor and Jacobean painting and replacing it with a more exuberant and emotional style. He was embraced by the English court, whose values he projected in elegant portraits, and in the two years it took him to make this work he was knighted by Charles I, his most famous patron, who gave him a gold medallion on a chain.

Van Dyck basks in the golden glow of the big, blooming sunflower before him – a symbol, perhaps, of the fact that his career has come to fruition and he's enjoying fame and success. The smaller, closed-up flower behind could represent his younger self, before he matured. In any case, the portrait is surely as much an ode to his talent as an artist as it is an ode to nature – a natural talent, if you will.

+ **ARTIST BIO**
Flemish, 1599–1641

+ **SEE THIS**
'The sunflower is mine,' declared Vincent van Gogh (see page 162), who created several paintings of them between 1888 and 1889.

+ **VISIT THIS**
Van Dyck was born and raised in Antwerp, where his talent was recognized early on by the great Peter Paul Rubens.

+ **READ THIS**
Self-Portrait with a Sunflower appears on the cover of Robin Blake's comprehensive 1999 biography *Anthony Van Dyck: A Life 1599–1641*.

Like This? Try These

→ Jacob Jordaens

→ Clara Peeters

→ Frans Snyders

Yayoi Kusama
PUMPKIN [WUTIU]
2018

Some artists stick to a certain style throughout their career. Others never stray far from a particular palette. For Kusama, it's all about compulsively repetitive patterns and images – more often than not, polka dots and pumpkins.

Like most of her work, this intricate piece flits between figuration and abstraction. The pumpkin floats in front of a decorative backdrop that vaguely resembles netting. There's something comical about the gourd's bulbous bodily form and its top hat-like stem. Stare for long enough at the rhythmic dots that bloom and wither on each lobe and the pumpkin will begin to pulse before your eyes. The experience is both therapeutic and disconcerting.

The celebrated Japanese artist suffered from hallucinations as a child and has been fascinated with inner vision and optical illusions ever since. Pumpkins are for her a source of comfort, partly because she grew up with them. They first cropped up in her work in the 1940s, before she moved to Kyoto to study at the Kyoto Municipal School of Arts and Crafts. Drawn to its postwar art scene, Kusama then moved to New York in 1958 and swiftly made a name for herself with her *Infinity Nets*, a series of abstract paintings composed of obsessively repeated brushstrokes. She then combined them with the pumpkin motif in various media and colour variations.

By the time she exhibited *Mirror Room (Pumpkin)* (1991) in the Japanese pavilion at the forty-fifth Venice Biennale, Kusama was back in Japan – living by her own choice in a psychiatric hospital – and the pumpkin was truly embedded in her practice. And yet, it was with this mirrored shrine in which rows of yellow-and-black gourds are infinitely reflected that she truly caught, and retained, her audience's attention. The meaning of it all is hard to fathom, but the hardiness of a pumpkin's skin seems significant. And perhaps those trademark polka dots can be seen as an ellipsis….

+ ARTIST BIO
Japanese, b. 1929

+ SEE THIS
Kusama's predilection for pumpkins is akin to Andy Warhol's penchant for the Campbell's Soup can.

+ VISIT THIS
In 2017, the five-storey Yayoi Kusama Museum opened in Tokyo.

+ READ THIS
The artist tells her own story in *Infinity Net: The Autobiography of Yayoi Kusama* (2010), translated by Ralph McCarthy.

Like This? Try These

→ Takashi Murakami

→ Yoshitomo Nara

→ Yoko Ono

Mary Moser
Flowers in a Vase, Which Stands on a Ledge
undated

Don't be tempted to dismiss floral painting as woman's play. Quite the opposite, Moser – the principal flower painter of the eighteenth century – was following in the footsteps of accomplished botanical artists such as Richard Earlom and Thomas Green. Floral work required patience and precision, and an artist's ability to succeed in it was a mark of great skill. It's also about much more than decoration.

This luminous watercolour shows a Grecian urn overflowing with closely observed blooms. Buttery-yellow daffodils jostle with pinky-white clematis and vibrant red tulips. Forget-me-nots add a splash of blue, while greenery elbows its way up and over the lip of the vase. Then there are the wilting marigolds and parched anemones languishing at its base, their petals curling and turning crisp.

Cut flowers bring joy, yes, but that joy is short-lived. A week on – more or less, depending on the flowers – and the natural world you've brought into your home is dying a slow death. It's this process that Moser captures here, most of her flowers thriving, but some verging on overripe. Even the petals of those tulips appear to be unfurling, like cuticles peeling back from skin. Teetering between beauty and decay, no wonder the artist placed them on a ledge.

Moser was trained by her father, the Swiss artist George Michael Moser, and won her first Society of Arts medal for her flower drawings at the age of fourteen. With her aptitude for floral work, she received several royal commissions and became drawing mistress to Princess Elizabeth. She also became the youngest original founding member of London's Royal Academy of Arts – in fact, alongside Angelica Kauffman (see page 180), she was the only woman admitted for more than a century. That she has been largely forgotten by art history, her works faded from view, is nothing short of baffling.

Like This? Try These

→ Maria Cosway

→ Angelica Kauffman

→ Laura Knight

Vincent van Gogh

Irises

1889

A dose of nature can be good for you, we're told, and that's what Van Gogh got when – after cutting off his ear on 23 December 1888 – he became a patient at a small psychiatric hospital on the outskirts of Saint-Rémy de Provence in southern France. There, in the last year of his life, a period of deep anguish but also unbridled creativity, he made nearly 130 dazzling works. Among the first was *Irises*, painted outside in the hospital garden.

+ ARTIST BIO
Dutch, 1853–90

+ SEE THIS
British painter and plantsman Cedric Morris bred irises, which he admired for their elegance. *Iris Seedlings* (1943) shows a pastel-coloured bouquet in a Chinese jug.

+ VISIT THIS
The Van Gogh Museum in Amsterdam is home to the world's greatest collection of works by the Dutch master.

+ READ THIS
In *The Yellow House: Van Gogh, Gauguin, and Nine Turbulent Weeks in Arles* (2006), Martin Gayford traces the run-up to Van Gogh's infamous act of violence.

This study from nature is one of four paintings of irises that Van Gogh created during his time in the asylum. A mass of blooms lean against one another, each one unique. The closely cropped composition, which is broken up into patches of luminous colour, nods to the decorative Japanese woodblock prints that the artist and his contemporaries admired so greatly.

Although a beauty – and one that Van Gogh's brother Theo described as 'full of air and life' – the work also evokes a sense of suffocation in its profusion of parts. The tangle of flowers twist and turn, overlapping and spilling over the edge of the canvas. In the background, another clump of orange flowers leaves no room for even a hint of sky. The space afforded to the reddish-brown soil in the foreground could arguably highlight the plants' dependency on other elements to survive. And then there are those expressive colours, which lend the work as a whole an otherworldly spark.

Van Gogh had long been troubled, experiencing dramatic highs and lows, but his year of confinement in Saint-Rémy de Provence was the most traumatic period of his life. His mental health steadily declined until, in 1890, at the age of thirty-seven, he committed suicide. The works he left behind, including those created in the hospital garden, combine true-to-life observation with his own passionate and dreamlike imagination.

Like This? Try These

→ Edvard Munch

→ Georges Seurat

→ Paul Signac

Lee Krasner
The Seasons
1957

An array of rounded elements jostle for space in this large-scale canvas, which is at once wholly abstract and enticingly figurative. Buds in lush shades of pink bloom and grow into ripe forms that swell and roil with a jumble of leafy green. Brown outlines sweep and curve across the painterly field, while little rivulets of paint drip defiantly across them.

Krasner's contribution to Abstract Expressionism was huge – and yet, scandalously, it was all but eclipsed by her husband, Jackson Pollock, whom she met in 1941 and whose meteoric career she went on to support. She was on her way to achieving recognition herself, but doing so as a woman in a male-centred establishment was hard. It was only after Pollock died in an alcohol-fuelled car accident in 1956 that she burst out with the works that would define her as an artist.

The Seasons is the climax of *Earth Green*, a series of seventeen works that Krasner began in the year of her husband's death. She relocated her studio from a small room in the couple's Long Island home to the big barn where Pollock used to work and began painting at night. With this newfound sense of freedom, the scale and immersive nature of her works soared. The result was exuberant and wild and secured her a retrospective at the Museum of Modern Art in New York in 1984, the first woman to be offered such a show.

Post-Pollock, Krasner had a chance to consider who she was as an artist, something we can see playing out in the strokes and sweeping movements of her long-handled brushes – she was just 1.5-metres (5-feet) tall – that flutter and dance across the surface of the canvas. Sometimes reckoning with personal trauma can lead to rebirth. Krasner harnessed the power of nature and applied it to her art, which is filled with fertile imagery – buds, breasts, vines – that captures the circle of life.

+ ARTIST BIO
American, 1908–84

+ SEE THIS
Pollock became famous for his drip paintings, which he created by pouring and splatting liquid household paint onto canvases laid out like rugs on the floor.

+ VISIT THIS
The Seasons hangs in New York's Whitney Museum of American Art.

+ READ THIS
Mary Gabriel's *Ninth Street Women* (2019) highlights the women in New York's postwar art scene.

Like This? Try These

→ Helen Frankenthaler

→ Elaine de Kooning

→ Joan Mitchell

Albrecht Dürer

Young Hare

1502

There's something strangely serious about this little hare – the downward slant of its brown eyes, the backward turn of its long but not yet full-grown ears. Its claws are sharpened to a point, its ultra-fine whiskers antennae-like, alert. Perhaps it's listening out for predators – or better yet, simply fed up with having to pose.

Dürer painted the creature in his studio, the window of which is reflected in its glistening right eye. While the sixteenth-century German painter and printmaker faithfully reproduced everything about the hare – from its fur, lying flat against its body and comprising several shades of brown as well as flecks of eggshell white, to its twitchy nose – he removed any suggestion of its surroundings. Instead, the hare perches in front of a non-existent backdrop; if it wasn't for the shadow, it could be floating.

The emptiness engulfing the hare makes the meaning of the watercolour hard to fathom. It also gives the animal a mystical quality, as if it's simply a figment of Dürer's imagination and might spring away at any moment. How did the artist manage to capture it in such hypnotic detail? The suggestion is that he produced quick sketches of it in various positions before attempting to pin it down with pigment.

Dürer was one of the first artists to create work based on observations from nature, and all – whether a piece of earth sprouting spindly blades of grass or the flamboyant plumage of a dead bird – are meticulous. In light of the current climate crisis, his fascination with the natural world seems particularly poignant – especially when you glance again at that gleaming eye and imagine that, like the hare in Dürer's studio, you're seeing the world for the first time.

+ ARTIST BIO
German, 1471–1528

+ SEE THIS
Dürer's woodcut of a fictional rhino with an armour-like hide, *The Rhinoceros* (1515), shaped public perceptions about the beast for two centuries.

+ VISIT THIS
Dürer's hare is one of the most popular pieces in Vienna's Albertina Museum, which is home to various works by the Renaissance artist.

+ READ THIS
The British potter Edmund de Waal's memoir, *The Hare with Amber Eyes: A Hidden Inheritance* (2010), tells a family story through the journey of a collection of netsuke.

Like This? Try These

→ Hans Baldung

→ Gustave Doré

→ Hans Dürer

Damien Hirst

Away from the Flock

1994

Hirst has given the traditional art form of still life new meaning. His lone lamb, caught mid-skip through spring fields, has been preserved in a formaldehyde-filled tank.

The bright-white frames offset the transparent turquoise solution, which hasn't tarnished the humble creature's white coat, still surprisingly fluffy. With its limbs extended, it seems to retain its bounce, which makes the work all the more poignant – tender as well as tragic. The contemporary British artist once said that he intended to illustrate the sad lives of animals and their limited choices – in this case, being eaten or stuck in a gallery.

Created as part of a group of sculptures called *Natural History*, *Away from the Flock* was shown at *Sensation*, the 1997 exhibition of bold and brazen work by the Young British Artists at London's Royal Academy of Arts. It was the first animal the artist froze in time; since then he's gone on to pickle several others, some intact, some skinned, some sliced in half. Most famous, perhaps, is *The Physical Impossibility of Death in the Mind of Someone Living* (1991), which shows a hulking tiger shark suspended in a steel-and-glass vitrine.

Hirst's art can be hard to swallow (*Away from the Flock* was famously vandalized with black ink) and a logistical nightmare for galleries and museums. And what about the ethical question mark dangling from each cadaver's lips? This is a controversial artist, whom you'll either love or hate, and one several critics accuse of simply setting out to shock for the sake of it. But maybe there's more to it. To Hirst, animal art is about human ethics and our refusal to accept mortality and decay. It's about exposing new ways of dealing with life and death. 'In a way, it's like putting an animal back together, instead of taking it apart,' he once said.

+ ARTIST BIO
British, b. 1965

+ SEE THIS
For art with a little more life in it, check out Hirst's 1991 installation *In and Out of Love (White Paintings and Live Butterflies)*.

+ VISIT THIS
There are three versions of *Away from the Flock*, one of which is in Edinburgh's National Galleries of Scotland.

+ READ THIS
The Penguin Classics edition of Charles Darwin's *On the Origin of Species* (2009) has a cover designed by Hirst.

Like This? Try These

→ Francis Bacon

→ Jeff Koons

→ Abigail Lane

Georgia O'Keeffe
Abstraction White Rose

1927

If not for the title, you might mistake this for a swirling plume of smoke. Better yet, perhaps you'd see in its subtly differentiated shades of blue and grey a stormy sky or a whirlpool. O'Keefe painted the physical world around her – from dry New Mexico hills to sun-bleached cow skulls – and she's best known for the magnified flower pictures that first made her popular in the 1920s.

O'Keeffe's oil paintings of stylized and enlarged flowers emerged from her more abstract work and continued to command her attention for almost two decades. She painted poppies in full bloom, velvety petunias, creamy lilies and dark irises. More often than not, she gives us a tightly cropped close-up – no doubt influenced by the photography of her husband, the photographer and gallerist Alfred Stieglitz. She draws our attention to the centre of these flowers and rids the canvas of any background that might detract from their beauty. Here, she captures the swirl of petals gently curving around a rose's heart. The subject flits enticingly between figuration and abstraction.

Gender stereotypes had their part to play in the interpretations of O'Keeffe's work. Many regarded her botanical forms as flamboyant expressions of female sexuality – a reading that Stieglitz encouraged, and that she later grew fed up with. Critics saw anatomy in the fleshy folds and upright stamens, despite the fact that, up close, any hint of sensuous imagery is dulled by the paintings' flat and graphic surfaces. In 1943, the artist said: 'Well – I made you take time to look at what I saw and when you took time to really notice my flowers you hung all your own associations with flowers on my flower and you write about my flower as if I think and see what you think and see of the flower – and I don't.'

+ ARTIST BIO
American, 1887–1986

+ SEE THIS
Alfred Stieglitz shot several intimate portraits of O'Keeffe, among them *Georgia O'Keeffe* (1918), which shows the artist in an open kimono staring directly at the camera.

+ VISIT THIS
Her lasting presence in northern New Mexico has prompted some guidebooks to refer to it as O'Keeffe Country.

+ READ THIS
Roxanne Robinson's biography *Georgia O'Keeffe* (1990) provides insight into the artist's long-lasting creativity.

Like This? Try These

→ Arthur Wesley Dow

→ Hilma af Klint

→ Agnes Pelton

Henri Rousseau

Tropical Forest with Monkeys

1910

Rousseau never left his native France – at least not physically. In his mind, he traversed dense jungles teeming with lush foliage and exotic animals.

This particular forest – a mass of leafy green splashed with giant red, yellow and violet petals – is inhabited by long-tailed monkeys that swing and scamper through the tall trees. In the background, an orange pair cling to stick-thin branches – one upright, the other upside down – like trained acrobats. Closer to us, a russet-coloured primate perches on a rock, toes dipped in a stream. It's clutching a reed that could easily be mistaken for a fishing rod and appears to be entirely unperturbed by the open-mouthed snake coiled around a trunk to the left.

For a brief stint, the self-taught French artist worked in a studio across the road from Paul Gauguin (see page 42) – yet unlike the Post-Impressionist, who travelled to Tahiti, Rousseau stayed close to home. A city dweller, he sketched the tropical plants in Paris's botanical gardens, as well as the caged animals in its zoo. He was also a frequent visitor of the Muséum National d'Histoire Naturelle, which opened in Paris in 1889 and displayed thousands of stuffed birds and mammals.

Rousseau's fantastical jungles may collate flora and fauna that don't belong together, not to mention disparate species, but there's something strangely seductive about them – the way they glimmer against a gallery wall and stick in your memory. His unconventional and illusory images found favour among early twentieth-century artists, not least the Surrealists. The appeal is enduring: many viewers today grew up reading Rudyard Kipling's The Jungle Book (1894), or at least watching the 1967 screen adaptation produced by Walt Disney. Just as Kipling inserted the man-cub Mowgli into his jungle, Rousseau invites us to roam through his.

+ ARTIST BIO
French, 1844–1910

+ SEE THIS
The artist painted The Dream (1910) in the same year. In it a naked woman lies on a sofa surrounded by a forest full of wild beasts.

+ VISIT THIS
The Jardin des Plantes in the centre of Paris is where Rousseau found much of his inspiration.

+ READ THIS
Charles Darwin's On the Origin of Species (1859) was published about fifty years before Rousseau painted his tropical forest and anthropomorphous monkeys.

Like This? Try These

→ André Bauchant

→ Camille Bombois

→ Séraphine Louis

Like This? Try These

→ Francis Bacon

→ Kitty Garman

→ Celia Paul

Lucian Freud
Girl with a Kitten
1947

Freud painted eight portraits of his first wife, Kathleen Garman, known as Kitty, between 1947 and 1951, and this is one of the most unsettling. You would think that paying attention to minute details – a cluster of eyelashes, the folds of a lower lip, wisps of hair – would make a work more realistic. And yet, Freud's razor-sharp precision threatens to sap his sitter of life.

Garman is shown against a beige wall clutching a kitten by its neck. She gazes blankly to the side, her stare cold and distant rather than tender, her knuckles turning white as she tightens her grip. There's a stark similarity between her and the young feline: both have the same wide, slightly upturned eyes, reflecting the light; Garman's straight dark eyebrows are mirrored in the kitten's markings; its pale paws, which look as if they've been dipped in cream, match her pallid fingers.

The portrait, which is closely cropped, exudes both fragility and strength. Garman's skin is like porcelain, tempting the viewer to reach out and tap it. She may not look particularly concerned as she half-strangles the kitten, with glazed-over eyes and parted lips, but she also doesn't look like she's enjoying it. The kitten, on the other hand, stares directly at us. In contrast with its handler's flyaway hair, its whiskers are unmoving.

Like many of Freud's uncompromisingly exact early portraits, *Girl with a Kitten* is almost too real, high definition. The ironic effect of such verisimilitude is that the sitter is stripped of her essence. The artist once said that his early portraits were the result of his 'visual aggression' with sitters, that he'd make both them and himself uncomfortable by sitting up close and staring. It's his merciless scrutiny that shines through here, far more than any feeling for his wife. And the endangered kitten? An omen, perhaps: this is a marriage that won't survive.

CHAPTER 9

THE BALANCE OF POWER

Raphael
Double Portrait

1516

Eye contact may be good for you, but it can also be painful. When we lock eyes with someone, we're making ourselves vulnerable – which is partly why, as soon as we set foot on public transport, most of us stare at our screens. Here Raphael gives us a glimpse of what it feels like to be truly seen. In *Double Portrait*, the Renaissance artist conjures in paint the power of a penetrating gaze.

Though their identities have long been contested, the general consensus is that the men before us are Venetian writers who most likely met Raphael during a visit to Rome. Their names are Agostino Beazzano and Andrea Navagero. (We don't know which is which.) The fellow with the beard oozes self-confidence. His long-haired companion is slightly less self-assured, with doe eyes, a chin dimple and a hint of a smile. Both look directly at us – sizing us up or asking, without asking, what we think we're doing here.

Raphael's palette is intense but masterfully balanced. The dark hats, hair and clothes of his sitters blend seamlessly with the background. Cutting through the shadows is the bright-white undershirt of the man on the right, as well as snatches of skin – glowing in the light. Note the highlight on the forehead of the figure on the left.

Depicted from their waists up, this pair resemble Roman busts, with a classical beauty that's reinforced by their air of composure. Neither one is talking, though their body language implies that they might have been before. Instead, they purse their lips as they turn to us. Like eye contact, silence can be hard for some people to handle. The fact that these two are unruffled by an extended pause suggests that they're great friends. It may also suggest that we've interrupted a private moment. But don't worry: if you start to feel uncomfortable, just pull out your phone.

+ ARTIST BIO
Italian, 1483–1520

+ SEE THIS
Raphael's *Portrait of Pope Julius II* (1511–12) is an altogether different experience. The melancholy pope casts his gaze towards the floor, which invites us to gaze at him free from restriction.

+ VISIT THIS
Take a stroll around London's National Portrait Gallery and you'll have plenty of opportunities to brush up on your eye contact.

+ READ THIS
The Norwegian adventurer Erling Kagge explores the elusive notion of silence in the smartphone era in *Silence: In the Age of Noise* (2017).

Like This? Try These

→ Melozzo da Forlì

→ Pietro Perugino

→ Giovanni Santi

Angelica Kauffman

Self-Portrait of the Artist Hesitating Between the Arts of Music and Painting

1794

Kauffman's career hangs in the balance in this vibrant eighteenth-century canvas. Set against a shadowy landscape, the composition centres on three illuminated female figures in action. The neoclassical artist herself stands in the middle, wearing a sculptural white dress, her arms open wide.

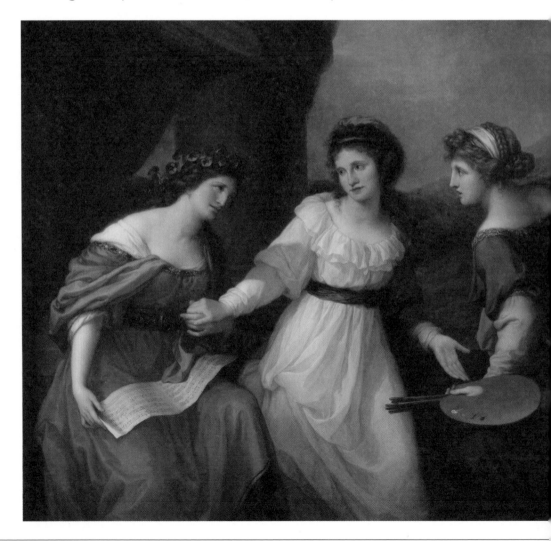

As a young woman she was both artistic and musical and in later life she looked back and dramatized her choice between the two professions: to the left is Music, a rumpled sheet in her hands; to the right, Painting, with a bundle of brushes and a palette daubed with colour. Both lean towards Kauffman, eagerly awaiting her decision.

Together with her contemporary, Mary Moser (see page 160), Kauffman was one of only two founding female members of London's Royal Academy of Arts; as shown in Johan Joseph Zoffany's group portrait (see page 194), painting was traditionally considered a male pursuit.

Here, the challenges women faced in the art world are symbolized in one dramatic gesture: Painting points to a temple at the top of a dark and craggy mountain cloaked in cloud, indicating the obstacles that Kauffman would have to navigate.

And yet, Painting is hard to resist. Unlike Music, she's dynamic – on her feet, lips parted, brows peaked. Her crimson sash swirls theatrically in the wind. In the eighteenth century, Music was the more 'feminine' art form – as shown by the demure nature of the figure on the left. She's sitting comfortably, her sash fixed in place, cradling Kauffman's hand in her own. But despite meeting Music's gaze, it's Painting that our protagonist is moving towards. The journey ahead may be rocky, but the young Kauffman pictured here clearly believes she has what it takes. She was right: by the time she painted this work, she was a prominent and progressive artist who created not only society portraits but also history paintings, the most elevated – and 'masculine' – genre there was.

+ ARTIST BIO
Swiss, 1741–1807

+ SEE THIS
In *Design* (1778–80), Kauffman depicts a female artist studying a classical cast – a nod to the fact that women were prohibited from drawing life models.

+ VISIT THIS
Self-Portrait of the Artist Hesitating Between the Arts of Music and Painting is on display at Nostell Priory, a National Trust property in West Yorkshire, UK.

+ READ THIS
An exhibition of Kauffman's work at the Royal Academy of Arts was cancelled in 2020 due to the coronavirus pandemic. You can, however, still explore the artist's life and work in the accompanying catalogue, *Angelica Kauffman* (2020).

Like This? Try These

→ Élisabeth Louise Vigée Le Brun

→ Mary Moser

→ Joshua Reynolds

Leonardo da Vinci

Lady with an Ermine (Portrait of Cecilia Gallerani)

c. 1489–90

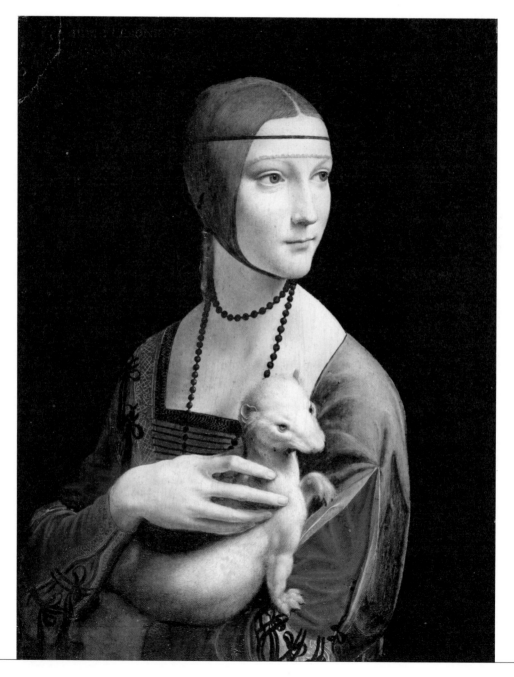

This might not be the portrait of a lady painted by Leonardo that you'd expect to find in a book of 100 artworks – but anyone who's squeezed past the camera-toting crowds at the Louvre to get a glimpse of the *Mona Lisa* (1503) will tell you that, even with that enigmatic smile, it's overrated. *Lady with an Ermine (Portrait of Cecilia Gallerani)*, on the other hand, is captivating, partly because we don't feel entirely at ease in its presence.

Sixteen-year-old Cecilia Gallerani was a member of the Milanese court and mistress to Ludovico Sforza, duke of Milan and Leonardo's principal patron. Here she gazes into the distance, dressed in an elegant but understated velvet gown with a square neckline. Her auburn hair is held back in a hairnet, while a narrow band wraps around her forehead and keeps in place a translucent veil with a lace fringe. A string of black beads dangles in front of her pale chest and in her arms is a ceremonial animal that symbolizes her virtue.

Or does it? The assumed innocence of this unmarried young woman is soon called into question – not least because it wasn't long after sitting for this portrait that she gave birth to Sforza's son. There's a hint of authority in her muscular hand, which restrains the equally muscular animal in her arms. Both turn to look at something, or someone, either ready to pounce or to disappear mysteriously into the dark background (an eighteenth-century addition, but that's another story).

The white ermine is also an emblem of the duke himself – and so, is he under the thumb of his young and beautiful mistress? Or does the similarity between the human and her animal, particularly in pallor and features, point to the fact that she's gaining in confidence because of her lover? Either way, there's something utterly beguiling about this formidable young woman – who, much like Leonardo's more famous painted lady, has a furtive smile playing on her lips.

+ ARTIST BIO
Italian, 1452–1519

+ SEE THIS
In his photograph *Louise Bourgeois* (1982), Robert Mapplethorpe replaces Cecilia Gallerani with the French-born American artist and the ermine with a phallic sculpture.

+ VISIT THIS
Leonardo's Renaissance masterpiece now resides in the Czartoryski Museum in Kraków, Poland.

+ READ THIS
Dan Brown's *The Da Vinci Code* (2003) follows a Harvard professor and a French cryptologist as they attempt to crack a series of codes connected with the artist.

Like This? Try These

→ Masaccio

→ Giacomo Raffaelli

→ Andrea del Verrocchio

Hans Holbein the Younger

The Ambassadors

1533

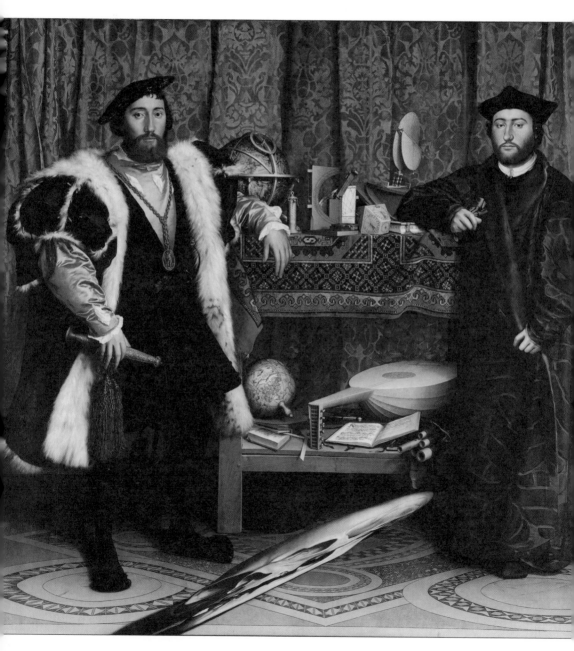

Another double portrait, this time of two young diplomats: Jean de Dinteville and his friend Georges de Selve. Don't worry if you're not familiar with the names. The canvas is bursting with elements that will shed light on these characters and the balance of power between the two schools of thought they represent.

Let's start with their appearances. De Dinteville is the larger of the pair – his feet slightly further forward and his arms carving out a wider space, claiming it as his own. His flamboyant costume is in stark contrast with that of his counterpart, whose more humble clothing suggests his ecclesiastical profession. Everything about De Dinteville's attire demonstrates wealth and status: the rosy satin shirt, the lynx fur, the short-cut jacket with its fashionably padded shoulders. In the sixteenth century, this man was in vogue.

Next, turn your attention to the objects on the wooden shelving unit between them. Astrological and geographical instruments refer to the worldliness and cultural backgrounds of both men. Note how the upper shelf contains instruments concerned with the heavens while the lower shelf holds those that reflect on the earth.

But despite all the pomp, something isn't quite right. Shadows fall in wrong directions and objects are riddled with faults. The lute has a broken string and its leather case is missing two of its wooden flutes. The skull, unavoidably present, is deliberately distorted by anamorphosis; it's visible only if you step to the side of the canvas, a half-hidden memento mori. The crucifix in the upper left-hand corner is also obscured, so much so that you might miss it. Perhaps the imperfections point to the political instability of the time, perhaps to the illness that threatened De Dinteville during the painting process. Regardless, in *The Ambassadors* scientific thought seems to be displacing religious faith, a matter of grave concern in the sixteenth century.

+ ARTIST BIO
German, 1497–1543

+ SEE THIS
The astrological and geographical instruments are much like those found in *The Astronomer* (1668) and *The Geographer* (1668–69), two portraits by Johannes Vermeer (see page 124).

+ VISIT THIS
See this pair for yourself in the National Gallery in London.

+ READ THIS
Fyodor Dostoevsky grapples with faith and reason in *The Brothers Karamazov* (1879–80), which follows three siblings who question God's existence after the murder of their father.

Like This? Try These

→ Anthony van Dyck

→ Ambrosius Holbein

→ Hans Holbein the Elder

Jean-Honoré Fragonard
The Swing
1767

+ ARTIST BIO
French, 1732–1806

+ SEE THIS
In her tantalizing paintings of half-submerged nudes in a sea of bubble-gum pinks, marine blues and lemon yellows, the London-based artist Flora Yukhnovich uses the Rococo style to explore sexual agency and power throughout art history.

+ VISIT THIS
Fragonard's painting hangs in the Wallace Collection in London, along with more of his masterpieces.

+ WATCH THIS
William Oldroyd's *Lady Macbeth* (2016) features a similar love triangle between a beautiful woman, her miserable husband and a young groomsman.

Like This? Try These

→ Thomas Gainsborough

→ Marguerite Gérard

→ Kehinde Wiley

The balance of power swings back and forth in this delightfully flirtatious painting by Fragonard. In the centre a young woman wearing a frothy pink frock and white stockings perches on a swing, its rope wound around bulky branches. To her right is her elderly husband, sitting on a stone bench and apparently smiling, controlling the swing with a pair of reins. To her left is a youthful man lounging in greenery, holding out his hat with a dreamy look on his face.

Fragonard was trained by François Boucher (see page 30), master of Rococo, the flamboyant eighteenth-century style that wafts between representation and metaphor. The younger painter took commissions from a small circle and this one came from the plucky aristocrat on the left, who wanted a portrait of his mistress. What better setting for his amorous scene than a dappled garden? As the tug of war takes place, a jumble of greenery creates a whimsical backdrop. Stone putti watch on fretfully and Étienne-Maurice Falconet's *Seated Cupid* (1757), a famous sculpture known as *l'amour menaçant* (menacing love), hints at something salacious.

Since it was commissioned by the lover, you would expect the balance of power to fall in his favour. But does it? The focal point of Fragonard's painting is the object of both men's affection: the woman rising above them. With the force of the swing, one of her dainty slippers has flown off, and as she lifts her leg to catch it she gives the young man a view up her dress. Let's imagine, just for a moment, that she intended to kick off the slipper – that it was a way of exercising her charms. If that were the case, the power would lie with neither her husband nor her lover, but firmly in her own ever so graceful hands.

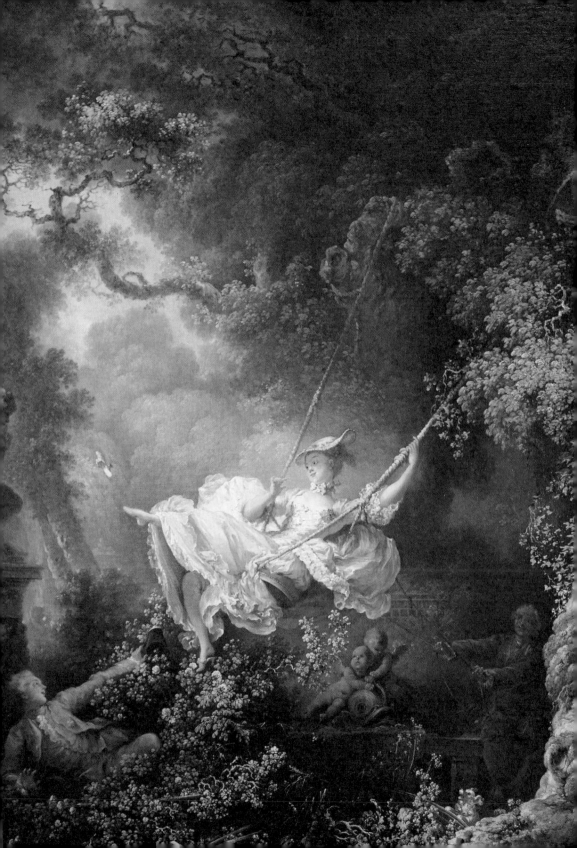

Sofonisba Anguissola

Bernardino Campi Painting Sofonisba Anguissola

c. 1559

At first glance, this double portrait might seem like an odd choice for a chapter on the balance of power. After all, there's nothing dramatic here: just a male artist adding the final touches to his canvas, which shows a female sitter. Or is there? In fact, what we have is Anguissola, a woman artist, negotiating the male-dominated art world – and succeeding.

The portrait shows the young Anguissola being painted by her teacher, Bernardino Campi, who holds a slender brush between his fingers as he illustrates the embroidery on her high-necked gown. The next thought that springs to mind: this is a man stamping his authority on a woman's body. But look again. Anguissola stands upright, with a self-assured look on her face, and it's her steady gaze that commands our attention – as it does Campi's (he turns to look at the viewer, who presumably stands in her place). There's no avoiding the fact that she looms over him, at least half his size again. And then there's this: in 1996, Sienese restorers discovered, beneath a layer of dark varnish, a third arm belonging to Anguissola, reaching up to swipe her teacher's brush.

Anguissola was an Italian noblewoman who enjoyed a prolific career that extended into her nineties. She was encouraged by her father to study art at a young age and she later encouraged other women artists, including her contemporaries Lavinia Fontana (see page 82) and Artemisia Gentileschi (see page 52). And yet, although she became court painter to Philip II of Spain, as a woman her access to models was limited and portraiture was the genre to which she remained restricted. Here she pushes the limits of its potential with a witty *mise en abyme* (painting within a painting), and at the same time asserts herself as a great artist.

+ ARTIST BIO
Italian, *c.* 1532–1625

+ SEE THIS
In *The Artist's Studio* (1854–55), Gustave Courbet (see page 12) asserts the male artist's role in society. He depicts himself at the centre, working on a landscape.

+ VISIT THIS
Anguissola's double portrait is housed in the Pinacoteca Nazionale di Siena.

+ READ THIS
Anguissola is one of the few women artists to be mentioned in Giorgio Vasari's *The Lives of the Artists* (1550), which recalls her ability to make figures 'appear truly alive'.

Like This? Try These

→ Lucia Anguissola

→ Mary Beale

→ Caterina van Hemessen

Michelangelo

David

1501–04

The balance of power tips surprisingly towards the little guy in the story of David and Goliath – or maybe it's not such a surprise after all. Goliath was sluggish and clumsy. David, a good shot when faced with a target much smaller than the giant, had a sling. Nevertheless, Michelangelo's sculpture pays tribute to David's heroism.

The physical presence of this world-famous sculpture is inescapable (not least because his *pisello* features on many an irreverent Italian postcard). Standing before us, David shifts his weight onto his right foot, his left leg bending at the knee. His ribcage rises as he takes a breath. Beneath a mop of curled hair, his face turns nearly ninety degrees. The sculptor has paid attention to the dip of David's belly button and the pertness of his nipples. Focus on his face and you'll see that, despite his cool, his eyes are peeled, his nostrils flared.

Michelangelo's male youth is beauty personified. His David is perfectly proportioned, with muscular limbs and – unlike unfinished works by the sculptor – zero blemishes. Except for his right hand, that is, which is gigantic and greatly detailed, with knobbly knuckles and throbbing veins. Perhaps the sculptor paid extra attention to it because it's closer to our eyeline (David is at least double the height of a normal person). The effect: this isn't an idealized sculpture, but a living, breathing boy. Michelangelo's adherence to the biblical narrative also detracts attention from the male body and diverts it to a greater overarching theme. There's more at stake here than the male nude. This is David pre-combat, brimming with energy.

The twenty-six-year-old Michelangelo took on the challenge of carving his Renaissance wonder from a colossal block of Carrara marble that had previously been worked on by two other artists before being abandoned. It was backbreaking, sweat-trickling work. Another David, then, confronting his Goliath.

+ ARTIST BIO
Italian, 1475–1564

+ SEE THIS
Donatello's *David* (c. 1440s) presents the boy triumphant, with a sword in his right hand, a stone in his left and the head of the giant at his feet.

+ VISIT THIS
Michelangelo's original sculpture is in the Galleria dell'Accademia in Florence, while a copy can be found in the nearby Piazza della Signoria.

+ READ THIS
We all love an underdog and Yann Martel's *Life of Pi* (2002) features a prime example in sixteen-year-old Pi.

Like This? Try These

→ Agnolo Bronzino

→ Donatello

→ Lorenzo Ghiberti

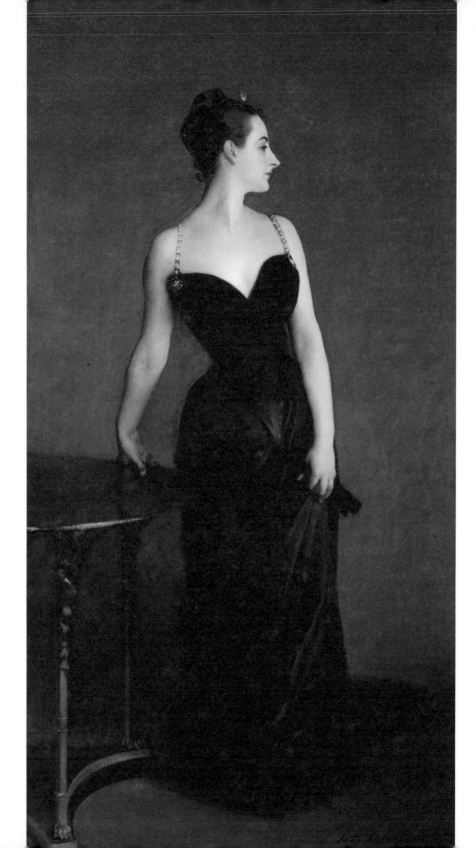

John Singer Sargent
Portrait of Madame X

1883–84

+ ARTIST BIO
American, 1856–1925

+ SEE THIS
Compare Sargent's portrait with his teacher Carolus-Duran's *Lady with a Glove* (1869), which gave the crowd the buttoned-up look they wanted.

+ VISIT THIS
Portrait of Madame X and several other works by the celebrated American artist are owned by the Metropolitan Museum of Art in New York.

+ READ THIS
Sargent's work has inspired several novels, including Gioia Diliberto's *I Am Madame X* (2003), which tells Madame Gautreau's story.

Like This? Try These

→ Cecilia Beaux

→ Thomas Eakins

→ James Abbott McNeill Whistler

Portraiture is often about enhancing the reputation of the sitter, but it can also bump up the artist. The Louisiana-born socialite Madame Pierre Gautreau was greatly admired in Paris for her beauty and style, and by painting her portrait Sargent hoped to scale the ranks.

She stands in a nondescript room, leaning on a delicate wooden table that gleams in the light. Her porcelain skin is offset by a black dress with a sweetheart neckline and a narrow waist, as well as reddish hair that's scraped back off her face. With her left hand, she clutches a fan. Turning her head to one side she's caught in profile, with arched eyebrows, a painted pout and an elegantly slanted nose.

Portrait of Madame X caused a scandal when it was exhibited at the Paris Salon of 1884, so much so that Sargent fled to Britain. At first glance, it's unclear why – Parisians were used to seeing female nudes, so it can't have been the flash of flesh. No, the issue was with the dress.

Instead of a pretty but modest gown like the kind worn by the middle-class women who attended the Salon year on year, Madame Gautreau's outfit is entirely anti-bourgeois. The gold straps are tantalizingly flimsy; in fact, the right strap was originally shown slipping from her shoulder, but Sargent swiftly repainted it after outraging viewers. Then there's that plunging neckline, which draws the eye down towards her breasts. And what about the erotic arch of her right arm, and the redness of her ears – burning with shame?

The scandal didn't hurt Sargent's reputation. Quite the opposite: it won him the fame and commissions he had been hoping for. No doubt he was proud of his achievement – he kept the daringly seductive portrait in his studio, close by at all times, a reminder that sex sells.

Johan Joseph Zoffany

The Academicians of the Royal Academy

1771–72

Cast your eyes over this institutional portrait. What do you see?
A group of thirty-four gentlemen discussing one of two nude models
before them. These are the original members of London's Royal
Academy of Arts, founded in 1768 – an occasion memorialized in
Zoffany's painting. But two original members are missing.

Because they were women, the artists Mary Moser (see page 160) and Angelica Kauffman (see page 180) were not allowed to enter the life-drawing room, a rule that reinforced gender inequality among artists. Drawing the male nude was considered an essential part of an artist's training, but it was deemed unsuitable for women. The German painter smuggled in the two female academicians by including them as half-finished portraits relegated to a drab wall on the right.

Kauffman and Moser's male colleagues own the space. These are posers as well as painters, finely dressed in velvety coats with gold buttons and smart black shoes with polished silver buckles. Look at the man in brown parked on a wooden packing case on the left, legs spread; the fellow standing beside him nonchalantly leans one foot on a ledge. And then there's the guy in green in the bottom right corner, surveying the room, his chin raised. One hand is slipped into his pocket while the other rests on a cane that in turn pins down a discarded nude torso – the third and final woman present.

Zoffany himself sits in the opposite corner, gazing out at us, palette in hand, unfazed by the artistic fraternity before him. His group portrait is a faithful record of the gender imbalance in the art world. After Kauffman and Moser, the next woman elected to the Academy was Dame Laura Knight – more than 150 years later, in 1936. Today the number of women members is rising, slowly but surely, and in 2019 the artist Rebecca Salter became the first female President.

+ ARTIST BIO
German, 1733–1810

+ SEE THIS
Joshua Reynolds, the first President, stands at the centre of the painting, dressed in black.

+ VISIT THIS
The Royal Academy of Arts celebrated its 250th birthday with an impressive expansion devised by the architect Sir David Chipperfield.

+ WATCH THIS
Shot over five years, *The Private Life of the Royal Academy* (2018) provides a sneak peek into the institution's inner workings.

Like This? Try These

→ Hugh Barron

→ Joshua Reynolds

→ George Romney

Diego Velázquez

Las Meninas

1656

Let's end with the balance of power in an extended family portrait in a royal court. Velázquez created his most famous painting in the old Moorish fortress of Philip IV of Spain and Queen Mariana – the Alcázar Royal Palace in Madrid.

The king and queen are relegated to a mirror on the back wall, which suggests that they stand in our place, being painted by Velázquez, who wields a paintbrush in his right hand, a palette in his left. Their daughter, the five-year-old Infanta Margarita of Spain, is flanked by her two *meninas* (maids of honour), Doña Isabel de Velasco and Doña María Augustina Sarmiento, the latter of whom curtsies as she offers the princess a beaker of water. To the right are two dwarves, Mari-Bárbola and Nicolás de Pertusato. De Pertusato prods the dozing dog with his toe, encouraging him to join his master and mistress; the dog doesn't lift an eyelid. In the shadows is a nun, conversing with an unidentified guard, and hovering on the steps beyond the threshold is the queen's chamberlain.

Although we can pinpoint the room in which the portrait is set, and name ten of the eleven sitters, there's an element of mystery here – particularly in that hazy mirror and the open door beside it, portals to other worlds. Velázquez, who was fascinated by art theory, showcases the capacity of paint to mystify viewers. It's been almost four centuries since the work was created and historians are still flummoxed by its meaning.

Who wields the power? The heads of the royal household are immortalized, hanging among history paintings, but also tiny and blurred. The illuminated Infanta is front and centre – and no wonder, since she's the only surviving royal child – but dependent on those around her. Then there's the artist himself, the puppeteer who toys with truth in paint. It would seem that here the balance tips in Velázquez's favour.

+ ARTIST BIO
Spanish, 1599–1660

+ SEE THIS
Another intriguing painting whose message is muddled by a mirror is the The *Arnolfini Portrait* (1434) by Jan van Eyck.

+ VISIT THIS
Head to Madrid to see *Las Meninas* in the Museo Nacional del Prado.

+ READ THIS
Everything Is Happening: Journey into a Painting (2015) – written by Michael Jacobs and completed, after his death, by his friend Ed Vulliamy – searches for the meaning of Velázquez's masterpiece.

Like This? Try These

→ Bartolomé Esteban Murillo

→ José de Ribera

→ Francisco de Zurbarán

CHANGE OF SCENE

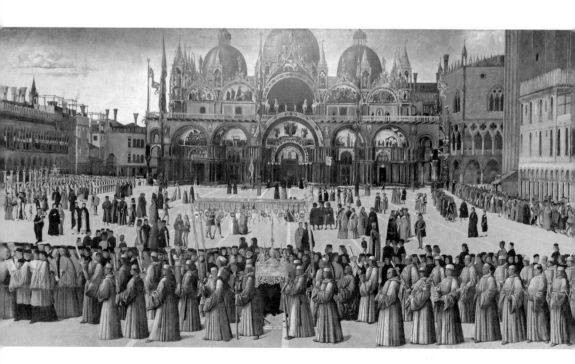

Gentile Bellini—Procession of the True Cross in Piazza San Marco

Gentile Bellini

Procession of the True Cross in Piazza San Marco

1496

Artists have long been aware of the power of architecture to enhance a narrative and create a sense of place – and Bellini's painstakingly laid-out panorama proves the point. The Renaissance master presents Piazza San Marco in all its glory, the historic epicentre of Venetian religious and political life.

Bellini was one of a handful of prominent Venetian artists commissioned to paint a canvas (or in his case three) for the Great Hall of the Confraternity of the Scuola Grande di San Giovanni Evangelista's headquarters. The theme: the miraculous workings of a fragment of wood from the cross on which Christ was crucified.

Here Bellini depicts an episode that took place on 25 April 1444, on the Feast of Saint Mark, patron saint of the city. During the ceremonial procession a merchant from Brescia knelt as the relic passed by and prayed for the survival of his dying son; the following day the boy miraculously recovered. Look closely and you'll find the merchant on his knees, hands in prayer, just behind the golden canopy being carried from right to left by white-robed members of the confraternity.

Though Bellini's brief was to commemorate the miracles of the True Cross, it's the meticulously rendered backdrop that commands our attention. The Basilica di San Marco is crowned with three domes and decorated with columns, marble revetment, reliefs, mosaics, and spoils from Constantinople that include the bronze horses on the second-storey terrace. To the right is the pink-and-white façade of the Palazzo Ducale, the seat of government. In front, the piazza itself, dotted with people.

Procession of the True Cross in Piazza San Marco captures a remarkable event, but the backdrop steals the show. This stunning visual tribute to a great city gives us a glimpse of the heart of Venice in the fifteenth century. In his portraits Bellini documented Venetian society; here he captures the pomp and ceremony of a religious ritual performed with undisguised civic pride.

+ ARTIST BIO
Italian, 1429–1507

+ SEE THIS
In 1479, Bellini was sent to Constantinople to foster cultural relations with the East. His formal portrait, *The Sultan Mehmed II* (1480), pays homage to the ruler of the Ottoman Empire.

+ VISIT THIS
Procession of the True Cross in Piazza San Marco hangs in the Gallerie dell'Accademia in Venice.

+ READ THIS
Jan Morris's magisterial *Venice* (2004) is essential reading whether or not you're planning on visiting the city.

Like This? Try These

→ Canaletto

→ Francesco Guardi

→ Paolo Veronese

Joseph Mallord William Turner

Yacht Approaching the Coast

1840–45

In this painting, Turner presents not so much a change of scene as a scene that's almost entirely obscured. Sunlight dazzles us, beaming down from the sky and glistening in the choppy sea, a thousand camera flashes. If it weren't for the gently billowing white sails of the yacht on the left-hand side of the canvas, we might struggle to decipher the subject.

A masterful artist of the ocean, who in later life was more and more often drawn to maritime themes, Turner gives us a swirling composition in which painterly flourishes surpass representation. The prolific British landscape painter reworked *Yacht Approaching the Coast* over several years towards the end of his career, covering the original image with atmospheric layers of light and dappled reflections on the water. Dark shapes and slices of white hint at other boats – there, to the left of the golden glow extending across the surface of the ocean towards the horizon. The sandy buildings on the left could be Venice, a city the artist visited and admired for its serene waterways and faded grandeur. The whirl of colours makes you wonder whether he tried to capture the fleeting effects and changing character of more than one day's weather.

Turner's is a loosely handled scene, an artist's impression of shimmering colour and light. So hazy is its overall appearance that it flits between being vaguely identifiable and wholly incomprehensible, which suggests that it might not be finished. In fact, all his paintings were works-in-progress that he'd revisit over the course of his life, searching for new meaning and potential with his brush. The effect, in oil paint as well as in watercolour, is that solid gives way to liquid, and what we're left with are the elements: sunlight, water, air. Looking at a Turner is a startling optical experience that takes you on a journey, its destination not always clear.

+ **ARTIST BIO**
British, 1775–1851

+ **SEE THIS**
Turner was inspired by the light-filled work of the French painter Claude Lorrain.

+ **VISIT THIS**
The majority of Turner's paintings can be found in London's Tate Britain.

+ **WATCH THIS**
Mike Leigh's *Mr Turner* (2014) paints on screen a self-assured portrait of the innovative artist in his final years.

Like This? Try These

→ John Constable

→ Thomas Girtin

→ Claude Lorrain

Katsushika Hokusai

The Great Wave off Kanagawa

1830–32

The most famous image in all of Japanese art is undoubtedly Hokusai's *The Great Wave off Kanagawa*, which started life as a low-cost print and now has its own emoji. The woodcut is part of *Thirty-Six Views of Mount Fuji*, a print series created in the artist's final decades. Far from slowing down, though, this surging breaker is full of life.

The enormous wave is a thrilling menace, its bright-white cap a mass of grappling claws. It towers above the snowy peak of Mount Fuji, on the distant horizon beneath a greying sky. Struggling to keep afloat in the trough are three narrow fishing boats, whose frightened crews cling onto the sides. The swell threatens to swallow them whole, and the remote volcanic mountain along with them.

A master of perspective, Hokusai manipulated proportions to showcase the formidable power of nature: the cresting wave takes up the majority of the page and dwarfs the sacred mountain, which should be the highest point in Japan. His use of colour also adds to the turbulence, with the frothing white spray – which could be mistaken for snow – contrasting with the newly imported Prussian blue.

Hokusai, who lived and worked in the city of Edo (now Tokyo), relied on selling a large number of his prints to make a living; each cost roughly the same as a double helping of noodles. He died in 1849, just ten years before Japanese prints began to be exported to Europe. In 1867, *The Great Wave off Kanagawa* was shown at the International Exposition in Paris and went on to influence the work of western artists such as Claude Monet (see page 211) and Vincent van Gogh (see page 162). Hokusai shows us an irresistible force of nature; little did he know his creation would sweep all the way around the globe.

+ ARTIST BIO
Japanese, 1760–1849

+ SEE THIS
Martin Bailey, a leading specialist on Van Gogh, believes that Hokusai's woodcut loosely inspired the swirling sky in the Dutch artist's *The Starry Night* (1889).

+ VISIT THIS
The British Museum in London and New York's Metropolitan Museum of Art showcase many works by Hokusai.

+ LISTEN TO THIS
French composer Claude Debussy's *La Mer* (1905) was no doubt inspired by Hokusai's *The Great Wave off Kanagawa*, a copy of which he kept on his wall.

Like This? Try These

→ Utagawa Hiroshige

→ Utagawa Kunisada

→ Utagawa Kuniyoshi

Laurence Stephen Lowry

Fun Fair at Daisy Nook

1953

To some critics, Lowry was stuck in a rut, his artwork repetitive and drab. To others, he was a loyal socialist who put England's smoggy industrial north on the map. Either way, in this particular painting the postwar British artist offers a bright alternative to the daily drudgery of working-class life that he usually chose to depict: instead of red-brick terraces, chimney stacks, freight trains and cotton mills, he captures a happy throng of people at leisure.

The setting is the annual Good Friday fair in Lancashire, run by the Silcock family, whose name is stamped on the tall mustard-yellow tent. The bottom half of the canvas is abuzz with activity as matchstick men, women and children (and cats and dogs) scurry to and fro. In the foreground there are folk selling balloons and whirligigs, as well as parents pushing prams. Unlike those he pictured on other canvases, these figures have faces – even if they are composed of basic dashes and dots. They wear colourful clothing, not just the soot-black coats and flat caps warn by his mill workers; the children have even donned pointed party hats.

Lowry tended the same patch of northern England throughout his career and, whether you admire him or not, there's no questioning his ability to conjure a particular time and place in paint. He makes us witnesses to everyday moments in working-class life: an eviction, a queue, a strike. Here, the moment may be more jubilant, but don't get too carried away. Beyond the rows of caravans and the tents, circus-like with their stripy awnings, there's calm – and a few specks, presumably people, heading home across the otherwise empty fields. The chimney in the upper right-hand corner is a reminder of the work that has to be done in the morning, as is the low-hanging sky, which – as in all Lowry's paintings – is a bleached white.

+ ARTIST BIO
British, 1887–1976

+ SEE THIS
Returning from Work (1929) is in many ways more typical Lowry, with smoking chimneys and stooped figures all in black.

+ VISIT THIS
The Lowry in Manchester is home to the world's biggest collection of works by the artist.

+ WATCH THIS
Mrs Lowry and Son (2019), directed by Adrian Noble, follows Lowry's life in the 1930s when he made art while caring for his widowed mother.

Like This? Try These

→ Alberto Giacometti

→ Utrillo

→ Adolphe Valette

Piet Mondrian

Broadway Boogie Woogie

1942–43

Mondrian fled from Europe to New York during the Second World War and this canvas pays tribute to the two things he loved most about his adoptive home: Broadway, a busy thoroughfare teeming with theatres; and boogie-woogie, a playful subgenre of jazz. The Dutch-born artist adjusted to his new life in the city with enthusiasm, and that included going out in midtown Manhattan and dancing late into the night to live bands.

Mondrian's grid of intersecting vertical and horizontal lines is in fact composed of a series of squares and rectangles in yellow, red and blue – the signature colours of De Stijl, the Dutch art and design movement he co-founded with Theo van Doesburg in 1917. Practitioners renounced realism in favour of pure and spiritual geometries that they believed could restore balance after the First World War. Theirs was a rational ideal comprised of long continuous lines and large windows of primary colours.

But with *Broadway Boogie Woogie*, the geometric master shook things up, casting aside his black outlines and breaking up his once solid colour planes into a bundle of jerky blips. He embraced a more fragmented composition and, in doing so, infused his work with verve. And the patches of white or grey? Time out when you need it.

Bumping up against one another, the small bars of colour evoke pulsating traffic as seen from above in Manhattan: yellow cabs, their horns never not sounding; blinking headlights by night; even traffic lights changing from red to amber. They flit across the canvas, like fingers dancing on piano keys to a radical and vital new rhythm. Stand in front of the work for long enough and you'll feel like you've tumbled into a game of Pac-Man – but don't worry, there are no ghosts here. Just life, boogying.

+ ARTIST BIO
Dutch, 1872–1944

+ SEE THIS
Mondrian's final painting, the unfinished diamond-shaped *Victory Boogie Woogie* (1942–44), turned this work on its head.

+ VISIT THIS
The Netherlands' Kunstmuseum Den Haag is home to the largest collection of works by Mondrian.

+ LISTEN TO THIS
Put on 'Boogie Woogie Prayer' (1939) by the three pianists Albert Ammons, Meade Lux Lewis and Pete Johnson, then look again.

Like This? Try These

→ Theo van Doesburg

→ Marlow Moss

→ Bridget Riley

Edward Hopper

Nighthawks

1942

+ **ARTIST BIO**
American, 1882–1967

+ **SEE THIS**
Hopper's *Morning Sun* (1952) shows a woman sitting on her bed, staring out at an empty city.

+ **READ THIS**
In *The Lonely City* (2016), Olivia Laing examines the relationship between isolation and creativity and its manifestations in the art of Hopper, Andy Warhol and others.

+ **WATCH THIS**
Hopper's art inspired many a shadowy scene in film noir, with directors such as Alfred Hitchcock and Wim Wenders looking to his paintings.

Like This? Try These

→ Lois Dodd

→ Robert Henri

→ Andrew Wyeth

No one captures urban life quite like Hopper, whose moody paintings tap into a strain of isolation that flourishes in a city. The loneliness creeps up on you as you stand shoulder to shoulder with strangers on public transport and makes your stomach turn when, in the thick of a crowd, it suddenly hits you. In his paintings, the twentieth-century American artist portrays men and women either alone or in hushed, isolated groups.

Nighthawks shows a floodlit diner at a lower-Manhattan intersection. Inside are four figures: a uniformed employee, a couple and a man drinking his coffee alone. No one is talking. Though they sit close together, the couple are distinctly disconnected; he stares grimly ahead with a cigarette sandwiched between his fingers, while she fiddles with what looks like a folded dollar bill. The gaunt waiter grimaces as he gets to work. The lone wolf has his hunched back to us and is snappily dressed in a dark suit and a hat, like the man opposite. Has he just got off work? Why is he hunched over? Fatigue, or something more sinister?

The sense of isolation is highlighted by the row of vacant bar stools, as well as the solitary salt and pepper shakers and a stray empty glass. Out on the street, there's no sign of life – just an eerie void of shadows. The empty shopfront opposite is seemingly abandoned. The fluorescent lighting is almost alien, as is the muddied palette and that sickly shade of green. Outside looks even less welcoming than inside, and the plate glass windows offer scant protection.

Is the all-night diner a refuge for lonely souls? The night owls may be lost in their own thoughts, but at least they're lost in them together; there may be some comfort in the mere proximity of others. And how about us? We're voyeurs, shut out in the cold.

Claude Monet

The Thames below Westminster

c. 1871

+ ARTIST BIO
French, 1840–1926

+ SEE THIS
Monet's canvas was probably influenced by the Thames paintings of Joseph Mallord William Turner (see page 200), particularly *The Burning of the Houses of Parliament* (1834–35).

+ VISIT THIS
The Thames below Westminster is owned by the National Gallery in London, just a fifteen-minute walk from the Houses of Parliament.

+ READ THIS
Bleak House (1853) by Charles Dickens opens with a description of London fog rolling down the river.

Think Monet and you're likely to summon up scenes of nature: landscapes, seascapes, gardens, haystacks and, of course, ponds crowded with waterlilies. But the Impressionist artist was also a master at handling urban architecture. Here he combines the natural and the manmade to startling effect.

Monet gives us a view of the Thames, with the recently renovated Westminster Bridge and the newly built Houses of Parliament on the horizon. In the foreground a couple of workers dismantle scaffolding on a jetty that's attached to Victoria Embankment, another urban advance, one that brought with it a much-improved sewage system. To the left, tugboats and barges glide along the river, reminding us that this grand waterway is integral to the commercial success of the city.

The scene is shrouded in a blanket of smog, the industrial pollution that plagued late-nineteenth-century London. But rather than evoking the grit and grime of the capital, the hazy wash of pearly greys and browns creates an air of tranquility. The sky is flecked with pale pink, hinting at the sun hiding behind the layer of mist, and the river is dappled with light and dark. 'Without the fog, London would not be a beautiful city,' Monet later told the art dealer René Gimpel. Unlike the Londoners, who complained about the fog, Monet saw it as a gift that made views eternally variable.

Monet had fled to London following the outbreak of the Franco-Prussian War in 1870. While he was there he painted five cityscapes, only one of which featured the Houses of Parliament. Some thirty years later he returned to the subject – repeatedly. This painting, like the later series, is both a study of nature and the effects of light and an ode to modernity. The architecture anchors the hazy composition: without the solid structures, you can almost imagine the mist blotting out London entirely.

Like This? Try These

→ Armand Guillaumin

→ Camille Pissarro

→ Alfred Sisley

Claude Monet 71

Like This? Try These

→ Elin Danielson-Gambogi

→ Ellen Thesleff

→ Maria Wiik

Helene Schjerfbeck
Shadow on the Wall (Breton Landscape)
1883

Schjerfbeck takes the loneliness that Edward Hopper (see page 208) captures in the city and transfers it to the countryside. There's a ghostly quality to her eerily abandoned landscape. But it doesn't trigger that pang of isolation.

After receiving a travel grant as a teenager, Schjerfbeck moved from Helsinki to Paris, where she continued her studies in the 1880s. While she was there, she took the opportunity to visit a liberal artists' colony in Pont-Aven in Brittany, perhaps relieved to escape from the big city.

It was in Brittany that Schjerfbeck turned away from the history painting that her native Finland was keen to promote and instead found inspiration in the everyday. Without a strict narrative to adhere to or a national identity to carve out, she was free to focus on conjuring an atmosphere, which she achieved through expressive brushwork and a balance of light and dark. *Shadow on the Wall (Breton Landscape)* is framed by three thick-set trees, which draw our gaze to the wooden bench at the centre, as vacant and lifeless as the bare branches above. The canvas is visible in patches beneath the hastily applied palette of muddy browns and mossy greens. The subdued tones and hazy finish add to the sense of calm, as well as the idea that the image could drift away at any minute.

Schjerfbeck's figure-free landscape is tinged with mystery. The trees cast strange shadows that creep like tendrils up the steep side of a small hill. Is there something lurking in those shadows? Possibly. The overriding feeling when we look at the work, though, is not fear. What comes across is a sense of relief – here, in nature, we can finally slow down and breathe. So, go on, take a seat.

Like This? Try These

→ Jules Breton

→ Maurice Denis

→ Jules Bastien-Lepage

Paul Cézanne
Bottom of the Ravine

1879

Modern art may well have begun with the Post-Impressionist painter Cézanne, who documented landscapes not just by looking at them, but by turning them over both in his mind and on canvas. The result: his art is less an imitation of nature than his perception of it. In other words, he fully appreciated and sought to understand the ever-evolving world around him.

This is no hushed and hollow landscape; *Bottom of the Ravine* zings with energy. The sun is shining – that we know from the brilliant blue sky and the daubs of mustard, ochre and orange on the craggy ground. Like a creeper on a building, greenery wends its way up the jagged side of the ravine. At the top, rock formations jut into the sky. To the left, a tree with a slender, sinuous trunk leans towards the edge of the canvas as if to give us a better view. Perhaps there's a hint of a breeze.

Inspired by his fellow French painter Camille Pissarro, who worked *en plein air*, Cézanne had begun to study nature in earnest in the 1870s. Unlike the Impressionists, however, who favoured spontaneous brushwork and strove to capture a fleeting moment, his art was more carefully considered and systematic, more solid. Cézanne would examine a landscape at great length, steadily building up forms through colour graduation and painterly strokes. Look again at this work and you'll notice the way that the green pigment in the background has been applied in a different direction to the rock closest to us.

Stare for long enough at this saturated work and soon it will seem less rendered, more real. Cézanne regarded nature as a complex subject richly deserving of his time and energy. Here, through meticulously arranged markings and subtle tonal variations, he lays it bare under the hot sun for all to see.

Richard Diebenkorn

Cityscape #1

1963

It makes sense to end a book on great art with a work that draws your eye optimistically towards the horizon. Some of Diebenkorn's figurative paintings may lack depth, but his cityscapes are always full of life. Here the twentieth-century American painter captures sunlight and shadows dancing along a West Coast vista. Though he rarely painted *en plein air*, the setting is reminiscent of Berkeley, California, where the artist lived in the early 1960s.

In *Cityscape #1* you can almost feel the heat rising off the tarmac road that cuts, like a warm knife through butter, from the bottom of the canvas up towards its crown. On the left are low-slung buildings that lazily climb the hill – as parched people might, if they were anywhere to be seen. But they're not, and their absence is underlined by the view on the right: the open expanse of a grass field and empty lots gathering dust.

Diebenkorn created a patchwork composition. His chosen palette combines bleached blues, greys and whites with sprinklered greens, sandy browns and, here and there, tomato red. Nothing is sharply delineated. On the horizon, the hazy edges of a pitched roof and the natural terrain seem to cascade into the infinitely blue ocean, or perhaps it's the sky. And what about that road: where does it lead? If your belly hasn't flopped yet, imagine you're in a car trundling towards the crest of the hill.

Diebenkorn painted his grid-like cityscapes with planes of colour that are both washy and intense. In parts they're as clear as glass; elsewhere they're made muddy by multiple layers and corrections. He's a brilliant colourist whose canvases ferry us from place to place; like the shapes and forms within *Cityscape #1*, one scene bleeds into another. Which begs the question: where to next?

+ ARTIST BIO
American, 1922–93

+ SEE THIS
Diebenkorn's West Coast version of Abstract Expressionism owed a great deal to artists such as Willem de Kooning, based on the opposite coast.

+ VISIT THIS
Stand in front of *Cityscape #1* in the San Francisco Museum of Modern Art and you'll feel yourself rising onto tiptoes to see what's over that hill.

+ LISTEN TO THIS
If you haven't already done so, try listening to 'California' (2002) by Phantom Planet as you look.

Like This? Try These

→ Agnes Martin

→ David Park

→ Clyfford Still

Index

Picture Credits

Author Bio

Chloë Ashby is a writer and editor. Since graduating from the Courtauld Institute of Art, she has written about art and culture for the *TLS*, *Guardian*, *FT Life & Arts*, *Spectator*, *Apollo*, *frieze* and others. She is the author of *The Colours of Art: The Story of Art in 80 Colour Palettes*, which will be published by Frances Lincoln in spring 2022. Her short fiction has appeared in *The London Magazine* and *The Fairlight Book of Short Stories*. Her first novel, *Wet Paint*, will be published by Trapeze, also in spring 2022.

www.chloeashby.com

Acknowledgements

Thanks to the artists for creating these works, and to the galleries and museums for sharing them. Thanks also to Pete and Laura at Quarto for asking me to write about them, to my stepdad Adam for being an early reader, and to you all – my family, friends and maybe even a stranger or two – for taking an interest in what I have to say. As I type, it's nearing lunchtime, and my thoughts are turning to which artwork I might like to reset in front of today. It's raining out, umbrellas blooming, and while I should probably seek out something bright and cheery, I can't shake from my head Gustave Caillebotte's *Paris Street; Rainy Day* (1877). The original is hanging in the Art Institute of Chicago, but I know I have a postcard here somewhere. 'But wait, it's not included in the book!' I hear you cry. (Just go with it….) The trouble is, there are more great artworks than there are pages.